DISCOVERING
LEONARDO

"Study me reader, if you find delight in me"
—LEONARDO DA VINCI
(Codex Madrid)

*The Art Lover's Guide
to Understanding
Leonardo da Vinci's
Masterpieces*

REBECCA TUCKER

PAUL CRENSHAW

UNIVERSE

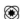

(PAGES 1, 3 AND 5)
The Last Supper, DETAIL
CA. 1495–97

DISCOVERING LEONARDO

The Art Lover's Guide to Leonardo da Vinci's Masterpieces

Published by Universe Publishing
A Division of Rizzoli International Publications, Inc.
300 Park Avenue South
New York, NY 10010
www.rizzoliusa.com

© 2011 Universe Publishing

PROJECT DIRECTOR: James Muschett

BOOK DESIGNER: Kevin Osborn, Research & Design, Ltd.,
Arlington, Virginia

EDITOR: Mary Ellen Wilson

PHOTOGRAPHY CREDITS
Alinari / Art Resource, NY: pp. 180, 183
Art Resource, NY: pp. 214, 217
Bildarchiv Preussischer Kulturbesitz / Art Resource, NY: pp. 60, 63
bpk, Berlin (Museo Thyssen-Bornemisza, Madrid), Lutz Braun / Art Resource, NY: pp. 236, 239
Cameraphoto Arte, Venice / Art Resource, NY: pp. 186, 189
HIP / Art Resource, NY: pp. 158, 161
Erich Lessing / Art Resource, NY: pp. 92, 95, 106, 109, 116, 119, 138, 141, 142–143, 218, 221, 228, 231, 232, 235, 246, 249
Réunion des Musées Nationaux / Art Resource, NY: front cover, pp. 134, 137, 162, 165, 204, 207, 250, 253, 254–255
National Gallery, London / Art Resource, NY: pp. 36, 39, 96, 99, 100, 102, 105
National Gallery of Art, Alisa Mellon Bruce Fund: pp. 222, 225, 227, 228
Private Collection, New York: pp. 88, 91
The Royal Collection, © 2011 Her Majesty Queen Elizabeth II: pp. 152, 155, 156–157, 172, 190, 193
Scala Art Resource, NY: pp. 32, 35, 50, 53, 54, 57, 58–59, 64, 67, 68, 71, 74, 77, 78, 81, 82, 110, 113, 114–115, 120, 123, 130, 133, 144, 147, 166, 169, 170–171, 176, 179, 200, 203, 242, 245, 256, 259
Scala / Ministero per i Beni e le Attivitá culturali / Art Resource, NY: pp. 26, 29 30–31, 40, 43, 46, 49, 124, 127, 128–129, 148, 151
Trustees of The British Museum / Art Resource, NY: pp. 72, 73, 194, 197, 198–199, 208, 211, 212–213

ISBN-13: 978-0-7893-2268-5

Library of Congress Catalog Control Number: 2011921539
2011 2012 2013 2014 / 10 9 8 7 6 5 4 3 2 1

PRINTED IN CHINA

CONTENTS

SCIENTIFIC VISION AND IMAGINATION

MACHINES AND MILITARY MATTERS

PORTRAITS

LEONARDO'S LIFE AND ART: DISCOVERING THE DELIGHTS OF NATURE

*"Study me reader,
if you find delight in me"*
—LEONARDO DA VINCI
(Codex Madrid)

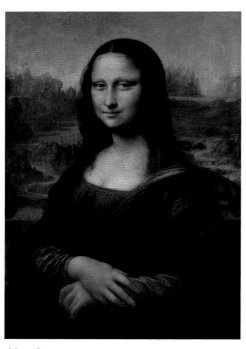

Mona Lisa
CA. 1503–6, AND POSSIBLY LATER

IT IS difficult to refrain from superlatives when discussing Leonardo da Vinci. His name inevitably arises in any consideration of the world's greatest thinkers, inventors, and, of course, artists. One points to designs such as a flying machine that would have been viable had the artist only had access to materials lightweight enough to sustain it, an astounding four hundred years before the Wright brothers. Does that make him a man ahead of his time—to adopt the cliché—or should we see him through a historical lens and assert that he epitomized his era as the ultimate "Renaissance man," a polymath skilled in many facilities, accomplished in myriad endeavors? Leonardo's portrait known as the *Mona Lisa* is today the most famous painting in the world—but why? Do the crowds that surround it daily at the Louvre Museum in Paris appreciate its historical importance or merely perpetuate its fame? Does the ubiquitous use of the image in our age of digital reproduction and modern advertising alter, subvert, or enhance its meaning? Or does the painting accrue so many new frames of reference that its original context is forever lost in the winding roads and waterways, clouded in the misty haze, that characterize the mysterious landscape in its own background?

We are fascinated by this artist, a fact attested not only by the admiring throngs but also by best-selling works of fiction, not to mention cartoons, Hollywood films, and video games. Who can blame modern audiences if they do not fully appreciate his work, and the thinking that lay behind it, because even in his own lifetime Leonardo's creations were often difficult to wholly comprehend. In his paintings both finished and unfinished, in his remarkable drawings, writings, and inventions, and in the story of his extraordinary life, Leonardo presents the viewer with compelling enigmas.

This book highlights Leonardo's principal paintings and drawings, set in relief against comparative works by contemporaries and forebears, to investigate the nuances of his genius. Illuminating key themes, ideas, and details will help to explain Leonardo's artistic production and provide insight into how his efforts fit into the rich fabric of the Italian Renaissance. The "windows" cut from the pages that follow allow readers to focus attention on the intricacies of each work. Yet it is important to remember that, for Leonardo, overall unity was a central goal. The die-cut openings and large-scale reproductions are intended to help readers see both the individual pieces of the puzzles within his images as well as the complete—and beautiful—construct as a whole. The accompanying texts illuminate the discrete elements and overarching significance of these works, providing notes on style, the artist's biography, patronage and audiences, visual traditions, and other relevant contextual details. The result is a comprehensive presentation that allows us to fill out our knowledge and understanding of this fascinating figure.

Mona Lisa, DETAIL
CA. 1503–6, AND POSSIBLY LATER

Art and Life

Leonardo carries the name of his birthplace, the town of Vinci, a commune in the region of Italy called Tuscany, where he was born on April 15, 1452, at 10:30 P.M. His father, Ser Piero di Antonio da Vinci (1427–1504), was a respectable official, notary, lawyer, and property owner who built a thriving career in the major Tuscan city of Florence; his mother, a local woman named Caterina, was the daughter of a farmer. Though Leonardo was born illegitimate, he appears to have been raised as an accepted member of Ser Piero's extended family, and sometime in the late 1460s he was apprenticed to the famous sculptor Andrea del Verrocchio (1435–1488). When Giorgio Vasari (1511–1574) wrote of Leonardo's time in the master's shop in his influential history of art entitled *Lives of the Artists,* first published in 1550, he emphasized the young artist's precocious natural talent. Vasari did more than deny Leonardo's dependence on any teacher; he commented that, upon witnessing his student's skills, Verrocchio abandoned painting altogether. Documents reveal a more mundane tale, showing that Leonardo followed a fairly traditional though wide-ranging course of study, learning the mechanics of

drawing, painting on panel and in fresco (on wet plaster walls), and likely also marble and bronze sculpture. He probably assisted Verrocchio on the project for the copper orb that sits atop the dome of the Florence cathedral (known as the *Duomo*), a celebrated feat of engineering at the time. He honed his judgment by examining the art of earlier Italian masters that enriched local churches and by observing works of antiquity available for study in the city's many prominent private collections, especially the renowned Medici palace. Thus his tremendous versatility, his seeming mastery of so many media, appears to have been nurtured by his training in Florence. But, most of all, his enduring teacher was nature itself.

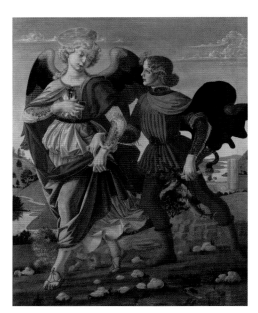

ANDREA DEL VERROCCHIO,
WITH LEONARDO DA VINCI (?),
Tobias and the Angel
CA. 1470–72

Leonardo's command of unaffected poses, lifelike anatomical features, compelling emotional expressions, and convincing natural environments is evident in his earliest artworks. He stayed in Verrocchio's shop at least through 1476, and his first independent works date to the later 1470s. During this period, he painted several religious subjects *(Tobias and the Angel,* an *Annunciation,* and an unfinished *St. Jerome),* a portrait *(Ginevra de' Benci),* and a succession of images of the Virgin and Child. He also began his first major commission, an altarpiece of the *Adoration of the Magi.* His initially delicate style developed into a more volumetric, powerful fusion of the observable world and complex theological concepts; this shift may show his engagement with the concepts of Florentine humanism.

Given his later reputation, it is perhaps surprising to recognize that Leonardo enjoyed only limited success in these early years. At the time Florence was the largest city in Europe, with a population of nearly 100,000, and its extremely competitive market was difficult to break into, no matter how talented the artist. Only one of Leonardo's paintings (the *Virgin with the Carnation*) can be connected to the city's most important family of art patrons, the Medici, and his only public commission, the above-mentioned *Adoration of the Magi,* came saddled with onerous contractual obligations. He was not yet recognized as one of the best Florentine artists, nor was he chosen in 1481 to be among the painters sent to work on the prestigious project of Pope Sixtus IV for his new Sistine Chapel in Rome. It is perhaps no coincidence that, in 1482, Leonardo left Florence for Milan to try to make his career at the court of Ludovico Sforza (1452–1508). Although ostensibly sent on the command of

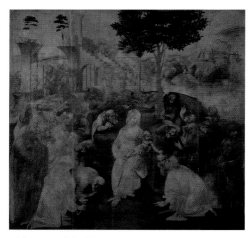

Adoration of the Magi
CA. 1481–82

Lorenzo de' Medici (1449–1492) to deliver a golden lyre as a present, Leonardo made clear his desire to enter the duke's service. He stayed for eighteen years.

Leaving the mercantile hustle and bustle of republican Florence for the glamour and pageantry of the duchy of Milan must have required many adjustments. One such adaptation is evident in the letter of introduction Leonardo wrote to the duke. Rather than present himself as a great artist, he focused on his skills as a military engineer, fortifications expert, and hydraulic specialist. Though his official duties spanned a wide range—from military consultancy to court decoration, in addition to painting and sculpture—this period was singularly fertile. While at court, Leonardo interacted with poets and intellectuals who assisted his diverse experiments in the fields of anatomy, physics, engineering, and especially mathematics. The mathematician Luca Pacioli (1446/7–1517), for example, helped with Leonardo's study of the role of geometry and proportion in the human figure. The architect Donato Bramante (1444–1514) worked with him on revolutionary centralized church designs as well as a new urban plan for the city of Milan. Leonardo established a painting workshop, collaborating with local artists and taking on pupils such as Bernardino Luini (ca. 1480/85–1532) and Giovanni Antonio Boltraffio (ca. 1467–1516). He portrayed several members of the court (*Lady with an Ermine*, *La Belle Ferronnière*, and the *Musician*), in the process redefining the expressive possibilities of that staid genre. He also spent many ultimately fruitless years working on an enormous commission for a bronze equestrian statue of Francesco Sforza, the father of the duke and founder of the family dynasty. His altarpiece for the church of San Francesco Grande (the *Madonna of the Rocks*) brought tremendous notoriety; it was probably purchased by a collector before ever being installed, causing a lawsuit that Leonardo later rectified by painting another version.

In his startling Milanese engineering projects and inventions, including the flying ornithopter, mobile tank, repeating weapon, submarines, mechanical drills, robotic creatures, and theatrical stage effects, Leonardo's motivating impulse was to use human reason in the search for divinely ordained natural truth, combining his delight in efficient function with his concern for aesthetics. These experiments epitomized his overall quest for balance between the universal and the particular. Such concepts also underlie all

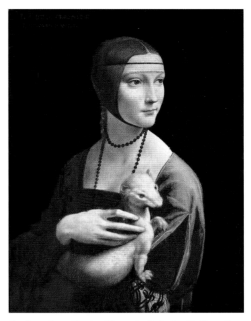

Lady with an Ermine (Portrait of Cecilia Gallerani)
1489–90

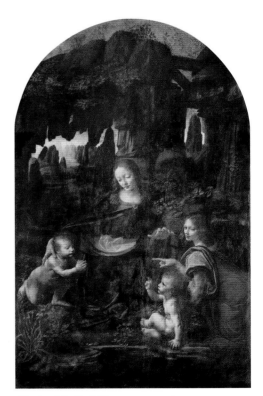

Virgin of the Rocks (PARIS VERSION)
1483–86

of his paintings, and in many ways the scientific and technical projects show his continuing efforts to better his skills as an artist. This constant experimenting made him a painstakingly slow painter, one who was sometimes seemingly incapable of finishing a work. When the prior of the monastery of Santa Maria delle Grazie grew concerned over the leisurely progress of the *Last Supper*, he complained directly to the Duke of Milan, describing what he considered to be bad work habits. He would "see Leonardo sometimes stand half a day at a time, lost in contemplation." In response, Leonardo explained to the duke "that men of lofty genius sometimes accomplish the most when they work the least, seeking out inventions with the mind, and forming those perfect ideas which the hands afterwards express and reproduce from the images already conceived in the brain." Though it began to decay soon after being completed because of Leonardo's unconventional technique, the *Last Supper* does in fact provide the fullest statement of how observation of nature, combined with his study of geometry, proportion, and theology, creates a visual manifestation of divine truth.

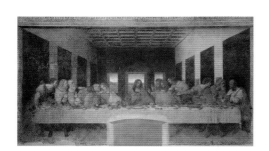

The Last Supper
CA. 1495–97

When Ludovico Sforza was expelled from power in 1499 and the French armies seized control of Milan, Leonardo and many other courtiers fled the city. In the ensuing years, he moved among several Italian city-states, searching for both a powerful patron and a receptive clientele. He visited Mantua, where he drew a portrait of the duchess Isabella d'Este (1474–1539), one of the most impressive female figures of the Renaissance, although he couldn't be persuaded to stay and work for her. (Isabella's taste for esoteric ancient subject matter and her penchant for micromanaging may have played a role in the decision.) Brief stops in Venice and Rome and a year spent working for the famously ruthless general Cesare Borgia (1475/6–1507) interrupted the artist's second residence in Florence, which lasted from about 1503 until 1508.

Upon returning to Florence, Leonardo was greeted with a fanfare he had not received as a youth. The city was no longer under the control of the Medici. Once again assertively a republic, Florence's new government seized upon Leonardo—not only as a desperately needed consultant for hydraulic and engineering projects but also as a respected artist. The commission for the *Battle of Anghiari* in the Salone dei Cinquecento (Hall of the 1500s) of the Florence Town Hall recognized Leonardo's preeminent status as a painter.

By setting the returning elder artist in direct competition with the younger Florentine talent Michelangelo Buonarroti (1475–1564), who was commissioned to paint the *Battle of Cascina* on the opposite wall, the city authorities could claim Leonardo and assert his Florentine identity over all other affiliations (especially his longtime connection with Milan, their hated enemy). Neither Leonardo nor Michelangelo completed their projects, which surely would have been the capstone to the glory of the Florentine Renaissance. Yet, even as a fragment, Leonardo's fresco attracted enthusiasts who marveled at the dramatic scene of combat. Although he was extolled as a son of Florence, evidence tells us that he lived a remarkably unsettled existence there. In a letter written by a Florentine agent to Isabella d'Este, who was still hoping to commission a painting from Leonardo, the artist was described as "living day to day" and "exasperated with the paintbrush." He devoted himself primarily to mathematical and anatomical study.

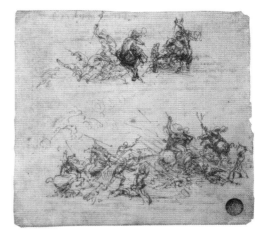

Study for the Battle of Anghiari
1503

The completed paintings from this period are generally smaller in scale and mark Leonardo's continuing investigations of vision, natural forces, and human psychology. The portrait of Lisa Gherardini del Giocondo (1479–1542 or ca. 1551), known as the *Mona Lisa*, provides the best example of the enhanced atmospheric quality he called *sfumato* (literally, "smokiness"), achieved by softening the outlines of the foreground figure and gently and gradually blending the elements of the background so that it appears to recede into the deep distance. Then there is her famous smile—a play upon her name—that provides a glimpse of spontaneity and personality so unusual in portraiture of the period. The smile was a peculiar artistic choice, because portraiture was supposed to permanently preserve a likeness for posterity. Ordinarily, momentary gestures and expressions were (pardon the pun) frowned upon. Leonardo's engagement with expression and natural beauty are found in other paintings of the period, notably the *Battle of Anghiari*, *Leda and the Swan*, and the *Burlington House Cartoon*.

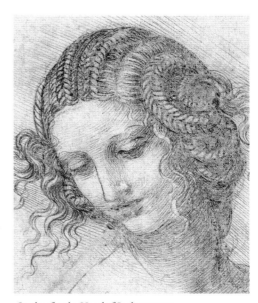

Studies for the Head of Leda, DETAIL
CA. 1508

In 1508 Leonardo returned to Milan. This time he stayed five years, working for patrons associated with the French occupiers of that city. For General Gian Giacomo Trivulzio (1440/41–1518), he produced designs for an equestrian funerary statue that resuscitated the grand aspirations of the unrealized Sforza monument. He also designed country homes and gardens, proposed hydraulic

projects, and continued his studies of anatomy and flight *(Codex on the Flight of Birds).* Though not his most artistically prolific years, the second Milan period saw the production of paintings marked by a strange and compelling ambiguity. The two renderings of *St. John* and the *Virgin and Child with St. Anne* share highly unusual iconographies and experimental approaches to the figure in landscape; they are among his most personal, and most perplexing, works.

In 1513 Leonardo's career experienced yet another twist. The French were driven out of Milan, and the son of Ludovico Sforza was installed as the new duke. Rather than returning triumphantly to his position as court artist to the Sforza, Leonardo was dismissed altogether. His ties with the French now worked against him. He searched for a new patron, this time in Rome, where he served as military consultant for Giuliano de' Medici (1479–1516), then Duke of Nemours, who served the Medici pope Leo X (1475–1521). Leonardo was unable to break into the pope's private patronage circle, however, and his impact in Rome is difficult to discern. He was clearly in dialogue with the successful painter Raphael Sanzio (1483–1520), whose *Portrait of Baldassare Castiglione,* a diplomat and later the author of the popular *Book of the Courtier,* owes something to the *Mona Lisa* in pose and tenor. Leonardo's constant traveling and lack of career certainty took a toll on his health and productivity. Leo X reportedly doubted whether he could ever finish anything. Few paintings are dated to this period, though Leonardo's interest in antique sculpture is documented in drawings. In some of the notebooks he complained of his situation, remarking on the vagaries of his patrons and the lack of work ethic among his students. Distrusted by the pope because of his reputation for dissecting cadavers (a practice prohibited by Church law), and depending entirely upon Giuliano de' Medici (later Duke of Nemours) for patronage (especially after the death of the French king Louis XII, in 1515), Leonardo was certainly a marginal figure in Rome. When Giuliano died in 1516, his worst fear appeared to have come true: he had no supporters left.

Fortunately, while traveling with Giuliano in Bologna in 1514, Leonardo had met and impressed the new French king, François I (1494–1547). François's great ambition (after the expansion of French territory) was to collect art and construct grand residences, as the Italian aristocrats he admired had done. He invited Leonardo to his court, offering renewed security: a château, a generous

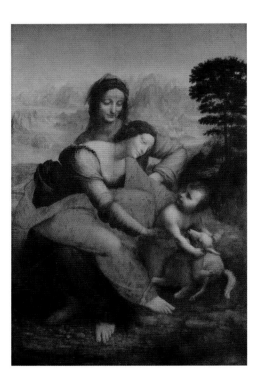

Virgin and Child with St. Anne
CA. 1510–13

salary, and an appointment as First Painter to the King. Leonardo spent his
last three years in France, where he devoted his time to reworking several
paintings that he brought with him from Italy (the *Virgin and Child with
St. Anne*, for example; the *Mona Lisa* was also still in his possession). He
created several new compositions, although sadly most are lost, and he
designed architecture, such as the Château Romorantin. Recorded accounts by
visitors and associates tell us that he suffered from an illness and had lost the
use of his right hand to paralysis. Nonetheless, he managed to fulfill his duties
as First Painter, re-creating his famous mechanical lion and designing
spectacular court festivities; he also continued his analysis of optics, the
movement of fluids, and the complexities of geometry. He enjoyed high status
and the opportunities that a generous and respectful patron could provide,
without the pressure to complete commissions on demanding timetables. In
Leonardo's elder days, courtiers and diplomats viewed him as one of the
"ornaments" of the French court.

After a lifetime of avoiding political and social ties, Leonardo found in
France a refuge where his artistry and intellect were equally respected.
Though he may have suffered from the effects of a stroke, he continued to
work on what was arguably his most difficult project, the organization and
editing of all his notes and drawings, which he intended to publish as different
treatises. More than six thousand pages of his writings have come down to us,
spanning the entire course of his career. This is probably only a fraction of his
original output. Though notoriously complex and difficult to decipher, in part
because of his famous backward, or "mirror," writing, the manuscripts provide
a first-hand look at Leonardo's intellectual and artistic concerns. They docu-
ment the problems he saw, the solutions he devised, the processes he used, and
the philosophies he harnessed in his expansive quest for understanding. He
worked on the *Codex Atlanticus*, the largest collection of his papers, for more
than forty years. It is a good example of the variety and richness of his
writings, containing notes on mathematics, botany, geology, flight, and
astronomy; designs for machines, weapons, and buildings; and meditations
on philosophy and fables, monetary accounting, and jokes. Included also are
preliminary drawings for many of his artworks and his thoughts on the
theory of art, with rules for painting and sculpture and the application of

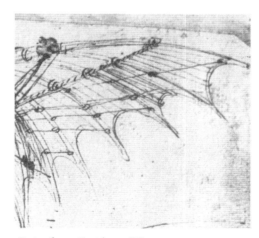

Design for an Ornithopter Wing, DETAILS
CA. 1490

observation in the practice of these arts. Rich and intensely detailed, capturing the incredible scope and remarkable focus of his thinking, the codices are indispensable material for understanding Leonardo. No other artist of the period left such a legacy. Today, these manuscripts are scattered among London, Milan, Paris, Seattle, Madrid, and Turin. Because of the enormity and breadth of his interests and investigations, captured over a long lifespan of recorded thoughts and observations, the task of preparing his notes for publication, like so many of his endeavors, remained incomplete: Leonardo died on May 2, 1519. Legend asserts that the French king himself attended at the artist's bedside, a mark of the high esteem in which Leonardo was held at the end of his life.

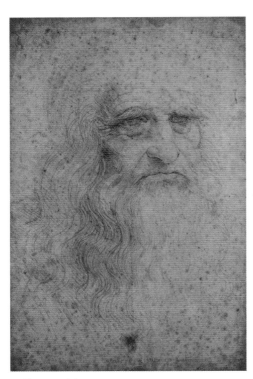

Self-Portrait (?)
CA. 1512

Vasari's account of Leonardo is awash in glowing terms. Not only was he gifted with a divine talent, he enjoyed "great bodily strength, joined to dexterity, with a spirit and courage ever royal and magnanimous." He was handsome, graceful, musically gifted, and extraordinarily intelligent. But there was a downside: Leonardo was so "variable and unstable" that he had difficulty completing things. Having mastered one idea, he quickly moved on to another. Moreover, as a child he had received only a limited education. Leonardo himself recognized that he was "unlettered," a problem solved only with laborious effort as a grown man. He taught himself rudimentary Latin (the language of scholars and intellectuals), studied mathematics with tremendous diligence, and gradually built a wide body of knowledge through rapacious reading of both modern and classical texts (visible in the book lists in the manuscripts). Despite having come from outside normal academic circles, he interacted with intellectuals, poets, other natural philosophers, and diplomats, and Vasari tells us he "was so pleasing in conversation that he attracted to himself the hearts of men." This geniality extended to animals as well. Vasari recounts a story of Leonardo buying caged birds in the market in order to set them free, and his vegetarianism has also been linked to ethical principles. Complex, contradictory, and confusing, Leonardo's character seems a mix of all things—just like his art. As Vasari summed up: "on account of all his qualities, so many and so divine, although he worked much more by words than by deeds, his name and fame can never be extinguished."

Themes in Leonardo's Art

Rather than a chronological or biographical approach, this book organizes the remarkable variety of Leonardo's art into thematic sections: A Revolution in Style; The Madonna; Saints and Apostles; Scientific Vision and Imagination; Machines and Military Matters; and Portraits. This structure allows works of similar subject matter to be seen together and illuminates important ideas in Leonardo's art. The paintings and drawings touch on a wide variety of issues, ideas, and problems, as the essays for each entry explain. Works by Leonardo's contemporaries and predecessors are interspersed to illuminate the traditions out of which he emerged and the divergent new directions that he explored. Several larger topics that extend beyond single works are addressed in sidebars. These include essays on Technique and Practice, Images of the Virgin, Anatomy in the Renaissance, and Leonardo as a Court Artist. The major organizational themes are introduced below.

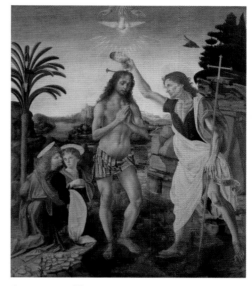

Andrea del Verrocchio,
with Leonardo da Vinci,
Baptism of Christ
Ca. 1470–75

A Revolution in Style

As addressed in the biographical section, Leonardo's training in the workshop of Verrocchio was in most senses a standard one. He would have learned to draw, to prepare panels for painting, to mix tempera colors (pigments suspended in egg yolk as a binding medium), and to paint in fresco, a process in which tempera is applied to wet plaster and bonds with the wall as it dries. He also trained in sculptural techniques, likely in marble and certainly in the basics of bronze casting. Two aspects of this training were essential to the Renaissance and to Leonardo's art for the rest of his life: the mastery of linear perspective, a geometric gridlike system for accurately plotting three-dimensional space on a two-dimensional surface, and the mastery of human form, which Leonardo took to a new level of investigation seemingly from the outset of his career, and which he continued to revolutionize to the very end through his anatomical investigations.

Leonardo did not rest on what he learned as an apprentice, and this section highlights the distinctions between his work and his master's style, as well as his sharp ascent in naturalism and complexity of form compared to the work of his predecessors. He developed several innovations in his painting techniques, experimenting frequently (and in the case of his wall paintings, disastrously)

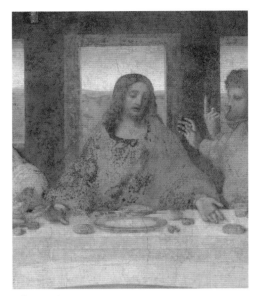

The Last Supper, DETAIL
CA. 1495–97

Virgin of the Rocks (LONDON VERSION)
1491–1508

with oil paint. The traditional practice of tempera painting suspended pigments in sticky and quick-drying egg yolk. By substituting viscous seed oils as the binding medium, artists could use darker and richer colors made from a wider variety of minerals; because the paint dried more slowly, they were able to smoothly blend transitions of light and shadow. This was especially important to Leonardo, who gradually built up thin layers of glazes on his paintings for additional subtlety. Oil paint had been commonplace in Northern Europe for three generations, but in the 1470s Leonardo was among the few artists in Florence who took up this new direction. By increasing the darkness of the backgrounds and pulling the highlights to a tonal contrast (what later came to be called *chiaroscuro*, the juxtaposition of lights and shadows or clear and obscure sections of a painting), he established a new degree of realistic representation. His figures "sit" within the space that surrounds them far more convincingly than they do in the works of his predecessors. Indeed, they appear to have weight and grounding rather than a buoyant, floating sensation, an effect so adored in the work of Botticelli, for example. The sense of three-dimensional volume was further enhanced by Leonardo's understanding of normative and graceful figural movements. He employed foreshortening—the illusion that limbs project toward the viewer—with accuracy, not affectation. And, perhaps most important, based upon his intensive observation of the natural world, Leonardo invented a technique that he called *sfumato* (literally, smokiness). This blurring of outlines and manipulation of color transitions mimicked the effect of forms in atmospheric space, enhancing their naturalism. He began to develop all of these ground-breaking approaches early in his career, and by examining preparatory drawings and paintings left at an early state of completion we can see how his process developed. Such is the case with the *Perspective Study for the Adoration of the Magi* and the unfinished *Adoration*, discussed in this section.

The Madonna

After Jesus himself, no figure was more frequently represented in altarpieces than the Virgin Mary. By the time Leonardo embarked on his career, her image had undergone a remarkable transformation in the Italian Renaissance, from heavenly queen enthroned with a divine child facing resolutely forward

to offer a blessing, surrounded by glittering gilded backgrounds, to a more naturalistic and human mother who received the news of her blessing, cared for her son at the nativity and moments of adoration, and nurtured him through childhood even as she foresaw his fate. Leonardo would add further dimensions to this complex tradition both visually and thematically.

In Leonardo's art, as in natural philosophy of the Renaissance, the quest to find the most representative is consistently linked to a search for the universal, the perfect, and the divine. In the images of Mary made over the course of his career, Leonardo sought to bridge the gap between the earthly and the heavenly. In the *Annunciation*, Gabriel arrives physically in Mary's world, a domestic garden recognizable, familiar, our own. In the *Benois Madonna* and the *Litta Madonna*, Mary sits, turns, and responds like any mother, her humanity shining through the sacred narrative enacted around her. In the *Virgin of the Rocks*, the Madonna figuratively bridges the human and celestial beings, while in the subjects that include St. Anne, she plays the same role metaphorically. In all these paintings, Leonardo insisted on the physicality of the bodies, visually asserting the corporeal humanness that is essential to the Christian faith while suggesting through symbols, fantastic landscapes, and perfect proportions that what we see is also a manifestation or reflection of God. Like the Florentine humanists who had surrounded him as he entered adulthood, Leonardo connected the visible world and the metaphysical one, showing how the divine order can be detected in the most mundane of natural things.

Madonna with a Flower (Benois Madonna)
CA. 1478–81

Saints and Apostles

In many of his writings, Leonardo mentioned his desire to capture human thoughts and emotions, which he called "the states of the soul" and "the motions of the mind." Here again he began from observation, repeatedly drawing people of different types and social classes in a spontaneous manner and even in caricature. Vasari's story of Leonardo following people in the streets to capture the variety of their countenances informs his search for an appropriate model for the brutal representation of Judas in the *Last Supper*. Several drawings for this figure exist, showing how Leonardo began with the specific and particular in order to represent the characteristics of the ultimate criminal. For Jesus, in contrast, Leonardo relied on his own imaginative capacity, drawing the face

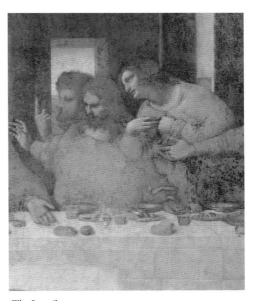

The Last Supper, DETAIL
CA. 1495–97

of the son of God from intellect and divine inspiration, an ideal form in perfect pyramidal equilibrium at the center of the tumultuous composition.

In trying to depict the "states of the soul," Leonardo had embarked on an ambitious project. Most Renaissance artists contented themselves with painting figures that drew from established conventions and accepted norms of beauty. Leonardo instead aimed to reveal the inner person through the depiction of expressions, gestures, and personality. The *St. Jerome*, for example, shows the extremes of the holy man's emotions. His physical suffering is etched in the drawn lines of cheek and neck. Sorrow is conveyed in his deep-set eyes and supplicating gesture. The saint's right arm swings wide, the cocked hand revealing a determined resolve to continue the castigation of his own flesh. The intensity of this painting, even unfinished, resonates with the viewer.

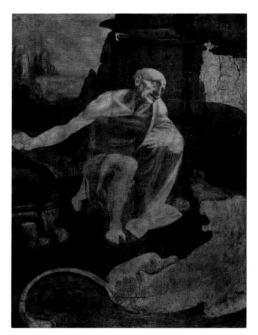

St. Jerome, DETAIL
1480–82

Scientific Vision and Imagination

Leonardo da Vinci is commonly considered a proto-modern scientist. In particular, his concern for empirical observation and for testing his conclusions within "real world" settings is often seen as evidence of a rational and experiment-based approach to gathering knowledge. Yet, in his own mind and in his time, this kind of approach was not science, at least not as defined by post-Enlightenment Western society. Rather, Leonardo practiced natural philosophy, a respected discipline derived from the writings of the classical Greek philosopher Aristotle. Leonardo, like Aristotle and other ancient natural philosophers such as Pliny the Elder, studied the natural world in all its manifestations, from the earth to the oceans, from humanity to the heavens. Today we would label and distinguish Leonardo's interests as the disciplines of geology, oceanography and hydrology, ethnography, astronomy, physics, chemistry, anatomy, and so on. For natural philosophers, however, all were linked as fundamental manifestations of the natural order. Examining its individual parts was a way to illuminate the divine order that was thought to exist under, and through, the whole of the physical universe. Thus the study of nature was undertaken by natural philosophers like Leonardo not merely to gain knowledge but to access and understand a higher power. In the Renaissance, that higher power was the Christian God, whose hand was thought to be discernable in all things.

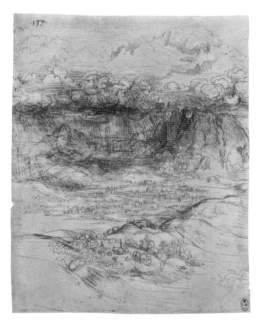

Storm in the Alps
CA. 1499 OR CA. 1508–10

Leonardo's astounding variety of interests is evident in the paintings, drawings, and designs throughout this volume, but this section specifically highlights his focus on ideal and natural human form, anatomy, fantasy, and the phenomena of landscape and geology. The underlying unity of nature that he believed existed inspired his experiments and investigations and became one of the fundamental goals of his art. His studies of human proportions provide a telling example of this principle. First, Leonardo carefully gathered an enormous amount of empirical data by measuring and charting his apprentices, friends, and acquaintances. He then analyzed the mass of numbers, searching for the perfect universal ratio that worked for all. This norm, he believed, should match accepted learning from classical and ecclesiastical doctrine, so Leonardo strove (sometimes unsuccessfully) to manipulate and massage his observations to fit established truths. *The Vitruvian Man* is an example of such a perfect solution: by putting the human figure at the center of an intellectual and physical universe, Leonardo attempted to show humankind's divine centrality as well.

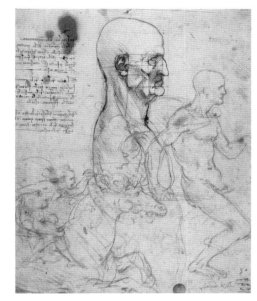

Man in Profile, Squared for Proportion
CA. 1490 AND CA. 1504

Within this construct, the artist's capacity for invention was a highly prized commodity. Elements of fantasy, such as bizarre costumes, fantastic beasts, and transcendent landscapes, populate his work in ways that seem confusing to our rationalist expectations. Yet for Leonardo and his contemporaries, invention in art was merely a reflection of the amazing variety of nature—and yet another manifestation of divinity.

Machines and Military Matters

If we judged by the ratio of interests among the astounding amount of extant material, Leonardo would clearly be listed among the great engineers, rather than painters, of history. The precociousness of a flying machine based on a study of bat's wings, or a helicopter, submarine, or tank, justify Leonardo's reputation as a "man ahead of his time." Many of his most famous inventions, such as the gigantic crossbow or the flying machines, seem never to have been intended for any practical use. They span the worlds of the pragmatic and the fantastic, allowing the artist to exercise his wildest imagination, bounded only by physical laws. In the context of Sforza court culture, the apparently frivolous origin of many such devices makes good sense: with these

Design for a Tank and Chariot with Scythes, DETAIL
CA. 1487

remarkable machines, Leonardo not only indulged his love of gadgetry but also astonished his audience.

Yet many of the designs have less significant, and even mundane, functions—a jack, a drill, a mill, a clock—that speak to Leonardo's interest in the machine itself. These served in other projects, whether the pulley system for the Sforza equestrian monument, the hydraulic systems for the Arno project, or the military equipment for his patrons. The *Design for a Scythed Chariot and Tank*, for example, shows his inventiveness applied to the gruesome task at hand: how best to kill as many enemy soldiers as possible. His comment on the drawing advising owners of such a vehicle to avoid running over their own soldiers seems callous today, but romantic notions of Leonardo fail to consider this aspect of his career. Though he felt personal abhorrence for war, he imagined ever-more-destructive machinery for his patrons, in the process advancing the ruinous possibilities for man and nature within mechanized conflict. Consequences of these ideas can be detected in the devastating religious and territorial wars of the sixteenth and seventeenth centuries.

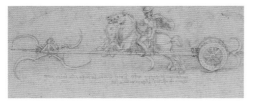

Design for a Tank and Chariot with Scythes, DETAIL
CA. 1487

From a broader perspective, the military and engineering projects reveal how Leonardo's art connects to the social structure and patronage arc of his career. Though the paintings may seem disconnected from his work as an engineer, philosophical alliances between the disciplines are conspicuous. Leonardo delighted in the efficiency of his machines, in their self-generated movements, and in the way they made the laws of nature visible. Weight, torque, flow, and pressure intrigued him, both as intellectual problems and as manifestations of the laws of nature. In a similar way, the paintings take on and resolve problems, making the solution so gracefully evident as to seem natural, logical, and perfect.

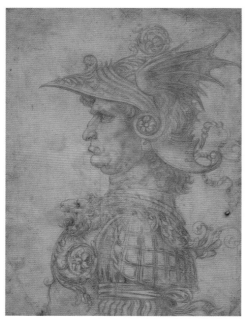

Study of a Warrior in Profile
CA. 1476

Portraits

Portraiture in the Renaissance was often derided in theoretical discourse as a straightforward representation of the model, devoid of art or grace, as beneath the "great" artists who were instead encouraged to focus on narrative or allegorical themes of religious or moral importance. That said, as social exclusivity of the aristocracy gave way to mercantile oligarchies, new desires for representation emerged. Leonardo managed merchant patrons and courtly

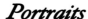

expectations in his portrait commissions, and he ultimately made the genre his own, thanks to his phenomenal innovations.

In his portraits, Leonardo used a variety of techniques to show the characteristics of his sitters, as in Ginevra de' Benci's convenient juniper bush (a symbol of chastity) or the dilated pupils that reveal the transient movements of the *Musician*. But in the *Mona Lisa*, he fully reveals the woman's inner life by activating her image with that famously inscrutable smile. Though Vasari tells us the expression is the result of jesters and clowns performing at the back of the room, the *Mona Lisa's* smile is more than a studio trick. Here the "motions of the mind" are made visible, and her physical beauty—natural and largely unadorned—blends perfectly with the deep serenity and dignity of the woman who is set against a vast and equally subtle and enigmatic landscape. In his concern for identifying, capturing, and revealing the psychology of a figure (though that term is anachronistic; in the Renaissance they would have referred to the passions of the soul exposed by the physical form of the body), Leonardo anticipated later developments in art, codified the Renaissance human-oriented mindset, and greatly advanced the field of portraiture.

Leonardo's Legacy

One can hardly overestimate the impact of Leonardo on artists of the later Renaissance. In Florence and Milan, where he spent most of his life, as well as in Rome, Venice, and France, where he stayed for only brief periods, his impact was lasting. In Vasari's progressive paradigm of artistic development in Italy, Leonardo ushered in the third "*maniera*," or style, following the generation of Giotto that saw ancient principles and good taste reborn and the second generation of Masaccio and Donatello who developed a new naturalism and inventions such as linear perspective. Leonardo, along with Michelangelo and Raphael, brought art to a perfection that not only rivaled antiquity but surpassed it. Many of the greatest artists of this so-called pinnacle, or High Renaissance, and continuing into later periods, counted Leonardo as an influence, including Giorgione, Veronese, and Caravaggio. His fame spread to the farther reaches of Northern Europe to influence the work of Albrecht Dürer and Rembrandt. Though Leonardo left behind few paintings, those

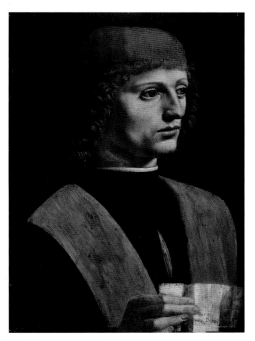

Portrait of a Musician
CA. 1485

that remained were visible in the collections of the greatest art collectors, such as the Medici, Pope Clement VII, and the king of France. These great collections in turn formed the basis of the major European public museums of the modern era. Leonardo's work was sought out by artists and enthusiasts and has always been recognized among the greatest cultural attractions of Europe.

Among Leonardo's writings, the *Treatise on Painting* remains his best-known work; it was highly influential among later European painters and academic theoreticians. The treatise is not a unified text but rather a collection of passages on specific topics drawn from a wide variety of manuscripts (some of which are lost) that were assembled and organized by Francesco Melzi (ca. 1491–1570), Leonardo's friend and heir. One later English translator called it "a chaos of intelligence." The statements touch on all aspects of the art of painting, from larger issues, such as the nature of the discipline and techniques like the use of perspective systems and color, to more mundane details such as how to represent leaves on trees. The text was highly influential in the sixteenth century and later; it circulated widely in manuscript form and, after 1651, was printed in many editions throughout the Continent.

Where does Leonardo scholarship and enthusiasm stand today? With the benefit of modern materials and technologies, engineers have finally brought some of his most amazing inventions to fruition. Important revelations have been made as his works have undergone cleaning and conservation. New investigations of his subject matter continue to be undertaken, and within the past five years the identity of the *Mona Lisa* has been affirmed with certainty, the result of a chance archival discovery. Every year, it seems, something exciting about Leonardo appears in the popular press. Unfortunately, most of these leads are dead ends, trumped-up ideas by enthusiasts that play on the notion of codes and secrets one hopes to identify, rather than on solid scholarship and careful investigation. If approached with patience and interest, the works of Leonardo reward continued study; as we look, and look again, they reveal their subtleties, their possibilities, and, eventually, their meanings. Therein lies the "delight" of Leonardo.

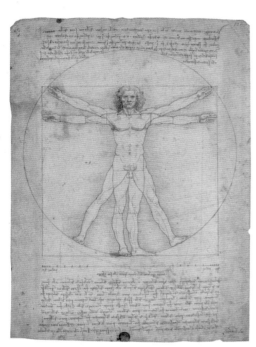

Vitruvian Man
CA. 1490

DISCOVERING
LEONARDO

*The Art Lover's Guide
to Understanding
Leonardo da Vinci's
Masterpieces*

LEONARDO DA VINCI

(1452–1519)

Annunciation

CA. 1473–75

OIL AND TEMPERA ON PANEL
39 ½ X 87 IN (100 X 221.5 CM)
UFFIZI GALLERY, FLORENCE

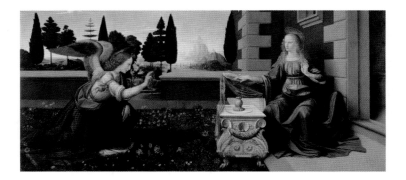

THIS INTRIGUING painting is probably one of Leonardo's own inventions, painted during his apprenticeship. When the panel was discovered in a monastery near Florence, scholars attributed it to the workshop of Domenico Ghirlandaio. Debate over attribution continues, but most accept this as an autograph painting, based on drawings for the figures done by Leonardo and the artist's fingerprints in the surface of the paint. It is clearly a youthful work, for there are many *pentimenti*, or evidence of the artist working through problems and changing his mind. These revisions suggest Leonardo was using a spontaneous style of execution, instead of working from a cartoon. The total effect is inconsistent; while some parts are fresh and startlingly original, others are derivative or even confusing. Note, for example, the rote way Leonardo has painted Mary's cloak over her lap and chair, creating the impression that she has three knees.

Yet, even as a young painter, Leonardo demonstrates his skills in this scene. For example, he shows off his ability with the fashionable new technique of one-point linear perspective, using a mathematical system to create a compelling recession into space. The orthogonal lines are inscribed into the gesso surface. (For more on the system of linear perspective, see the "Technique and Practice" sidebar.) In addition, Leonardo paints a far background with atmospheric perspective, registering the sense of depth through increasing haze and blue tones—a technique that originated in Northern Europe and was much admired in Florence. Through spatial complexity and a striking unity in tone, Leonardo creates a convincingly naturalistic setting for this holy moment.

The Annunciation is a key Christian story with a long visual tradition. Mary, in her usual blue and red garment, sits on the porch of a grand palazzo, positioned at the liminal space between inside and out. She is reading a book set on a table that is heavily embellished with classical carvings. These decorations are copied from Verrocchio's recently completed Medici tomb in the Old

Sacristy of San Lorenzo. At the left, the archangel Gabriel approaches, raising a hand to announce to Mary that she has been chosen to be the mother of God. Symbols of Mary's virginity abound, including Gabriel's beautifully detailed lily and the enclosed space of the verdant walled garden. Leonardo eliminates a few traditional features: no floating dove or figure of God the father appears. Instead, the setting is resolutely naturalistic. The angel is painted in motion, the ribbons on his sleeves still fluttering, and he casts a shadow on the meadow just as if he were a corporeal being. Leonardo was interested in the narrative here; he moved the angel's head to a profile in order to put the two figures in direct communication. He also created a gap in the wall to highlight Gabriel's emphatic gesture. Mary's figure shows a variety of responses, rather than the single emotional state that was typical in the period, following sermons and other theology. On the one hand, the announcement has taken her by surprise, interrupting her reading (note how her fingers still mark her place in the text); this stage was known as *conturbatio*. But her calm expression conveys her thoughtful reflection on the news *(cogitatio)*. Finally, her raised right hand signals acceptance of God's will *(humiliato)*. Though this youthful work has awkward passages, it captures key elements of Leonardo's art: his willingness to experiment, his interest in telling a story, and his concern for naturalism.

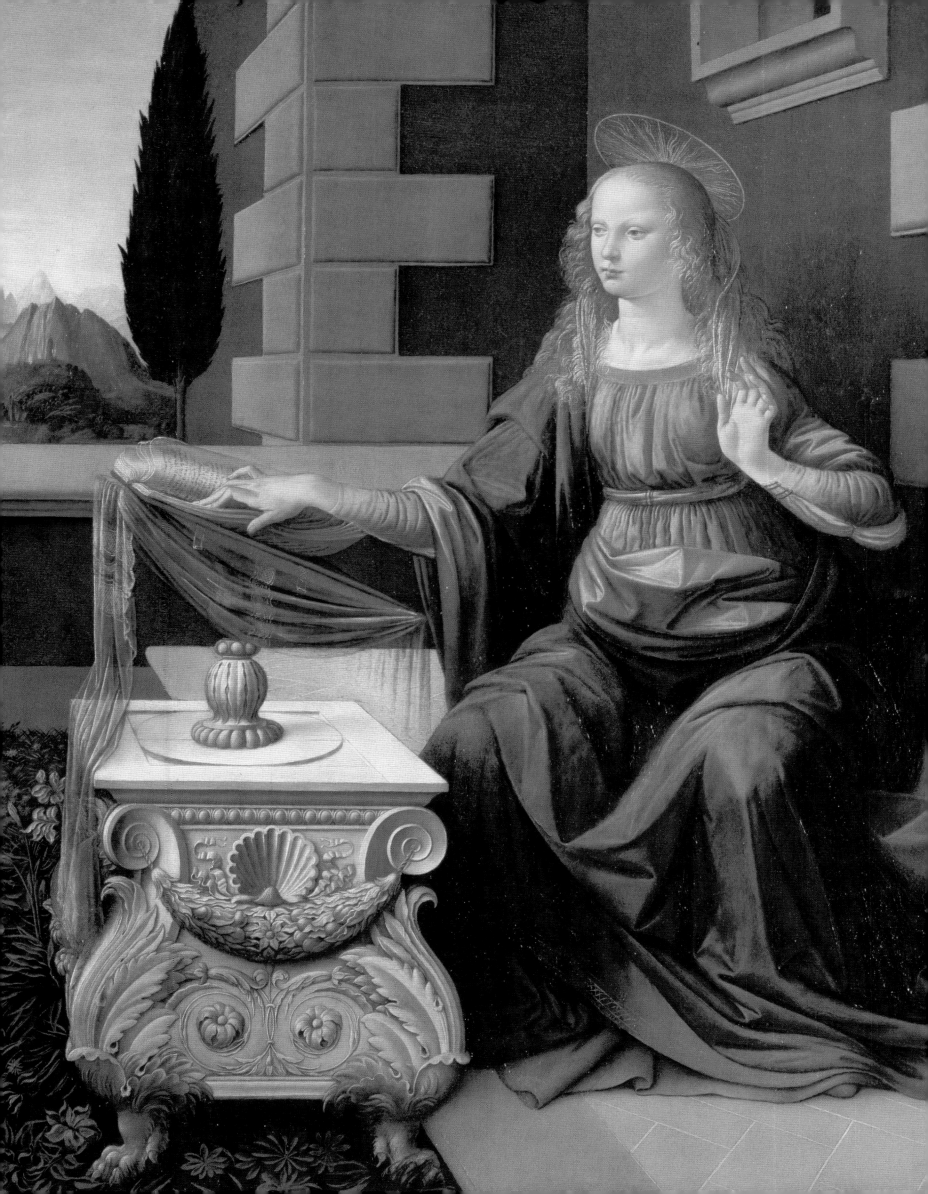

LEONARDO DA VINCI
(1452–1519)

Annunciation
CA. 1473–75

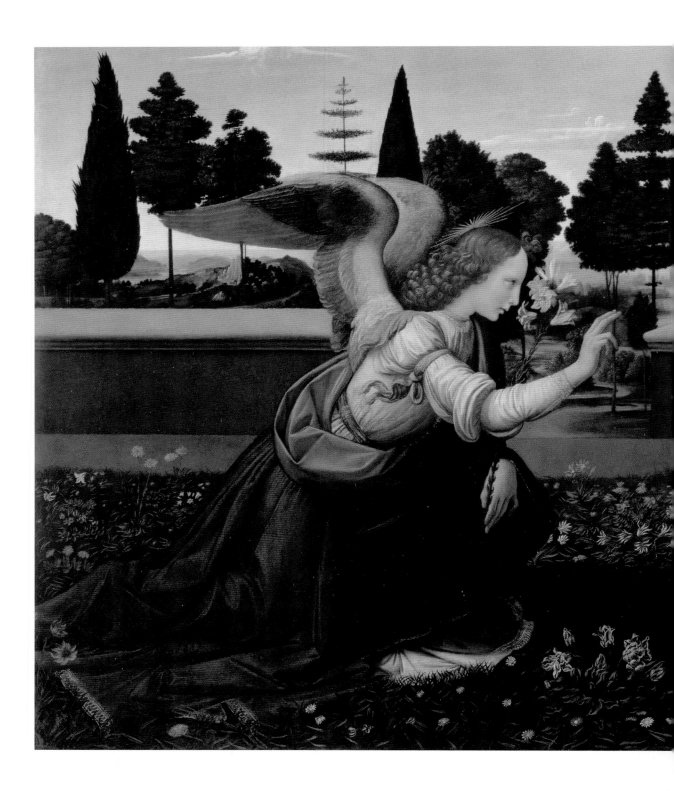

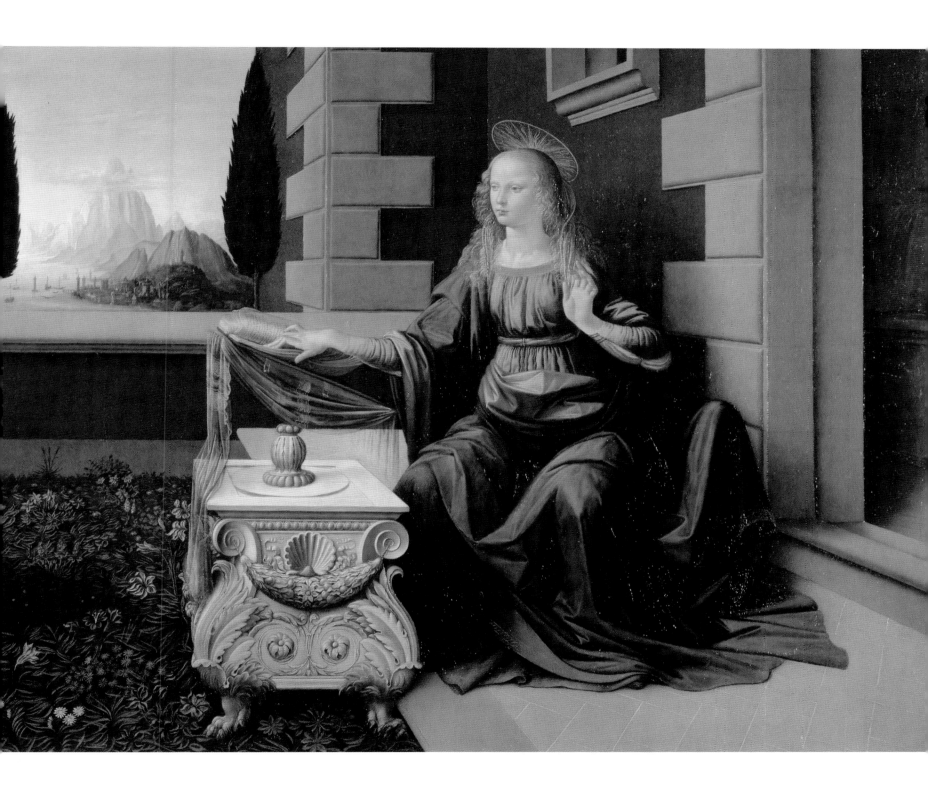

FRA ANGELICO
(CA. 1395/1400–1455)

Annunciation

CA. 1442–43

FRESCO
90 ½ X 117 IN (230 X 297 CM)
SAN MARCO CONVENT, FLORENCE

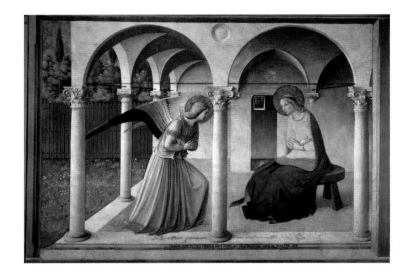

THIS FRESCO tells the Annunciation narrative in subtle, reverent detail. According to the Gospel of St. Luke (1:26–38), when Gabriel arrived at the house of Mary in Nazareth, he greeted her with the words, "Hail Mary, full of grace." Here, Gabriel has just arrived, with his wings still open. He kneels gracefully before Mary, whose thoughtful expression suggests her surprise. Gabriel explains that she has been chosen to bear the son of God, and Mary's acceptance of God's will is conveyed by her folded hands. The similar postures and gestures of the two figures emphasize their unity. Though Mary and the angel occupy different archways in the loggia, and her muted dress contrasts with the angel's brilliant colors, as they incline together they signal their mutual obedience to the divine agenda.

Fra Angelico presents the initial Christian mystery without the usual fanfare, relying instead on the tender emotions evoked to activate faith. None of the traditional accoutrements are present: no banner, no lilies, no book, no vase of water, no angels trumpeting in celebration. The symbols in the scene are embedded in the simple space, which acts as an overarching metaphor for the Virgin. She sits on a plain stool, representing her humility, outside her cell-like room. The garden, with its plain fence, is a representation of the *hortus conclusus*, the paradisical enclosed garden that represents virginity. As in the biblical account, cypress trees mark the dense forest outside this calm space. The framing loggia refers to Mary's role as a manifestation of the Temple and the repository of the Word (God). In fact, Fra Angelico presents two scenes: the Annunciation occurs as the dove of the Holy Spirit (barely visible in a translucent roundel over Mary's head) also registers the Incarnation, or conception, of God's son in the womb under her hands.

This fresco is located in the monastery of San Marco, a Dominican establishment in Florence. When given to the friars in 1436 by Pope Eugenius IV, the monastery was in need of drastic repairs. Cosimo de' Medici had the building reconstructed and expanded by his favorite architect, Michelozzo, at enormous expense. Many details in the painting reiterate the connection with the new building: the grated windows are like those found in the monk's cells; the classical columns and accurate Ionic and Corinthian capitals mimic those built by Michelozzo in a similar loggia on the first floor; the cypress trees evoke Florence; and the linear perspective emphasizes the space as contiguous with the viewer's reality.

At the base of the fresco, two inscriptions speak to the viewers. The top one, written in Gothic script, says: "Hail, Mother of Mercy, the noble resting place of the Holy Trinity." Below, in darker capitals, is a directive: "When you come before the figure of the intact virgin, as you pass by, take care that you do not fail to say 'Ave!'" Each time they passed this image, traveling between cloistered and public spaces, the monks would kneel and say the "Hail, Mary" prayer. The painting thus evokes and records the religious practice of the monastery: as Gabriel kneels, so, too, should the viewer bow before Mary.

Fra Angelico (known in his lifetime as Fra Giovanni) entered the order of St. Dominic as a young man; his life of chastity and his sweetly pious paintings later gave rise to the nickname "Angelico" (meaning, "of the angels").

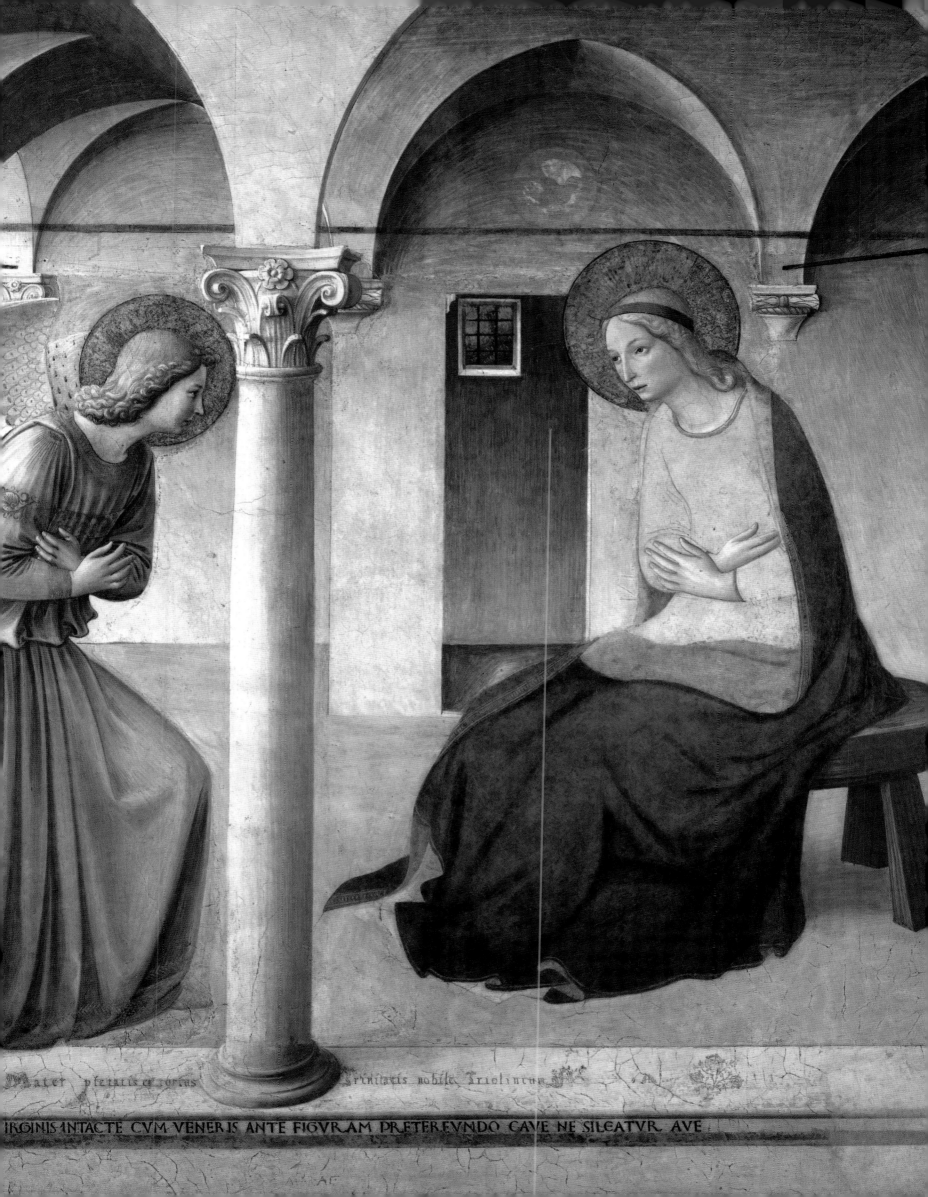

MATER PIETATIS ET TOTIUS TRINITATIS NOBILE TRICLINIUM VIRGINIS INTACTE CVM VENERIS ANTE FIGVRAM PRETEREVNDO CAVE NE SILEATVR AVE

ANDREA DEL VERROCCHIO, WITH LEONARDO DA VINCI (?)

(1435–1488) (1452–1519)

Tobias and the Angel

CA. 1470–72

TEMPERA ON PANEL
33 ¼ X 26 IN (84.4 X 66.2 CM)
NATIONAL GALLERY, LONDON

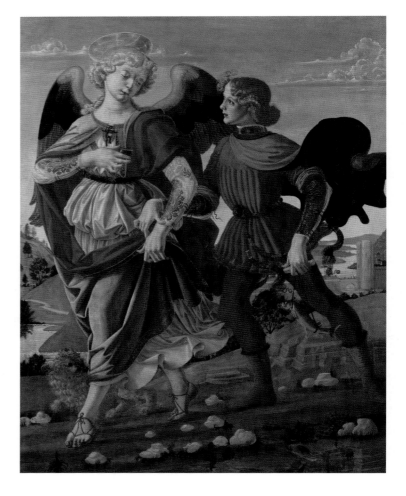

THE STORY of Tobias and the Angel comes from the Book of Tobit, in the Old Testament. In the larger narrative, Tobias is an example of filial devotion, and his blind father stands for righteousness. In response to Tobias's obedience and his father Tobit's piety, God sends the archangel Raphael (disguised as a mortal) to accompany Tobias as he goes to collect a debt on his father's behalf. With such an expert guide, Tobias not only collects the money but, on the way, frees Sarah from an evil spirit, wins her as his bride, and, on returning home, heals his father's blindness. Overall, the story of Tobias demonstrates how pious and correct behavior can help one escape from despair.

In the part of the story shown here, Tobias journeys with the archangel Raphael (whom he does not recognize) and his trusty dog. As they walk by the river Tigris, a fish leaps out of the water; Tobias catches it on Raphael's order. In the painting, Tobias carries the fish from a string in his left hand, which also clutches the receipt for the debt he is going to collect. The river is barely visible in the foreground of the placid landscape. In the next part of the story, Raphael tells Tobias to roast the fish, saving the innards. Later, Tobias will burn the fish's heart and liver to drive away the evil spirit persecuting Sarah and use the gall to heal his father's blindness.

This painting is a work by Andrea del Verrocchio, Leonardo's teacher, who ran a prestigious workshop in Florence. As was typical in the period, the image is a collaborative work. Verrocchio was responsible for the overall design and the execution of the primary figures; assistants painted other parts, such as the landscape. Leonardo probably contributed the dog and the fish. These were added later in a thin paint—one can see the landscape through the dog's fur. As a young apprentice in Verrocchio's shop, Leonardo was known for his interest in animal studies. In his *Lives* (1550), Giorgio Vasari tells us how Leonardo crafted a painting on leather to show the head of Medusa, using studies of lizards, bats, and spiders to make it startlingly lifelike. Certainly the sprightly step of the dog, its perky attentiveness, and its flowing coat are characteristic of Leonardo's interest in direct observation from nature. The gutted fish is wonderfully real, from the detailed scales to the gasping mouth; such naturalism contrasts with the bland execution of the rest of the landscape and the graceful but rote curlicues of the draperies.

Confraternities dedicated to the archangel Raphael were founded in Florence in the fifteenth century for both adults and boys. Devotion to Raphael flourished, perhaps because he was seen as a protector of travelers and a healer. These would have been important themes for the merchant population of Florence in a period of economic expansion. Indeed, the story of Tobias enjoyed much popularity there, as the narrative emphasized filial devotion, together with mercantile activity, civic duty, and marriage within one's class.

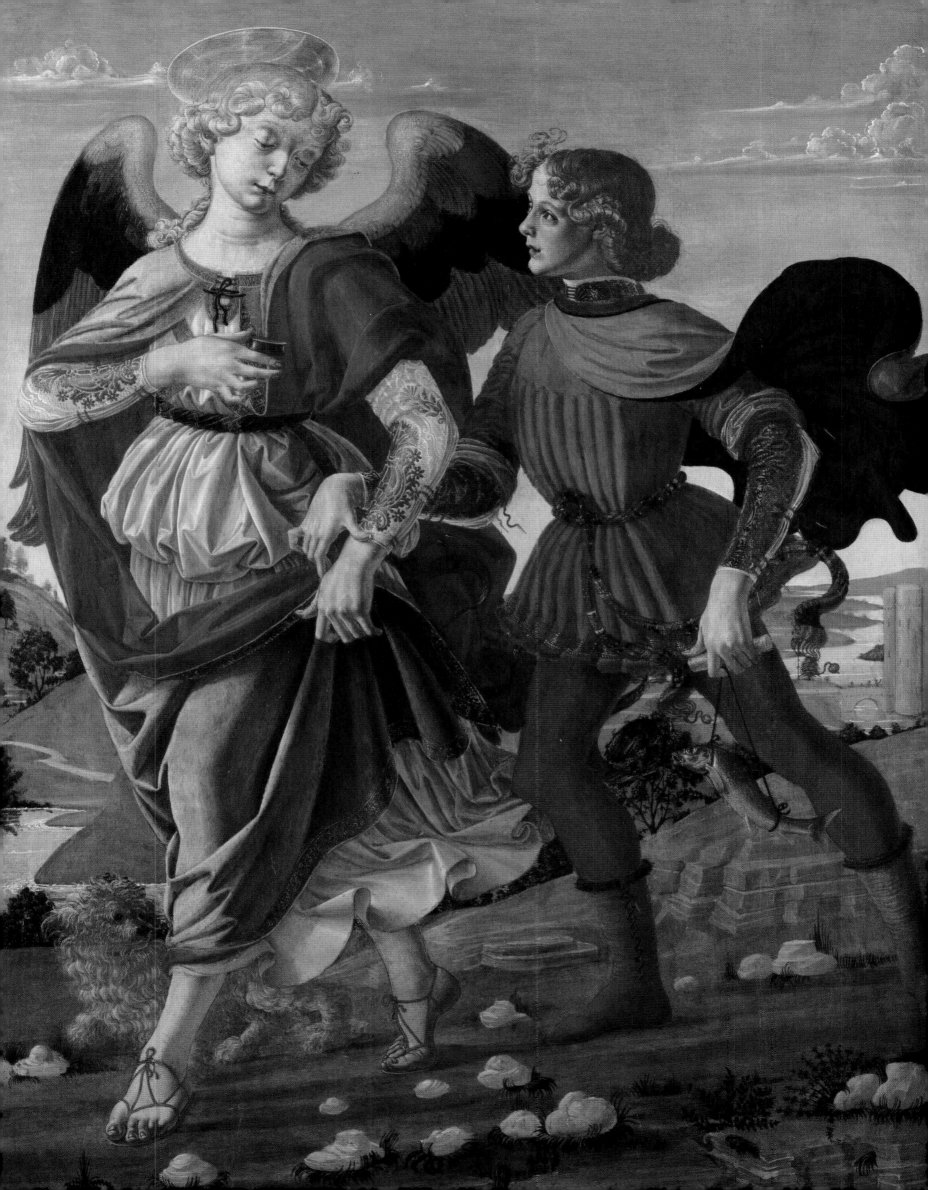

ANDREA DEL VERROCCHIO, WITH LEONARDO DA VINCI
(1435–1488) (1452–1519)

Baptism of Christ
CA. 1470–75

OIL AND TEMPERA ON POPLAR PANEL
71 X 59 ½ IN (180 X 151.3 CM)
UFFIZI GALLERY, FLORENCE

ACCORDING TO Giorgio Vasari, "At that time [about 1470] Verrocchio was working on a panel picture showing the Baptism of Christ by St. John, for which Leonardo painted an angel who was holding some garments; and despite his youth, he executed it in such a manner that his angel was far better than the figures painted by Andrea. This was the reason why Andrea would never touch colors again, he was so ashamed that a boy understood their use better than he did."

Although Vasari's story is perhaps embellished, it is nonetheless true that Verrocchio painted little after the completion of this work. It is clear from recent technical examinations, though, that Leonardo's contribution to the painting is more extensive than just the peripheral figure. The work seems to have been painted in at least two phases and by as many as three artists. Verrocchio, as master of the workshop, must certainly be given credit for the overall composition, the underlying sketch on the gesso ground, and, likely, the large areas executed in tempera. At a later point, parts of the painting were reworked in oil, which was then still uncommon in Florence. Presumably this later contribution was Leonardo's, and it included not only the angel on the far left but also the body of Christ, the riverbed, and large parts of the background, excluding the rocks on the right. This outcropping continues the sharp edging typical of such features in Quattrocento tempera painting, while infrared reflectograms reveal that the initial sketch included more conventional trees behind the angels. Leonardo seems to have refined this area to gain a more extensive view into the distance and to incorporate a softer touch and more subtle lighting. Fingerprints typical of those found in other works by Leonardo are present in Christ's body, and a recent restoration has renewed the luminescent oils used in this area, which contrast with the body of St. John. The left angel is also softly executed and displays a typically Leonardesque corkscrew motion in the hips and torso.

Modern scholars search desperately to distinguish the hand of Leonardo from that of his master, but it is not merely an academic exercise. Even though most viewers in the Renaissance would not have been able to make such distinctions, discerning patrons did care about which parts were workshop contributions, and the extent of the role of the master was a common element in contracts of the period. Moreover, admiring fellow artists made note of even the smallest pieces by Leonardo and other great masters. Vasari was not alone in the sixteenth century in remarking that an angel by Leonardo was to be found in the Vallombrosa Church of San Salvi, outside the walls of Florence.

The Vallombrosan order was founded in the eleventh century by St. John Gualbert, son of the noble Florentine Gualbert Visdomini. The monks had a long history with the Crusades, and the choice of the subject of John the Baptist was likely due to the saint being the namesake of the founder of their order; it also afforded an opportunity to show a view of the Holy Land, with its exotic landscape of rocky desert and palm trees. The Church of San Salvi was partially destroyed in 1529, during the siege of Florence by a Spanish army; by midcentury the painting was on view in the Accademia in Florence.

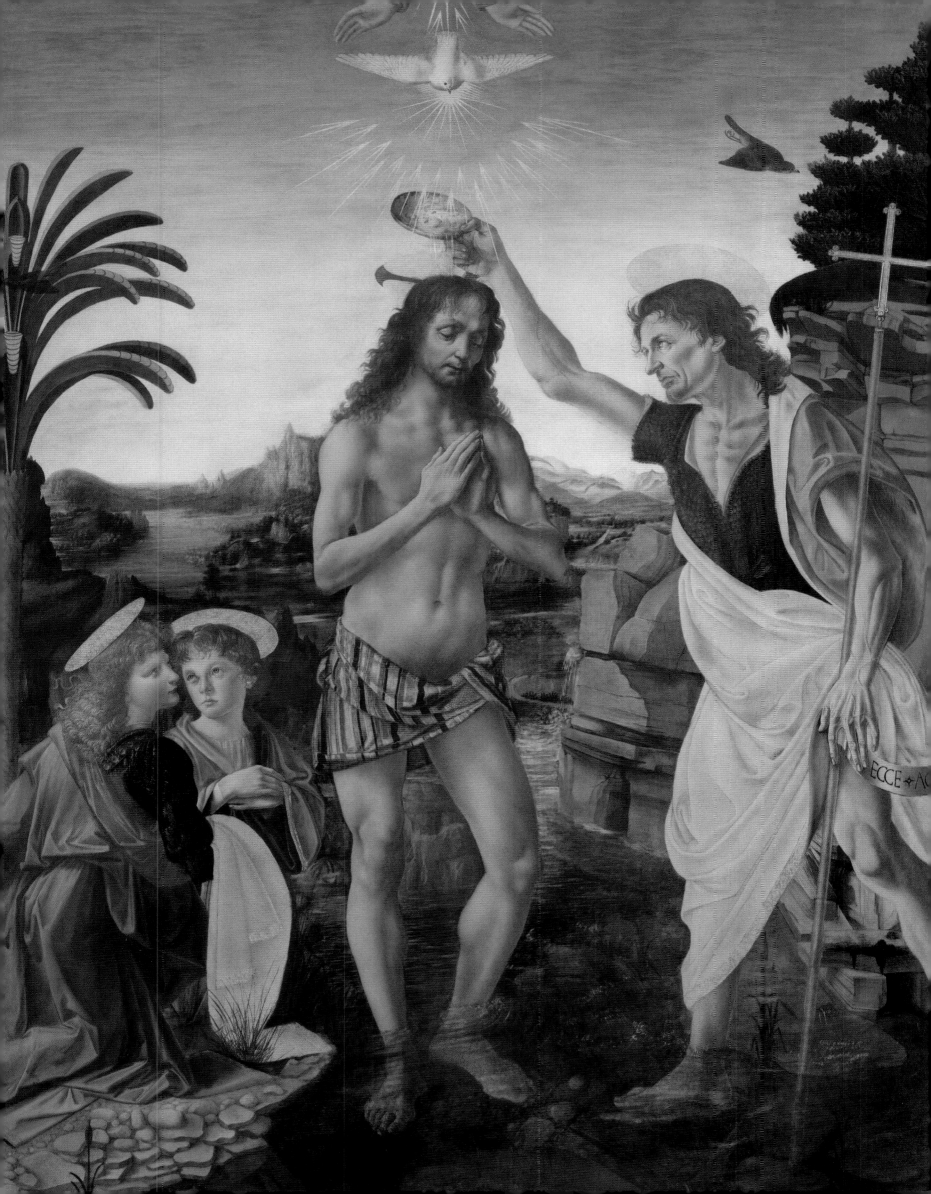

TECHNIQUE AND PRACTICE

LEONARDO experimented with artistic techniques in the same way that he investigated the natural world, challenging the conventional wisdom and testing the parameters of the possible. On occasion the results were disastrous, as seen in the *Last Supper*. He also took an inordinate amount of time to complete projects, in part because of his varied interests at any given moment, but also because of the amount of study that he devoted to each project. Most of the time, however, Leonardo's deliberate approach ultimately led to images of far greater complexity and subtlety than those produced by his predecessors and peers.

As an apprentice to Andrea del Verrocchio in the 1470s, Leonardo learned the basics of painting and sculpture. Rarely could an artist carry on a professional practice in both media, and today we primarily think of Leonardo as a painter. In fact, he spent a great deal of time planning several sculptural and architectural projects that were never realized, mainly because his unbounded ambition encountered inadequate funding. The fountainhead of all three disciplines—painting, sculpture, and architecture— was the Tuscan practice and conceptual framework of *disegno*. Literally, the word means "drawing," but for the Italians of the Renaissance, especially in Florence, *disegno* was also a mental process, the root of the English word *design*. *Disegno* was equated with genius, with good taste, and with sound judgment, just as much as with manual skill and dexterity. Few artists rivaled Leonardo in the number of individual studies he devoted to every element in a painting; each plant, rock outcropping, drapery, gesture, limb, and digit, not to mention facial expressions and hair, were drawn from life, often multiple times, before being painted on the panel. Moreover, Leonardo's notebooks demonstrate that he saw, learned, and even thought by means of drawing.

The principal objective of painting in the Renaissance was to portray a narrative or important figure through a convincing illusion of reality. Mastering the rules of one-point linear perspective was vitally important to Renaissance artists, and for this skill Leonardo was highly praised by the mathematician Luca Pacioli (1446/7–1517). On a practical level, this geometric system allowed artists to accurately render three-dimensional space on a two-dimensional surface. Lines receding into space that are parallel to the sight line of the viewer are drawn diagonally in the painting to converge at a vanishing point on the horizon line (see *Perspective Study for the* Adoration of the Magi). By plotting this system, artists could then fill in figures, architecture, and other elements of the setting to create a realistic-looking space. The connection between mathematics and perspective also allowed artists to stress the intellectual aspects of their profession. Leonardo emphasized perfect geometrical forms and idealized ratios in the proportions of figures and their placement within the overall composition. Moreover, he took illusionistic space to a heightened level of realism by incorporating a new atmospheric quality that he called *sfumato*, or "smokiness." This effect was created by softening the outlines of forms and darkening the backgrounds so that highlighted areas emerge forward in seemingly tangible relief.

Since the beginning of Leonardo's career, artists and enthusiasts have been fascinated by his technical innovations. The paintings that he left unfinished in Florence became attractions during his lifetime, and even today they provide tremendous clues to his preparations and methods. Recent conservation efforts have revealed even more insights into his technical approaches. It has become clear from the restoration of the *Last Supper*, for example, that he was dissatisfied with the limitations of the fresco technique and sought an alternative. Traditionally, true fresco (or *buon fresco*) called for tempera paint to be applied directly onto wet plaster, but certain pigments could not be used because they would not chemically bond with the plaster. The deeply saturated oil paints that Leonardo preferred were thus impossible to use. Furthermore, the subtle layering that allowed artists to achieve smooth transitions of light and dark was mitigated by the quickness with which the plaster dried. To circumvent these obstacles, Leonardo tried to paint in oils on dry plaster. Unfortunately, within just a few years moisture started seeping into the wall, causing the paints to flake off.

Not only did Leonardo aim for a level of craftsmanship that astounded his contemporaries, but he involved all his experiments, observations, and knowledge of nature in his art. In the end, filtering his observations through the lens of his intellect in search of the ideal slowed his progress and limited his production. As Vasari explains: "But, in truth, one can believe that his vast and most excellent mind was hampered through being too full of desire, and that his wish ever to seek out excellence upon excellence, and perfection upon perfection, was the reason of it."

Tobias and the Angel

(PAGE 36)

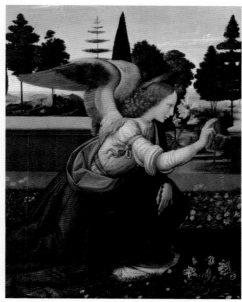

Annunciation

(PAGE 26)

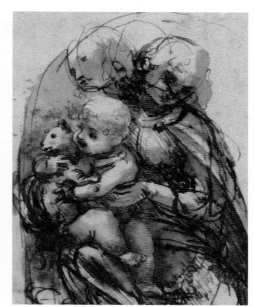

Study for the MADONNA OF THE CAT

(PAGE 72)

Adoration of the Magi

(PAGE 50)

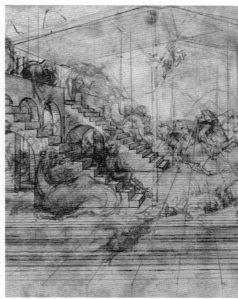

Perspective Study for the ADORATION
OF THE MAGI (PAGE 54)

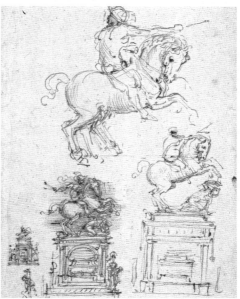

Studies for the Trivulzio Monument

(PAGE 190)

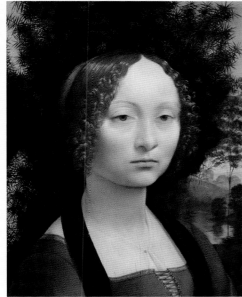

Ginevra de' Benci

(PAGE 222)

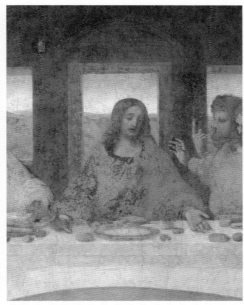

The Last Supper

(PAGE 124)

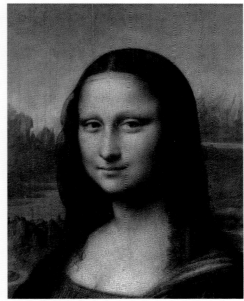

Mona Lisa

(PAGE 250)

GENTILE DA FABRIANO

(CA. 1370–1427)

Adoration of the Magi

1423

TEMPERA ON WALNUT PANEL
118 x 111 ⅜ IN (300 X 283 CM)
UFFIZI GALLERY, FLORENCE

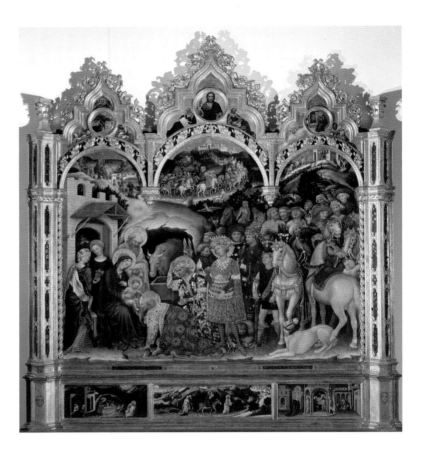

GENTILE DA Fabriano was one of the most sought-after artists in Italy in the first decades of the fifteenth century. In 1423, he completed an altarpiece representing the Adoration of the Magi for Palla Strozzi, the richest man in Florence, for the sacristy of the church of Santa Trinità. In this location the clergy donned their vestments to carry the host to the altar, and Gentile reflected the purpose of the sacristy in two ways: first, in the fabulous draperies that adorn the dozens of figures, including the three kings from the East, and, second, in the subject itself, the Adoration, which was the first demonstration of the body of Christ (the *Corpus Christi*) to the public. So packed is the scene with exuberance and details that the crowd seems to burst out of the tripartite Gothic framework. The feast of the Epiphany, January 6, was celebrated in Renaissance Florence with parades that included hundreds of participants. Gentile has captured this festive atmosphere in his painting.

The scene develops in a continuous narrative. In the top left arch, the magi stand atop a mountain where they first view the miraculous star. The surrounding sea alludes to their journey that takes them to the Holy Land, shown in the middle arch. Here the kings and their splendid procession enter Jerusalem, where they are turned away and redirected to Bethlehem, seen in the right arch. In the foreground the company visits the Holy Family. Gentile created a rhythmic movement, with the first and oldest magus prostrated to kiss the feet of the child, the second in the process of kneeling, and the youngest still standing. Moreover, the kings demonstrate deference to the majesty of Christ: the first has taken off his crown and placed it on the ground, the second removes his own as he approaches, and the last, while the youngest, still wears his sign of worldly merit. Had this been a royal commission rather than executed for a merchant patron in the Florentine Republic, the deference of the earthly kings might not have been such a prominent feature.

Gentile delighted in illustrating a cavalcade of activity amid the kings' entourage. Figures and beasts are seen in frontal and rear projection, faces turn in all directions, and brocaded draperies, floppy hats and turbans, and bands of jewelry create a continuous flow from one figure to the next. The rich ornamentation and array of gilded details made this one of the most exquisite altarpieces of its time. A wealth of comical vignettes occupies the scene, with the attendants telling jokes, animals chasing and kicking one another, and soldiers molesting a traveler.

In the predella panels below the main scene, Gentile demonstrated his skills through three different types of settings. These panoramic views with realistic lighting effects are among the earliest in Italian art. On the left, a night scene sparkles with the Nativity and the Annunciation to the shepherds in the background. In the center predella, the Holy Family trudges along a curving road in a horizontal mountainous landscape on the Flight into Egypt. On the right, the Presentation in the Temple reveals Gentile's mastery of an architectural and spatial rendering that is complex for its time.

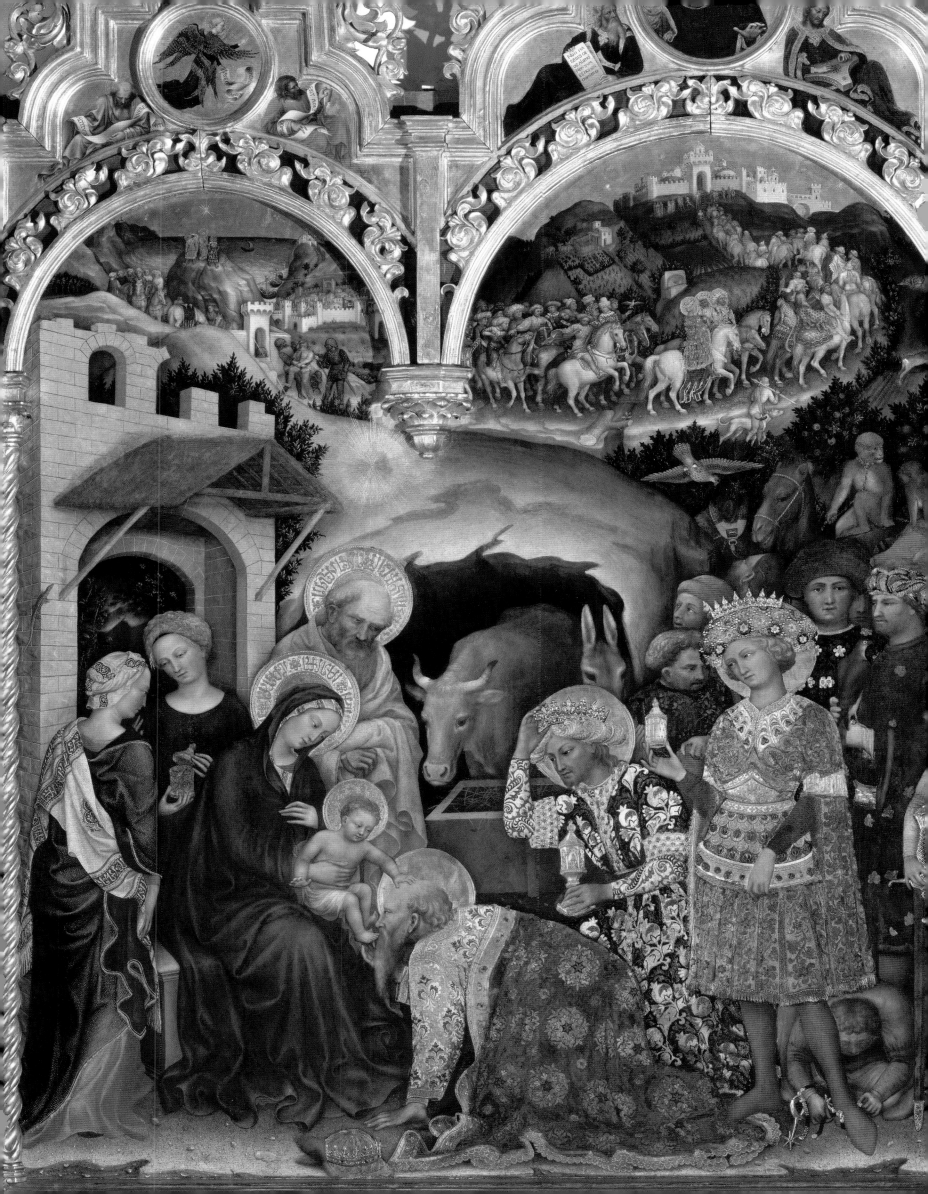

LEONARDO DA VINCI

(1452–1519)

Adoration of the Magi

CA. 1481–82

OIL ON PANEL
40 ½ X 29 IN (102.8 X 73.5 CM)
UFFIZI GALLERY, FLORENCE

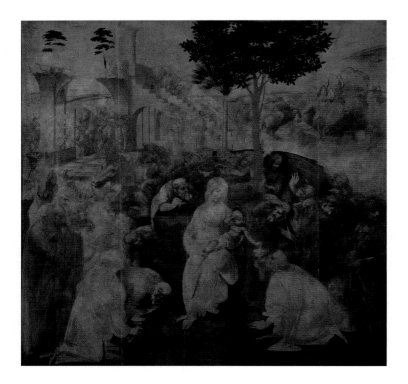

LEONARDO left this work unfinished when he departed Florence for Milan in 1482/83, providing a glimpse of his revolutionary technical process at the outset of his career. It is the only painting from his early period in Florence for which we have documented information about the commission, and the terms were in some respects highly unusual.

The monks of San Donato a Scopeto commissioned the *Adoration of the Magi* for the high altar of their monastery, located near Florence's Porta Romana. The complicated negotiations were finalized in July 1481. The painting was supposed to be completed in twenty-four months but not more than thirty, and during that time Leonardo was to work on nothing else. This stipulation may be one reason he discontinued work on the *St. Jerome* (see later entry), which was similarly abandoned at an early stage. It may also have been a hedge, even at this early point in his career, against Leonardo's proclivity to flitter from one exploration to another. The contract contained other odd elements: the painter was to be paid with a share in a real estate holding, and he was supposed to provide a dowry for the daughter of another person. Leonardo's father had done notarial work for the monks, but the contractual obligations were not favorable, since the young artist incurred high out-of-pocket costs. Two subsequent documentary notes indicate that he had difficulty securing materials and meeting the obligations to fund the dowry. By 1496 it was clear that Leonardo had no intention of finishing the commission, which was given instead to Filippino Lippi, whose painting is now also in the Uffizi.

Leonardo's *Adoration* was seen by Giorgio Vasari in the sixteenth century in the home of Amerigo Benci and was later acquired by the Medici family. Benci had given Leonardo one of the artist's earliest commissions, the portrait of his daughter Ginevra (see later entry). It is possible that Leonardo left the panel in the hands of a trusted patron in case he should return to Florence, but the terms of the contract were specific and lead to another conclusion. In the event that Leonardo did not finish the painting, he was obliged to forfeit the part he had done, and the monks were free to do with it as they pleased. They would have had little use for an unfinished work, however, and given the peculiarities of Leonardo's method at the time—particularly his use of oil paint—it may have been difficult to find another artist able to bring it to completion. Benci likely worked out a deal to acquire the painting from the monks and to leave it as it was, a sign of the genius of a young master. Such appreciation for the unfinished works of painters as a direct indication of their ideas and revelation of their working method had roots in ancient writing.

Leonardo's composition—and Filippino's as well, for that matter—is indebted to a precedent by Sandro Botticelli, the *Adoration for Gaspare del Lama* (also in the Uffizi). All three compositions employ a powerful perspectival view in the ruined architecture, a rickety roof over the Holy Family that is held aloft by tree limbs, and a strong pyramidal structure for the main figural group. Leonardo's construction of the perspective is discussed in the next entry.

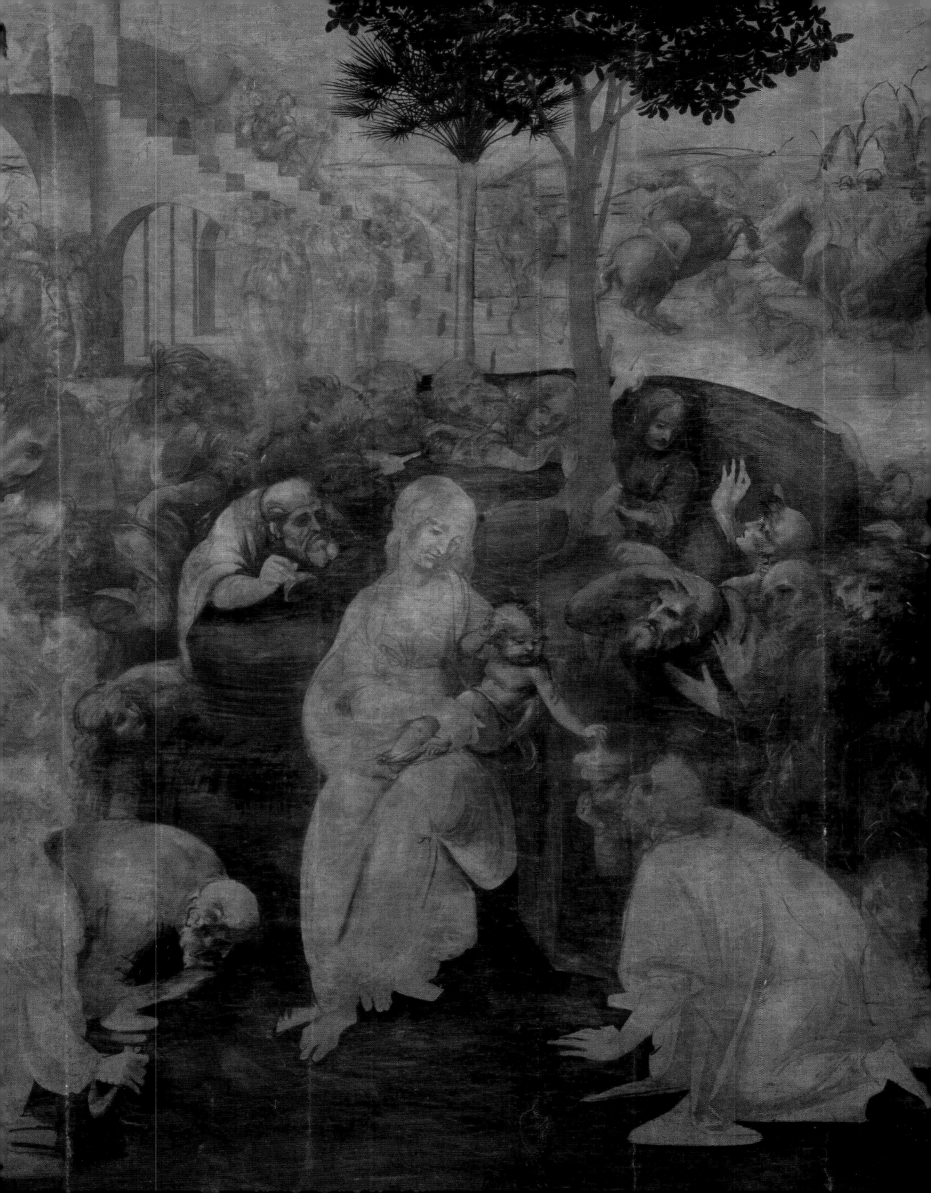

LEONARDO DA VINCI

(1452–1519)

Perspective Study for the Adoration of the Magi

CA. 1481

PEN, INK, METALPOINT, AND WHITE HEIGHTENING
6 ½ X 11 ½ IN (165 X 290 MM)
UFFIZI GALLERY, FLORENCE

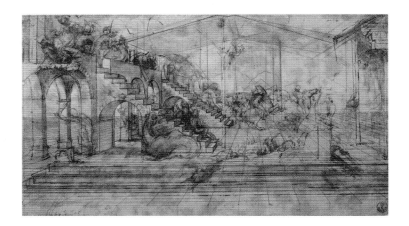

ZOOMING perspectival arrangements were all the rage in Florence in the middle of the fifteenth century. The fame of such artists as Paolo Uccello, Andrea Castagno, and Piero della Francesca was based on their knowledge of one-point linear perspective, an invention of the sculptor and architect Filippo Brunelleschi that enabled artists to accurately depict three-dimensional space on a two-dimensional surface. Perspective provided more than just a formal accomplishment, however; it also allowed artists to maintain that their profession demanded knowledge of mathematics, and this connection greatly enhanced the prestige of painting among humanists and well-to-do patrons who wanted to be conversant about art. Nevertheless, the taste for such demonstrations for their own sake was beginning to wane. This drawing is one of two known compositional sketches by Leonardo related to the *Adoration of the Magi* (see previous entry). Despite the survival of these studies, the painting contains no indication of a directly transferred design. Leonardo employed the complicated one-point linear-perspective system of the drawing more sparingly in the painting before abandoning the work altogether. This perspectival recession would be a central feature of his most famous painting in his lifetime, the *Last Supper*.

The diagonal lines, called orthogonals, recede to the vanishing point along the horizon line at the center background. The elements of scenery that Leonardo placed onto this spatial grid presented many challenges. Not one but a double staircase and several arcades complicate the organization. Moreover, Leonardo has added a pitched roof, supported by wooden beams, over the central portion of the space. He likely took his cue from a painting of the same subject by Sandro Botticelli, the *Adoration for Gaspare del Lama* (also in the Uffizi). Completed a few years earlier, Botticelli's scene set the traditional stable of the Nativity amid the ruins of the palace of David, with a makeshift roof

supported by beams and trees. Botticelli also emphasized a strong illusionistic perspective and set the Holy Family on an earthen mound in the center of the ruins. For the painted version, Leonardo abandoned the roof but kept the mound and the ruined surroundings. Although he did not represent the Holy Family and kings in this sketch, the mound is indicated in the foreground, with grassy tufts emerging from the top.

According to a medieval legend, the three wise men from the East had been enemies prior to their journey, but they united in their quest and officially made peace upon witnessing the Nativity. Almost all of the figures in this drawing are engaged in battle, an indication that Leonardo has departed from the tradition of representing a festival-type atmosphere amid the plenteous entourage of the kings (see for example Gentile da Fabriano's *Adoration of the Magi*). Figures in hand-to-hand combat climb the stairs to claim higher ground, horses rear and kick, and others seek strategic positions among the ruins of the temple. The battle is also evident in the painted composition but does not dominate the action as much, since it is mitigated by the crowd surrounding the Madonna and Child.

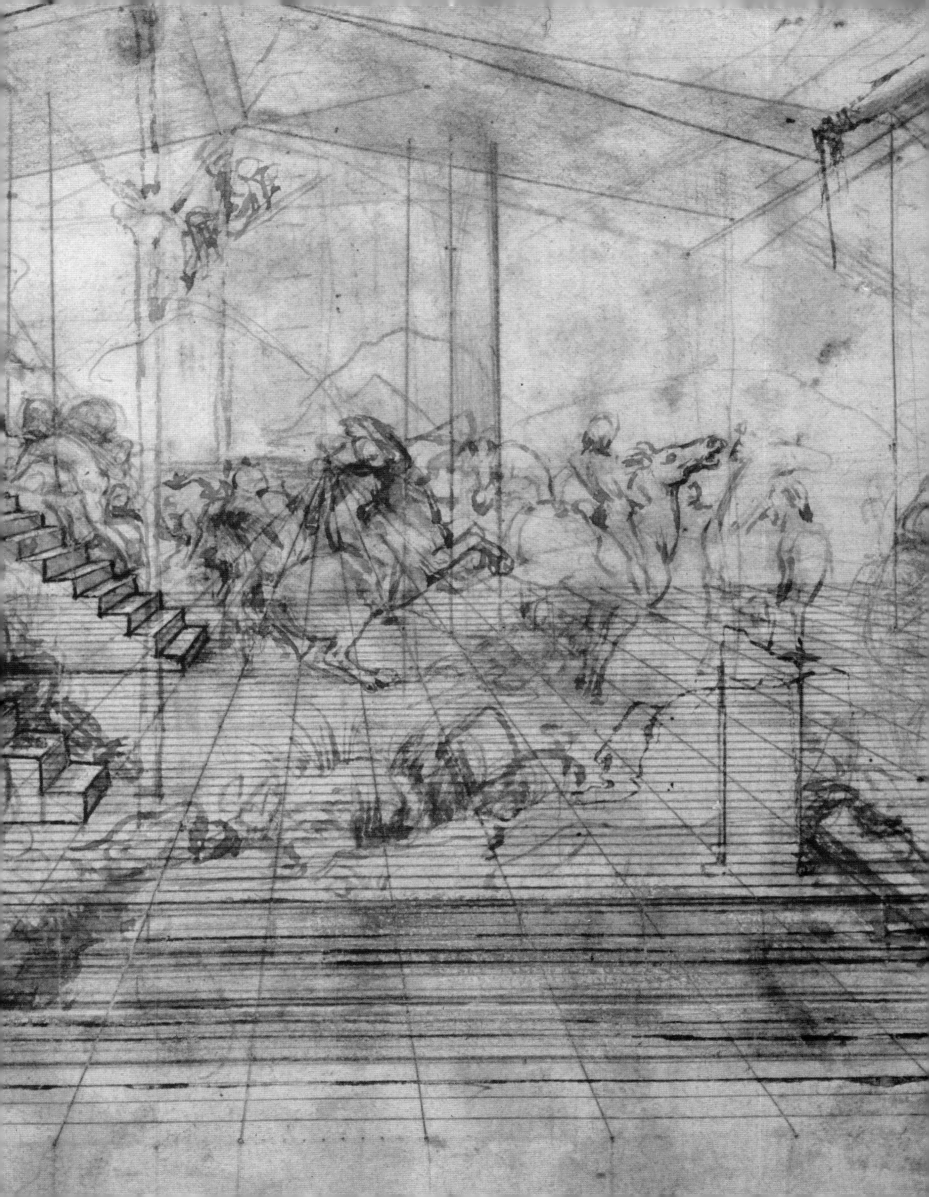

LEONARDO DA VINCI
(1452–1519)

Perspective Study for the Adoration of the Magi
CA. 1481

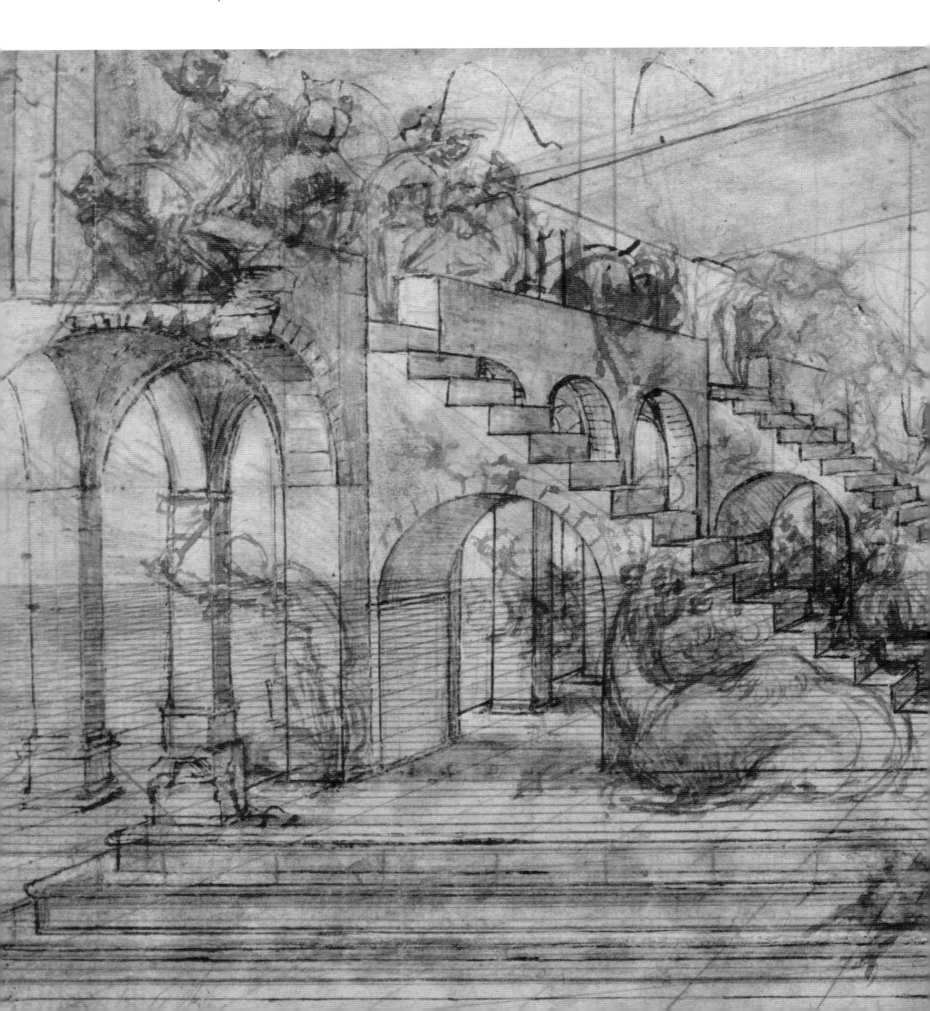

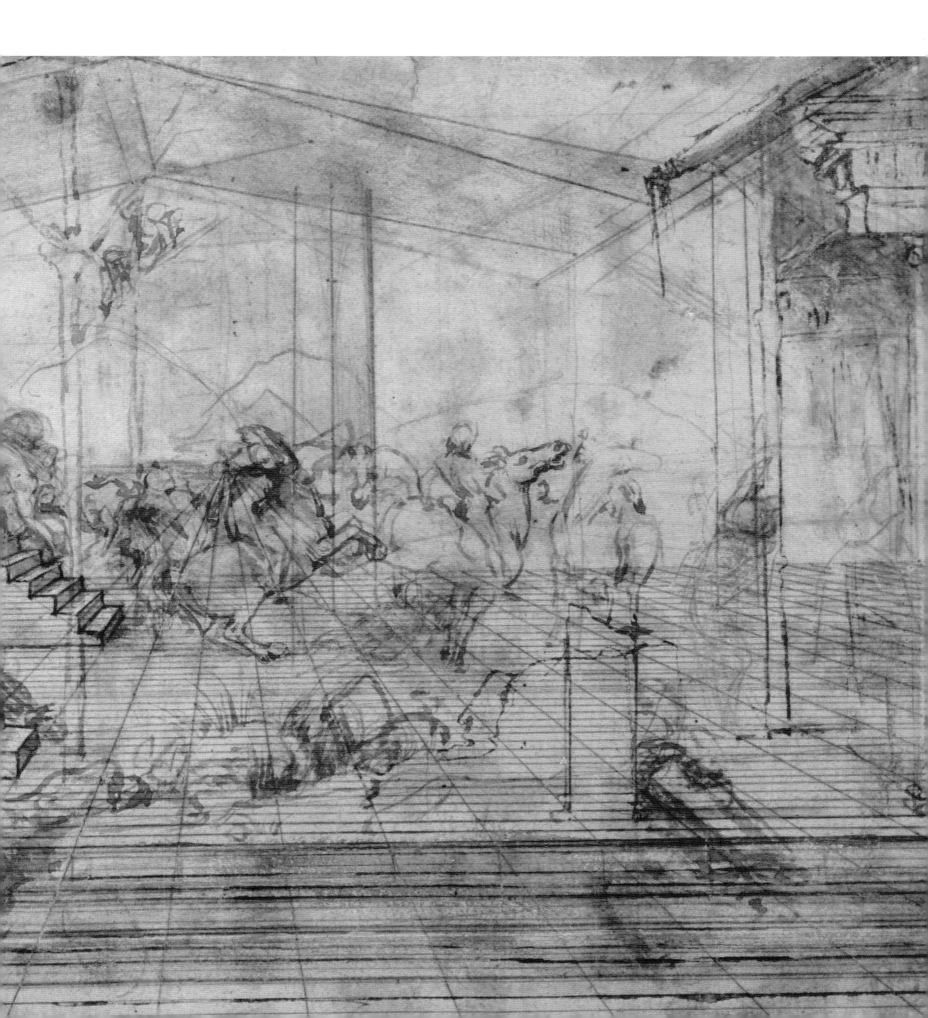

LEONARDO DA VINCI

(1452–1519)

Madonna and Child with a Carnation

CA. 1472–78

TEMPERA AND OIL ON PANEL
24 X 18 ½ IN (62 X 47.5 CM)
ALTE PINAKOTHEK, BAYERISCHE STAATSGEMÄLDESAMMLUNGEN, MUNICH

THE *Madonna and Child with a Carnation* is perhaps Leonardo's first autonomous work. Painted while the artist was in Andrea del Verrocchio's workshop, it shows the type of sweet, maternal Virgins in half length that Verrocchio popularized in Florentine painting and sculpture.

Mary appears in an interior space, seated on a stone ledge in front of a row of double windows. This type of domestic setting was unusual; most of the works produced in Verrocchio's shop show the Virgin either within a church or in front of a landscape. Leonardo may have seen similar compositions in Netherlandish paintings. Similarly Northern is the oil medium that Leonardo used here perhaps for the first time. Oil paint offered him the chance to achieve deep colors within a tonally rich atmosphere: note the flowing reds, cool blues, and brilliant yellows in the Virgin's clothing. Another attribute of the oil medium is its ability to render details of texture, seen here in the varied fabrics, the shiny effects of metal and jewels, the braided hair, and the soft modeling of flesh. An example of Leonardo's efforts is the glass vase of elaborate shape containing a bouquet of flowers, in the lower right corner. Leonardo attempts to capture both the reflective and transparent qualities of the glass; highlights on the curves show the vessel's form, while the stems of the flowers can be seen through its center. The vase not only acts as a repository for a beautiful bouquet but also represents Mary's virginity. Renaissance viewers believed that, like glass, which can be permeated without losing its integrity, Mary was impregnated and gave birth without sex, and thus without original sin.

The carnation that Mary offers to her son is a symbol of the Passion, the sequence of painful events in Jesus's life leading up to and including the Crucifixion. Leonardo's close attention to human behavior can be seen in the figure of the Christ Child, who appears more babyish than the infants usually found in paintings of the time. The roly-poly child with thick folds of skin at elbow, wrist, and knee—telling details directly observed from life—lurches forward to grab at the flower, seemingly transfixed by it. The impetuous gesture is certainly characteristic of babies, but metaphorically it signals Jesus's willing acceptance of his destiny. Mary's sweetly resigned expression records her own acceptance of her son's future.

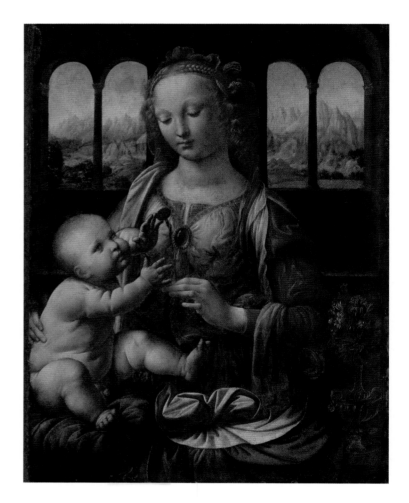

This painting may have been commissioned by a member of the Medici family. Indeed, the windows, courtly attire of the Virgin (including rich robes, jewels, and elaborately plaited hair), and motif of repeated balls (on the foreground cushion) all reference that Florentine political dynasty. Giorgio Vasari discusses the work in his *Lives* (1550), stating that it was in the collection of Pope Clement VII (Giulio de Medici). Leonardo not only painted marvelous flowers, Vasari said, but even captured the drops of dew on them, in a manner "more real than reality." However, no such dewdrops are visible in this work. It is possible that Vasari was using this imagined detail to make an age-old point about the painter's ability to outdo nature. Pictured, and possibly also displayed, within a Medici space, this image of a domestic Virgin must have offered a compelling doubling of art and reality.

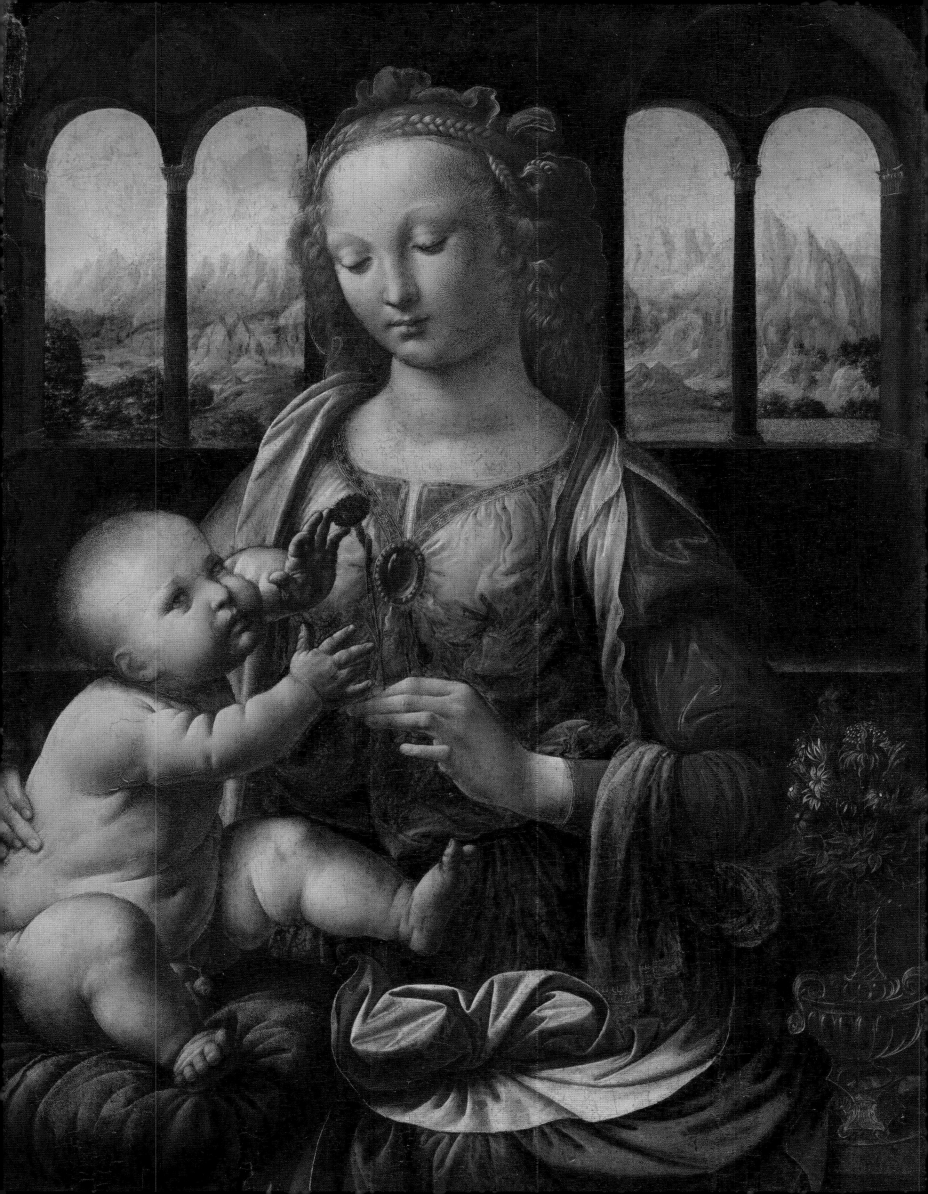

CARLO CRIVELLI

(1435/40–1493)

Madonna and Child

CA. 1478–80

TEMPERA ON PANEL
17 ¾ X 13 IN (45 X 33 CM)
ACCADEMIA CARRARA, BERGAMO

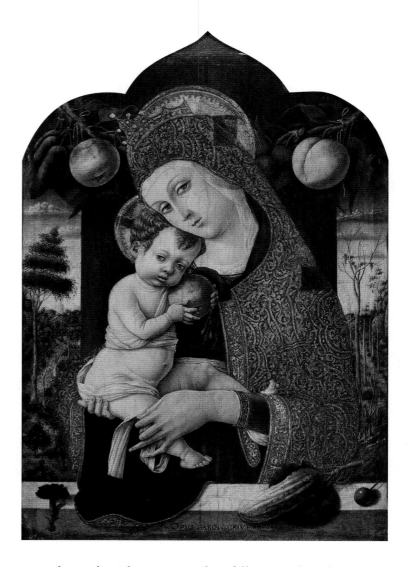

IN THIS resplendent painting, Carlo Crivelli conveyed a traditionally devotional image of Mary and the baby Jesus. The figures stand in the shallow foreground space between a stone ledge and a silk cloth of honor. A distant landscape recedes at the sides. Fruit, flowers, and swags fill the corners of the composition, adding to the impression of lively two-dimensional patterning and visual richness. The steep foreshortening of the foreground elements suggests this image was meant to be seen from a lower perspective, probably by a kneeling patron in a domestic interior.

Crivelli draws on a number of different visual traditions in this complex image. The deep, rich colors and heavy use of gold are typical of the art of Venice, where the artist had trained. By contrast, the convincing illusionism of the flower, cucumber, and cherry on the parapet speak to his familiarity with the new spatial systems emanating from Florence in the later fifteenth century. Lastly, the landscape, with its meandering road, diminutive city, and misty vista, utilizes a Netherlandish aerial perspective. The meticulously detailed fruits, nuts, flowers, and vegetables strewn about are Crivelli's signature motifs. These startlingly naturalistic details convey meanings deriving from biblical sources, devotional writings, and humanist treatises.

Crivelli was well educated (his surviving notebooks include notations in Latin), and he worked for a wealthy and erudite set of patrons in the area of the Marches. For such clients, deciphering the symbolism of these works added intellectual pleasure to their visual richness. This painting activates both brain and eye to serve the practice of devotion. For example, the linear, flat figure of Mary emphasizes her ideal nature: removed from the viewer, she is rendered with an elegant sway that conveys aristocratic grace. The heavy pearl-encrusted crown would remind viewers of her role as queen of heaven, while the cloth of gold she wears reiterates her high status. Crivelli paints both crown and cloak using relief in the surface of the paint, as if the fabulous objects were truly present. The items on the foreground ledge continue the startling illusionism: the carnation on the left, nailed to the stone through its stem, casts a sharp shadow onto the surface of the shelf. Next to it Mary's cloak curls suggestively toward the viewer, while the

cucumber to the right appears ready to fall into our lap. These details enliven the hieratic splendor of the image, helping the viewer cross the boundary between the earthly and the heavenly realms.

The painting's symbols revolve around the themes of sacrifice and redemption. A succulent peach and a bunch of hazelnuts hang on the right part of the swag. Like the apple on the other side and the one clutched by the baby Jesus, the sweet peach refers to the fruit of the Tree of Knowledge. The juice of the cherry and pears refers to the Passion, and the carnation signals divine love. The barren tree on the right signals that this is a land of death; the left landscape, by contrast, is green and vibrant. The transition is provided by the holy figures at the center, who ensure the possibility of everlasting life for Christians. While capturing the heavenly splendor of the holy figures, Crivelli's work contains a richly allusive network of meanings, all of which provide access points for meditating on the mysteries of the Christian faith.

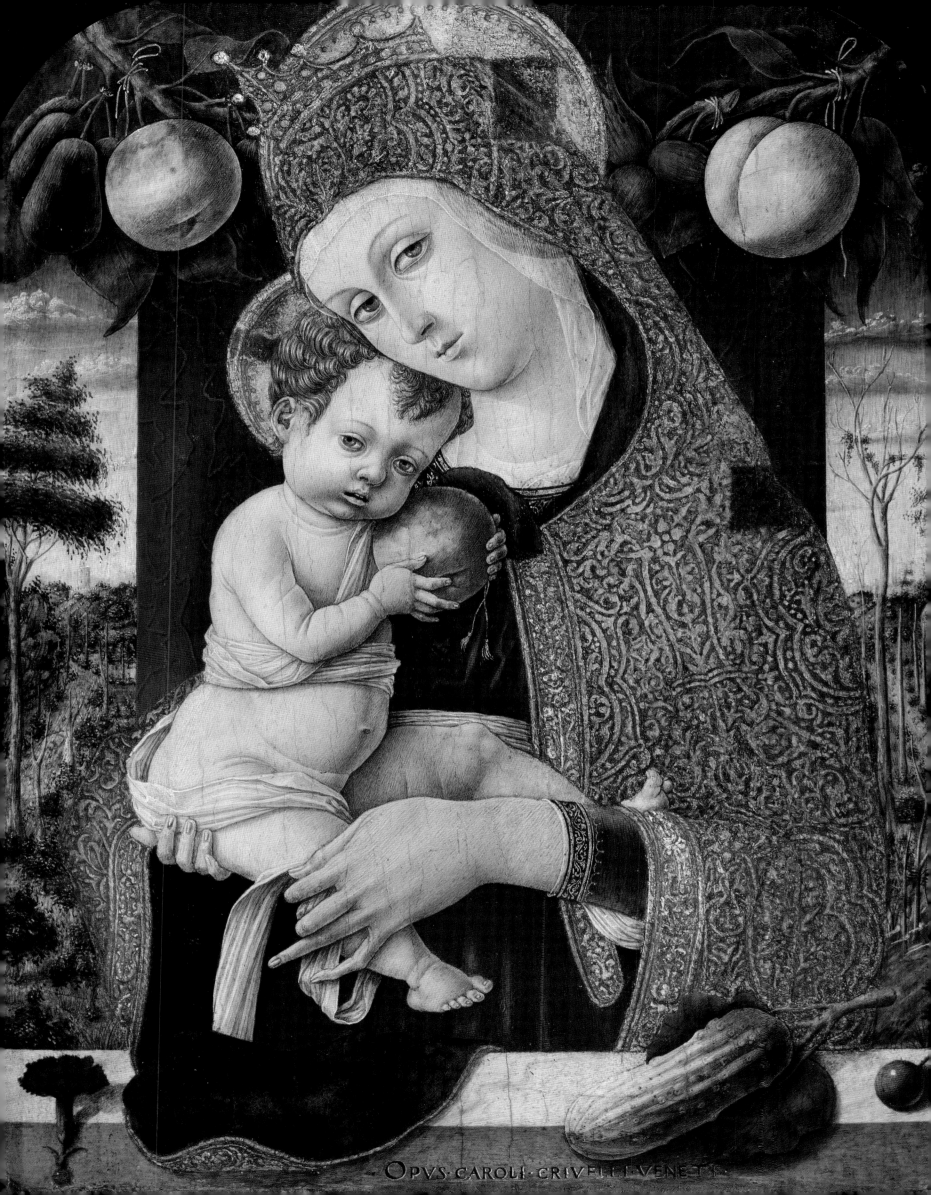

OPVS·CAROLI·CRIVELLI·VENETI·

LEONARDO DA VINCI
(1452–1519)

Madonna with a Flower (Benois Madonna)

CA. 1478–81

OIL ON CANVAS (TRANSFERRED FROM PANEL)
19 ½ X 12 IN (49.5 X 31 CM)
HERMITAGE, ST. PETERSBURG

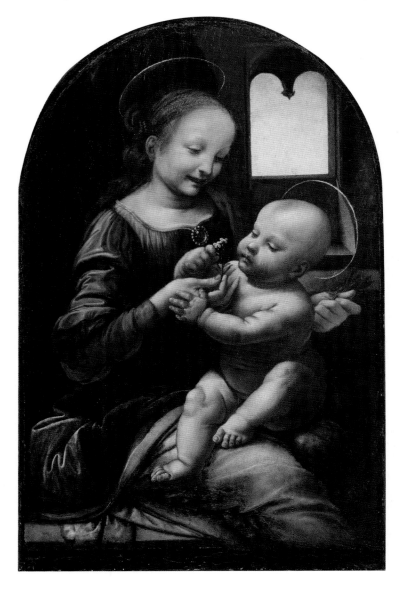

THE *Benois Madonna*, so called after one of its early owners, was long thought to be lost. When it appeared in an exhibition in 1908, it was hailed as a rare early work by Leonardo, probably painted soon after the artist left Andrea del Verrocchio's workshop. The source for the composition is a low relief by another student of Verrocchio, Desiderio da Settignano, now in the Victoria and Albert Museum, London; that Leonardo looked outside his master's own works shows a widening of his artistic horizons at this early stage.

The darkness of this painting is striking. The Virgin sits in front of a shadowy chamber, its somber atmosphere surrounding her. A bright light illuminates her face and the figure of the baby on her lap, but the forms behind the child are barely visible in the shadows. This technique of modeling through a wide tonal range, known as *chiaroscuro*, became one of Leonardo's signature effects. Chiaroscuro allows forms to advance, emphasizing three-dimensionality while also increasing a scene's drama and atmosphere. Here, the technique creates the effect of a secluded moment between mother and son. Their interaction is the focus of the painting.

Two drawings for a lost painting known as the *Madonna of the Cat*, illustrated on the next two pages, show Leonardo developing the physical relationship between two similar figures and gradually refining the pose of the Virgin. One can see how the artist changed his mind about the position of the Virgin's knees, using heavy strokes to build the forms at a dramatic raking angle. In the second sketch, Leonardo has emphasized Mary's complex turned posture by moving her head to the right. In both drawings, the dynamism stems from the incipient sense of moment in the figures. The baby lifts his leg, turns his torso, and grasps at the writhing cat. Mary echoes the gesture as she restrains her wiggling child with gentle hands.

Leonardo incorporated the innovations seen in the *Madonna of the Cat* studies into the *Benois Madonna*. The baby squirms in a similar manner, grabbing clumsily at the flower in his mother's hand. Mary raises her left knee, supports the baby with her left hand, and smiles in delight at his curiosity about the blossom she holds. Leonardo has captured the affectionate relationship between the two, a baby's natural inquisitiveness that charms a mother.

This type of genuine, unaffected interaction became a signature element of Leonardo's style. Many of his early images of the Virgin and Child are traditional in format but include instances of these unusually lifelike details. Technical studies of the *Benois Madonna* reveal that Leonardo worked on enhancing this effect. He eliminated many of the extraneous surface details found in his earlier paintings of this subject, such as the *Madonna of the Carnation*; curls on the Virgin's forehead, for example, were painted over. The greater simplicity allows Leonardo—and the viewer—to appreciate the figures as intrinsically human, a point central to Christian doctrine and humanist theological scholarship of the Renaissance. The naturalism of their emotional relationship also carries devotional weight as the viewer is invited to consider the end of the story, when the son is dead and the mother is distraught. But for now, in the painting, affection and joy rule the day.

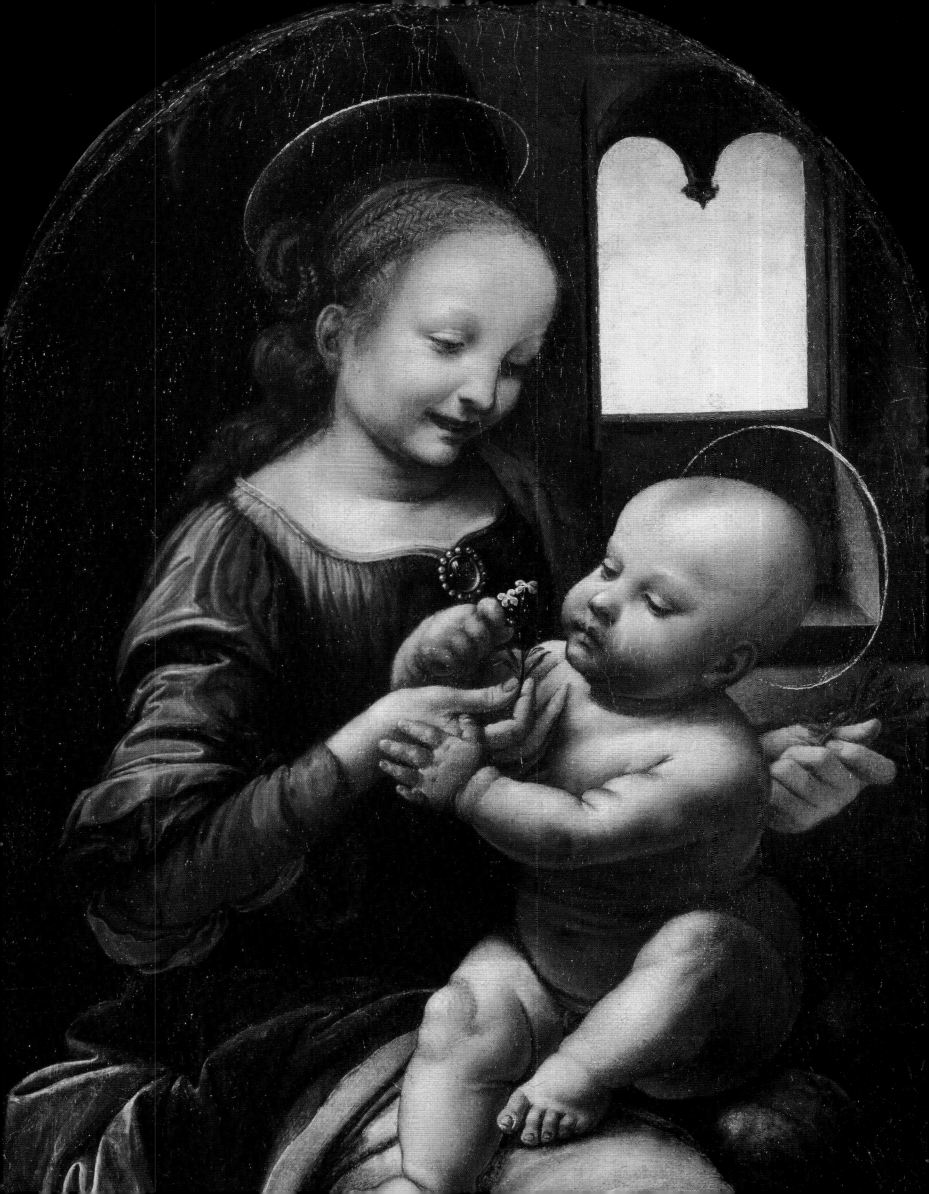

LEONARDO DA VINCI
(1452–1519)

Studies for the
Madonna of the Cat,
front and back of sheet
CA. 1480S

PEN AND BROWN INK,
WITH BROWN WASH
5 X 3 ½ IN (130 X 94 MM)
BRITISH MUSEUM, LONDON

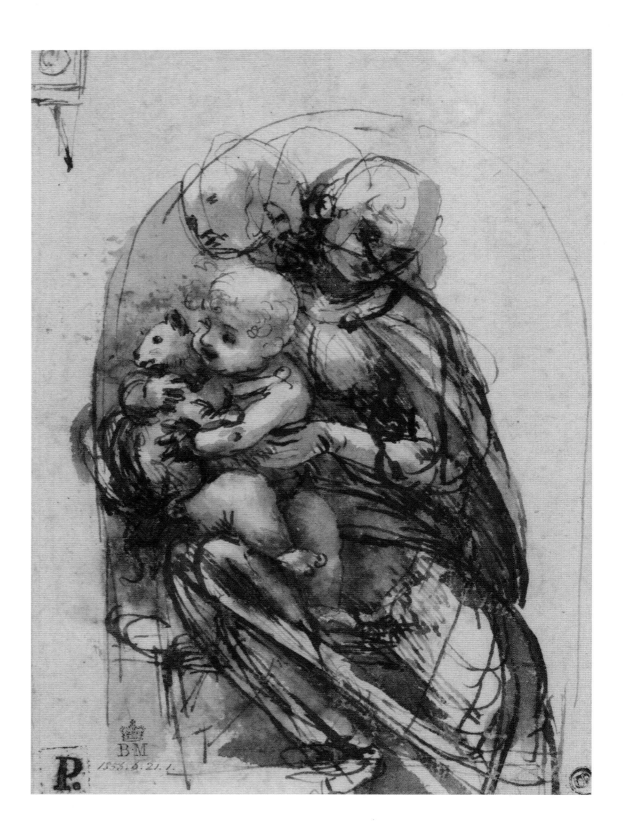

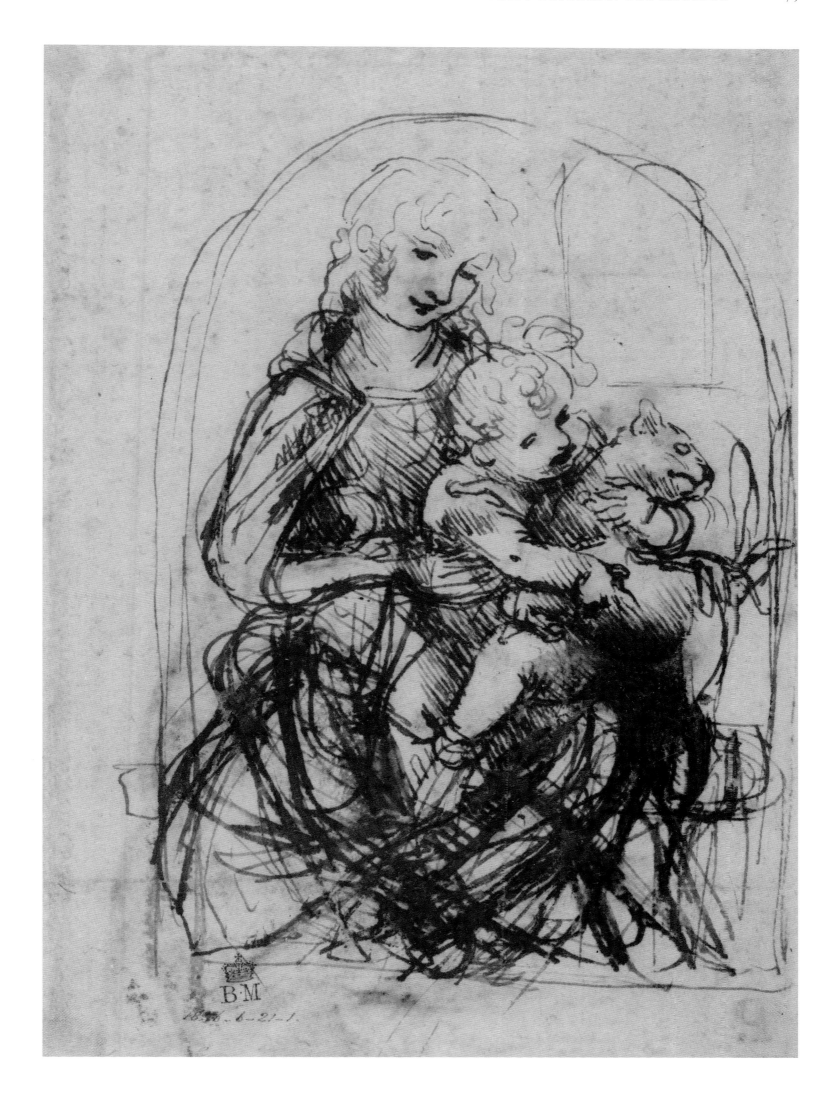

FILIPPO LIPPI
(1406–1469)

Virgin and Child with Two Angels

CA. 1460–65

TEMPERA ON PANEL
37 ½ X 24 ½ IN (95 X 62 CM)
UFFIZI GALLERY, FLORENCE

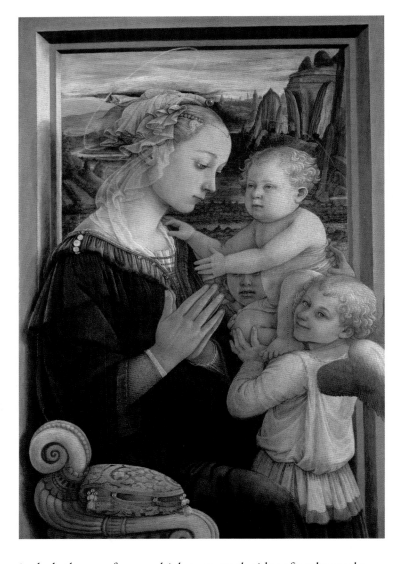

THIS IMAGE of the Virgin Mary with the baby Jesus is an innovative take on the traditional model. Lippi has included two unusual elements: the background door or window frame and the distant landscape vista. These additions activate the devotional image, providing both a narrative expansion of the main subject and an intriguing visual link between the world within the painting and the realm of the viewer. Lippi's model was highly influential: Ghirlandaio, Verrocchio, and Leonardo all followed his example.

Mary sits in a narrow slice of space between the foreground and the framed opening behind her. There seems to be insufficient room for her body, let alone the substantial cushioned chair she sits on or the three young children on the right side. The framed opening pushes her body forward; in the closest foreground, her knee, the armrest, and the angel's wings all project into the viewer's space. She is depicted in three-quarter view, her hands raised in prayer and her eyes downcast. Jesus is a particularly robust infant in this scene: his roly-poly body requires two angels to support it. Though Mary is lost in thought, probably musing on the premonition of her son's death, Jesus is preternaturally alert. He reaches out to her, about to recapture her attention. His initiative suggests not only concern for his mother but also his larger understanding of the Christian narrative of death and salvation beginning here. From that perspective, this moment calls not for melancholy but celebration. The foreground angel certainly understands this—he looks out at the viewer with a cheery grin. The combination of serene piety and earthy humor is typical of Lippi's work.

Fra Filippo Lippi was a member of the community of Carmelite friars, and many elements in the painting have been interpreted as conveying that order's particular concerns and approaches. Mary was their patron saint, and Carmelite prayers dedicated to her often feature visual metaphors that link natural phenomena with sacred concepts. On the right, the craggy rocks may refer to the Carmelite monks' origin in the desert communities of the Holy Land. By contrast, the carefully tended fields of lush vegetation in the middle ground may indicate the European setting of Carmelite institutions in the later thirteenth century, after the order was expelled by the Saracens. Other symbols include the gray frame, which suggests the idea of a tabernacle (a structure, frame, or canopy enclosing sacred objects), and the elaborate chair, which may be seen as the Throne of Wisdom. Such readings draw from medieval allegorical traditions, here transformed from lofty intellectual enterprises into concrete vernacular metaphors. Earthy, expressive, and accessible, Lippi's painting boldly merges the sacred and the secular into a single elegant image.

Though replete with complex symbolism, the painting also celebrates material beauty, from the pearls on the embroidered cushion to Mary's elaborate headdress and lovely face. The grinning angel adds humor, while the baby's gesture seems particularly touching and naturalistic. Some suggest that Lippi's inclusion of such everyday family details drew from his own struggles with the life of celibacy required of monks. In 1456 Lippi ran off with a nun, who bore him two children.

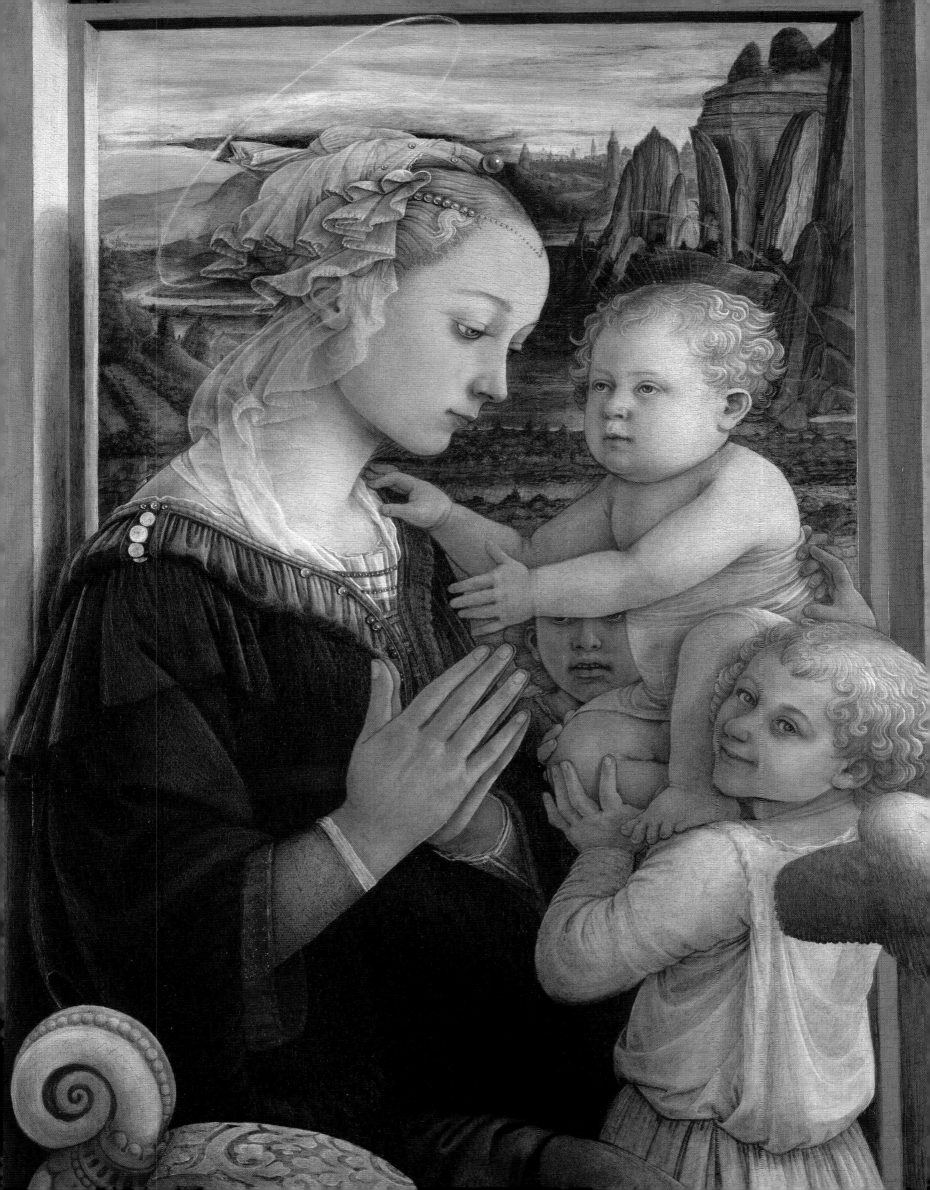

LEONARDO DA VINCI (AND WORKSHOP)

(1452–1519)

Madonna Litta

CA. 1490

TEMPERA AND OIL ON CANVAS (TRANSFERRED FROM PANEL)
16 ½ X 13 IN (42 X 33 CM)
HERMITAGE, ST. PETERSBURG

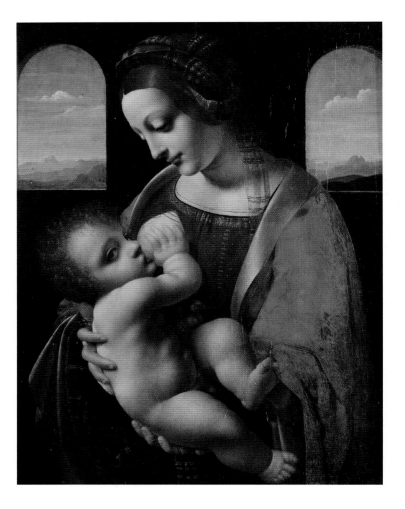

IN 1482 Leonardo moved to Milan to seek service with the Duke of Milan, Ludovico Sforza. He began this painting soon after his arrival, possibly on commission from the prominent Visconti family. The work later passed from the Visconti to the Litta collection, from whom Czar Alexander II of Russia bought it in 1865.

In many ways Leonardo has imported the formulas of his earlier Florentine Madonnas: a domestic Virgin cradles the baby Jesus in an affectionate moment. Both figures are shown without halos to emphasize their earthly character. Two windows open onto a distant landscape, framing this intimate interior scene. Mary's serene expression, captured by the beautiful study of light traversing her cheek and jaw, is a quintessential Leonardesque motif.

Yet the *Madonna Litta* departs from Leonardo's usual approach in several respects. It displays little of the atmospheric quality that distinguishes his work in this period; rather than soft transitions, the forms are rendered with a hard outline. In the landscape, the characteristic vertical mountains depicted in a hazy atmosphere have been replaced with a horizontal vista made up of rolling hills in shades of blue. The effect is placid and even. In addition, the child here is unlike the chubby infants painted by Leonardo in earlier works; Jesus's body is smoother, without any of the artist's usual dramatic foreshortenings, and he sits weightlessly in his mother's arms. More toddler than infant, the boy has a full head of curly red hair rendered with short discrete strokes. These unsatisfying departures from Leonardo's earlier subtleties have called into question the attribution of the painting. Most scholars generally agree that the composition was laid out by Leonardo, and that he may have painted the head of the Virgin. The rest was probably finished in the 1490s by an assistant who worked closely with the master during his first Milan period. Furthermore, some of the painting's delicate layering effects may have been lost during restoration efforts in the nineteenth century, when it was transferred from panel to canvas.

Images of the Virgin nursing had been popular in Tuscany since the thirteenth century, drawing upon a long tradition of Byzantine iconographic types. The significance of breast-feeding went beyond representing the emotional bond between mother and child. Such depictions allowed patrons and audiences to reiterate Christian dogma of the Trinity: Jesus's birth by a human mother made it possible for the divine to be simultaneously flesh, deity, and spirit. Additionally, the emphasis on Mary nurturing the Christ Child probably enhanced the painting's devotional possibilities: as the cult of the Virgin grew during the Renaissance, Mary not only became an object of veneration but was celebrated as an exemplary mother as well.

As was typical of Leonardo's style, the artist here has insisted on physical accuracy: Mary's breasts are full and ample, and her red dress even shows the seams that were unlaced when nursing. These kinds of details not only allowed women to identify with Mary but also encouraged all viewers to celebrate the Virgin's central role in the Christian story. As she provided life and sustenance to her son, so could she nurture all the Christian faithful. Jesus's outward glance reiterates the connection between the holy figures pictured and the devotions of the audience.

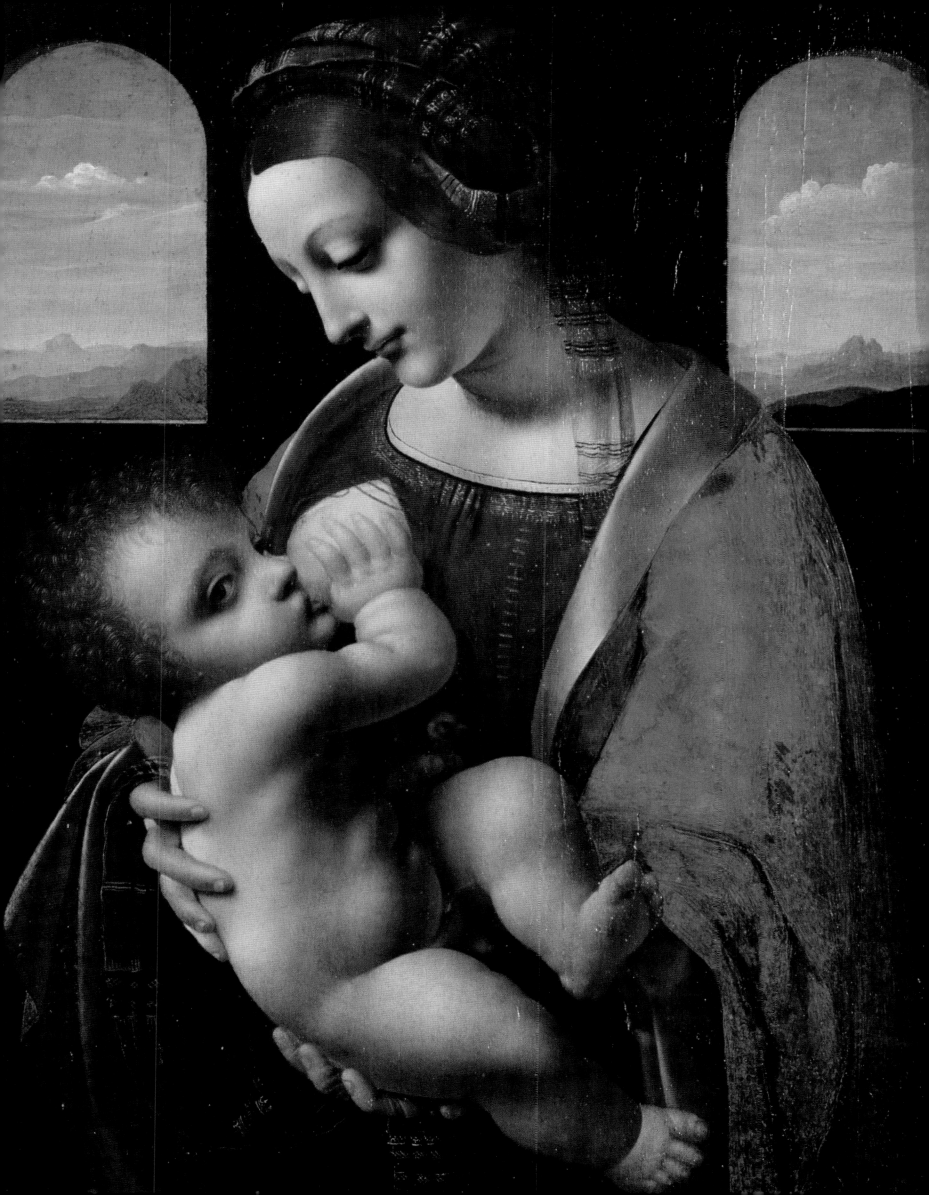

AMBROGIO LORENZETTI

(CA. 1290–1348)

Virgin and Child Nursing

CA. 1340

TEMPERA ON PANEL
35 ½ X 17 ¾ IN (90 X 45 CM)
MUSEUM OF SACRED ART, SIENA

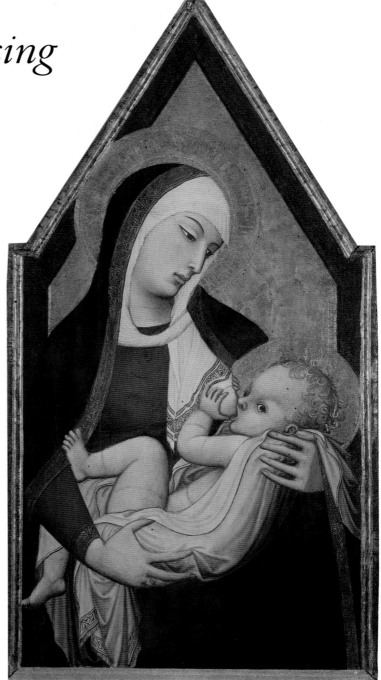

AMBROGIO LORENZETTI was one of the foremost painters in the Tuscan city of Siena in the fourteenth century. He painted frescoes and altarpieces for civic and religious spaces as well as devotional works such as this one.

The angled shape of the panel is typical of Trecento religious paintings and was used for both polyptychs (altarpieces with several joined panels) and stand-alone works of art. Portable and visually accessible, this relatively small painting was probably used in a private setting. The high number of standardized images of Mary that date from this period suggests that a thriving art market existed in Tuscany, especially one for artworks featuring the Virgin.

The painting shows Mary nursing the baby Jesus. Lorenzetti subtly manipulates the conventions for such imagery in order to enhance the visceral power of the scene. Set against a wall of glittering gold that signals a heavenly realm, Mary's figure is made up of planes of brilliant, solid colors. She stands slightly off center, her body arcing to the left to accommodate the weight of the child cradled in her arms. Her halo and arm overlap the frame, expanding the space of the scene on all sides. The baby curls up cozily against her, their two figures locked together in a fluid and curving rhythm. The Virgin's bare breast appears from under her layers of clothing, as if disconnected from her body; in its ample roundness, her fertility and bounty are apparent. With a charming naturalism, the Christ Child grabs at his mother's breast, glancing over his shoulder to gaze at the viewer. Like Mary, the viewer watches the baby suckle, and fourteenth-century viewers in particular would have contemplated the Christian miracle of God made man.

Scenes of Mary nursing the infant Jesus reiterated important Christian beliefs in the humanity of Christ and in Mary's role as a link between the earthly and the divine. She appears here as a perfect mother caring for her baby, a common act that emphasizes her humility. Theologically speaking, Mary was also seen as Ecclesia, and her act of nursing could be viewed as the Church nourishing all the Christian faithful through the Eucharist. At the same time, Mary played the role of intermediary in the drama of salvation, and so her devotion to the baby functioned as a sign of her care for all humanity. Such layered ideas appear in sermons of the time, including those of the renowned preacher Bernardino of Siena, who spoke of the "unthinkable power of the Virgin Mother." This image of Mary nursing shows that power: to create, to nourish, and, ultimately, to make redemption possible.

Nursing also called up other associations in Trecento Italy. In the early fourteenth century, only breast milk was available, and access to a reliable source meant the difference between life and death for an infant. Well-to-do families often employed a wet nurse to fill this function. However, wet-nursing was roundly condemned by preachers, who instead encouraged mothers to nurse their own children. Therefore, Lorenzetti's painting frames the Virgin not only as the mother of God but also as an exemplar of proper maternal behavior, thus expanding the viewer's religious devotion into the arena of social norms.

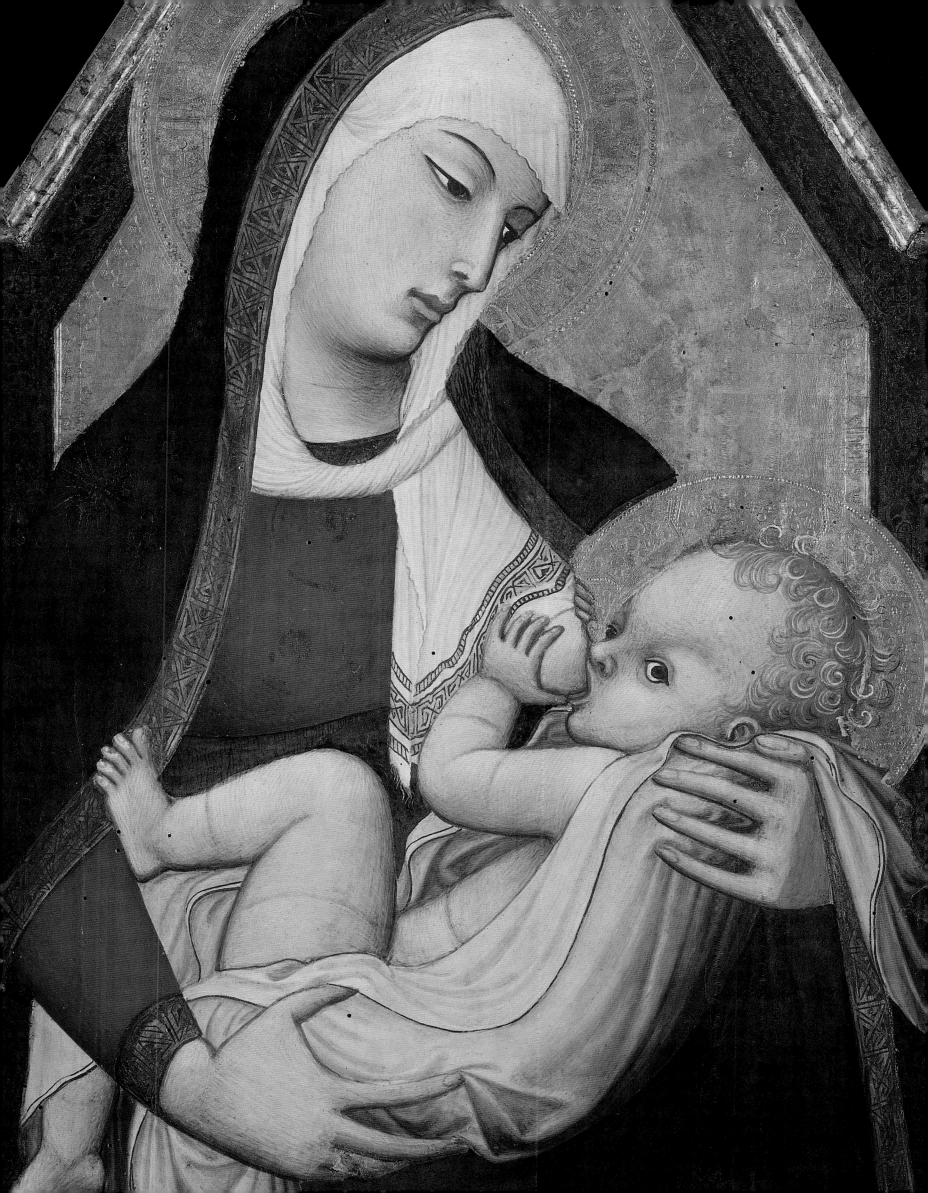

IMAGES OF THE VIRGIN

SINCE 431 C.E., when the Council of Ephesus sanctioned her cult, Mary has been one of the central characters in the history of art. During the Renaissance she became the subject of fresco cycles, public altarpieces, and small domestic scenes made in painting, sculpture, manuscript illuminations, prints, and decorative arts; cathedrals and churches were erected and named in her honor; and individuals as well as entire cities (such as Siena) put themselves under her protection. Since European audiences then were almost entirely Christian, images of the Virgin served not only religious but also social and political purposes. In Siena, for example, representations of the Virgin were used to help authorize the expansion of the city's territory and to justify the ideology of its civic government. Mary was also invoked to guard individuals and communities against the rampant dangers of disease, foreign invasion, and famine.

In the Renaissance, Mary's life and emotional state paralleled Christ's incarnation and Passion. What he suffered physically, she suffered as well, in a bodily sense in some cases or sentimentally in others. Thus, images of the events in her life tracked the larger sequence of Christian history. From the Annunciation (which marked the arrival of God in human form), to her swoon during the Crucifixion (out of sympathy for her dying son), to her death and assumption to heaven (which mimicked Christ's own), the Virgin's life held abiding interest to Christians.

Iconic images of Mary emerged in the Eastern Church during the Byzantine Empire (ca. 306–1453). Expressing different theological concepts, these works established several distinct themes in the Marian visual tradition. In most Byzantine imagery, she was shown standing or in half-length, with the baby Jesus in her arms. Subtle variations in stance, gesture, and interaction conveyed her varied roles in the church: mother, bride, queen of heaven, handmaiden of God, and intercessor for humankind.

Leonardo's devotional images of the Virgin and Child emphasize Mary's maternal role, revising and updating the prevailing iconographic traditions with Renaissance conceptions of human nature. Viewers of his time would have been familiar with the idea of Mary as queen of heaven (used by Carlo Crivelli, for example) showing her as regal, distant, perfect, and emotionally reserved. By contrast, the half-length images of the Virgin that Leonardo produced between about 1495 and 1501 were startlingly original. These paintings merged Christian doctrine with a penetrating attention to the emotional and psychological state of both mother and baby. Few artists could match the compelling appeal of these deeply human figures, rendered with such distinctive naturalism in form and setting. In many ways, Leonardo's Virgins encapsulated the teachings of the Franciscan and Dominican orders, which emphasized a physical, here-and-now religious practice heightened by empathetic emotions. These mendicant orders revolutionized Christian devotion in the early Renaissance, establishing new feasts in Mary's honor, preaching regularly to the population, and commissioning new public imagery of Mary's life in fresco cycles and altarpieces. In all these venues, church teachings emphasizing Mary's humanity took center stage. In Florence and Milan, where a prosperous middle class had both the financial resources to patronize art and the time to appreciate it, Leonardo's images of the newly accessible Virgin found an admiring audience.

Leonardo's major early commissions for the churches of San Donato a Scopeto in Florence *(Adoration of the Magi)* and San Francesco Grande in Milan *(Virgin of the Rocks)* feature the Virgin. Both altarpieces adjusted existing iconography to allow for new forms of devotion, such as the doctrine of the Immaculate Conception (introduced in 1477). Leonardo presented the Virgin Mother as a resolutely physical being, placed in recognizable earthly settings. Though complex humanist, theological, and classical ideas are embedded in each altarpiece, the paintings also assert that Mary was a real person, relatable and emotionally available. Leonardo's success with the *Virgin of the Rocks* attests to his ability to translate church teaching and the patron's needs into a vibrant and visually compelling experience for the viewer.

The interest in Mary as a historical figure led to a concomitant interest in her family, as seen in Leonardo's later paintings showing her with her mother. As the Marian cult expanded in the later fifteenth and sixteenth centuries, new and innovative images provided a wide range of access points for the faithful. As the perfect mother, the obedient spouse, the humble woman, the pure virgin, as one who suffered for others or who acts as the intercessor for all, Mary provided a model for emulation and a locus for devotion to viewers of different genders and at different places in Renaissance society.

Annunciation
(PAGE 26)

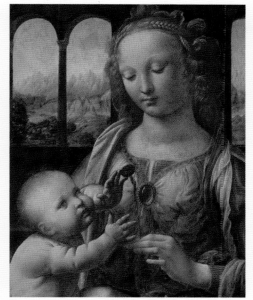

Madonna and Child with a Carnation
(PAGE 60)

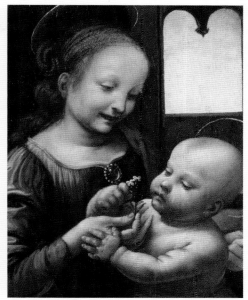

Madonna with a Flower (Benois Madonna)
(PAGE 68)

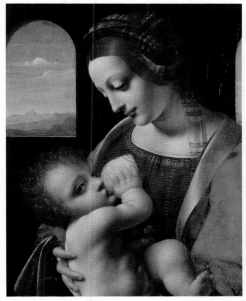

Madonna Litta
(PAGE 78)

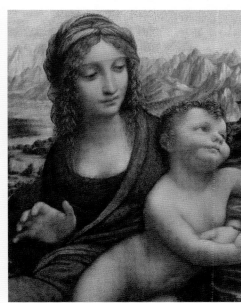

Madonna of the Yarnwinder
(PAGE 88)

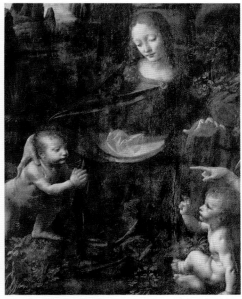

Virgin of the Rocks (PARIS VERSION)
(PAGE 92)

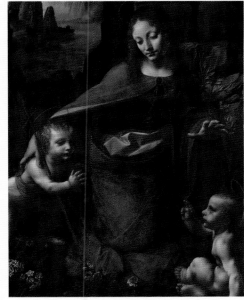

Virgin of the Rocks (LONDON VERSION)
(PAGE 96)

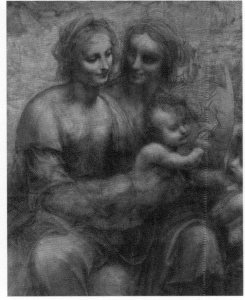

*Virgin and Child with Ss. Anne and John the
Baptist (Burlington House Cartoon)* (PAGE 102)

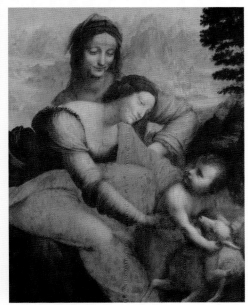

Virgin and Child with St. Anne
(PAGE 106)

LEONARDO DA VINCI (AND WORKSHOP)

(1452–1519)

Madonna of the Yarnwinder

1501

OIL ON POPLAR PANEL
19 ¾ X 14 ½ IN (50.2 X 36.4 CM)
PRIVATE COLLECTION

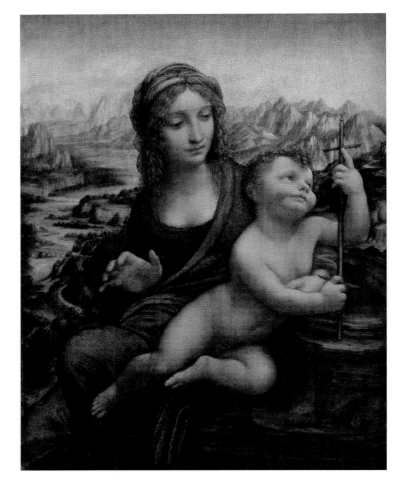

THIS PAINTING exists in two versions, which differ slightly from each other. Both were begun in Leonardo's workshop and likely brought to completion by Leonardo and one of his assistants. One version was made for Florimond Robertet, secretary of state to Louis XII of France. Since the French king controlled Florence as well as Milan and much of the territory in between, this commission was an important one for Leonardo, who was bound to Louis' service for several years after 1500. It is not known for whom the other painting was made or if it was simply a variation of this one. Such repetition was common studio practice in the fifteenth century but was beginning to be frowned upon in critical discussions about artistic originality.

Fra Pietro de Novellara, one of the advisors to the famous Mantuan patron Isabella d'Este, explained in a letter dated April 14, 1501, that this painting had just been begun by Leonardo. He praised many parts of the work: the composition of complex forms, the way the intertwined figures mirrored each other, and in particular how Leonardo imbued those elements with emotionally relevant religious significance. The way the Christ child stretches out his arms and body to grasp the yarnwinder (whose shape symbolizes the Crucifixion) sparked Fra Pietro's admiration. Similarly, he points to the nuanced response of the Virgin: she instinctively restrains her son with one hand, metaphorically protecting him from the Crucifixion to come. Her other hand is raised in an anxious, uncertain gesture—she knows that this is his fate. Fra Pietro admired the contrast between the anxiety conveyed by the mother's pose and the eager grasp of the child, recognizing the religious meanings inherent in the gestures. By imbuing their relationship with this rich psychological and emotional narrative, Leonardo gives the painting greater complexity than that typically found in devotional images.

Expanding on the landscape setting of the earlier *Virgin of the Rocks* and preceding the fantastic backdrop of the *Mona Lisa*, in this work Leonardo added an extensive vista traversing distant hills, valleys, and mountains. Such an environment was unusual for veneration images of the Madonna and Child, who usually appeared within an ecclesiastical or domestic structure. The vast setting may allude to the biblical story of the Rest on the Flight into Egypt, a subject that became increasingly popular in art of the sixteenth and seventeenth centuries.

The crossed bars of the yarnwinder represent a visual symbol of the Crucifixion, while the practice of spinning and winding yarn refers to the Virgin's virtuous domesticity. In fact, infrared reflectograms reveal that originally the work contained the front of a house with figures, sketched in on the left side, underneath the present landscape. The switch from a domestic scene to one of untamed wilderness suggests that Leonardo wanted to emphasize Mary's connection to nature, specifically to the fecundity and power of the natural world. His choice of background sets Christ's life and death within a cosmic cycle, lending an air of inevitability to the narrative. In this context, the action of spinning may have evoked the example from classical mythology of the Fates, who spun threads that represented a person's life. Jesus's eager gesture of reaching toward the yarnwinder suggests his willingness to embrace his own destiny.

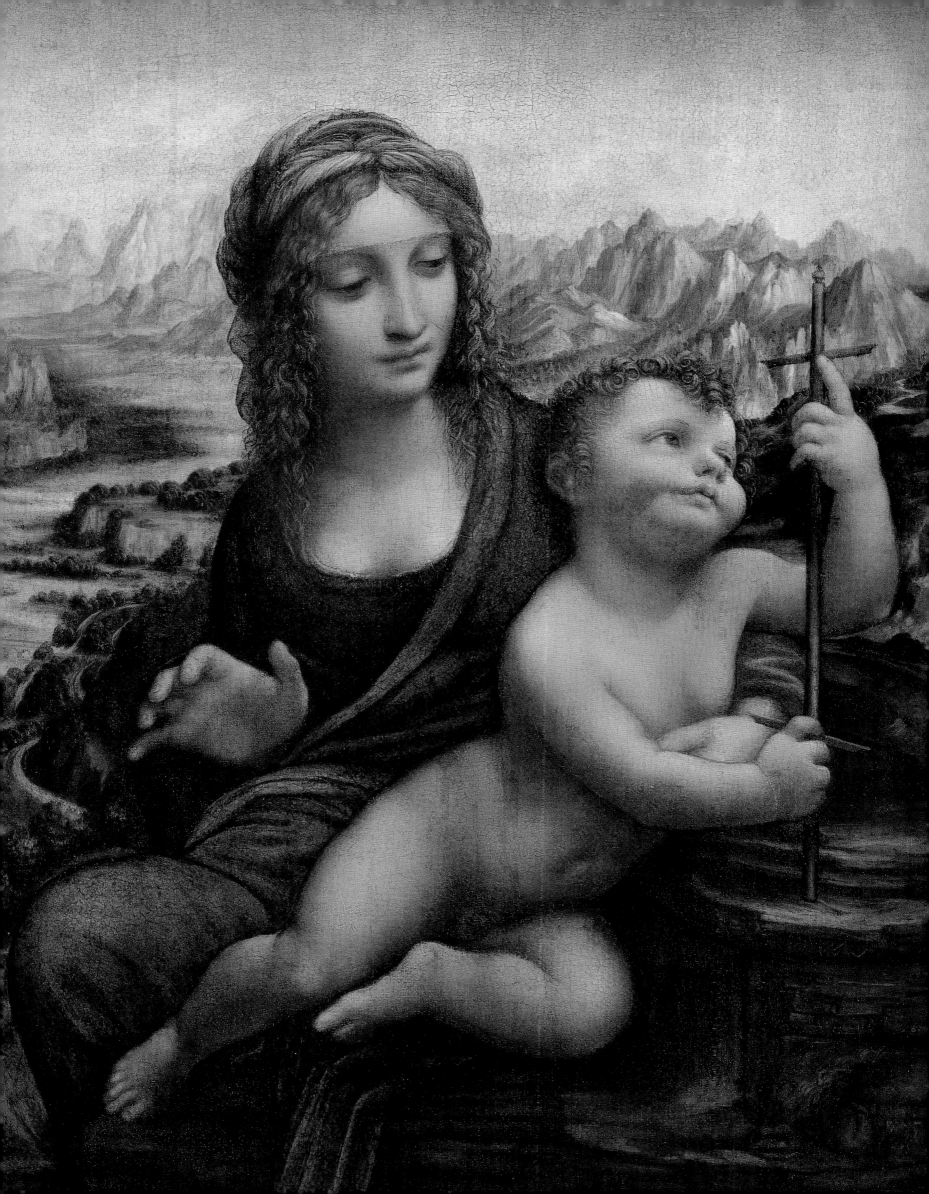

LEONARDO DA VINCI

(1452–1519)

Virgin of the Rocks (Paris version)

1483–86

OIL ON PANEL, TRANSFERRED TO CANVAS
78 X 48 IN (197 X 120 CM)
LOUVRE MUSEUM, PARIS

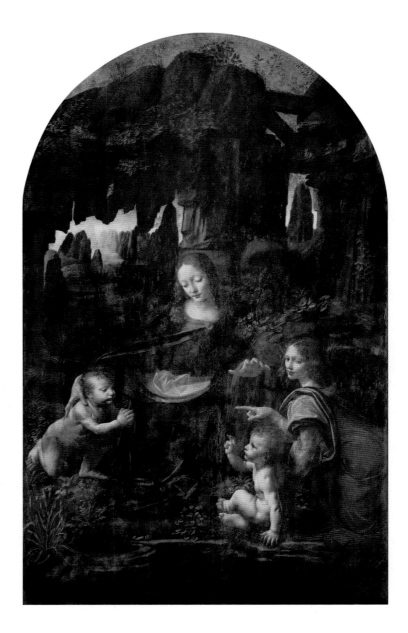

THE *Virgin of the Rocks* was a milestone in Leonardo's career, establishing him as the preeminent painter in Milan. The commission for the painting came from the Confraternity of the Immaculate Conception, a secular Franciscan group with a special devotion to the relatively new idea that the Virgin had been born free of original sin. The contract was signed on April 25, 1483, and specified that Leonardo's panel would be part of a larger polyptych for the church of San Francesco Grande in Milan; in addition, his colleagues Ambrogio and Evangelista de Predis were contracted to produce two side panels showing music-making angels (today in the National Gallery, London). An elaborate gilded frame had already been constructed for the altarpiece, and evidence suggests that Leonardo's panel could be lifted to reveal a three-dimensional holy image built into a niche behind.

A long-standing mystery has surrounded the relationship between this painting and another version of the same subject now in the National Gallery, London. Legal documents dating between 1491 and 1506 reveal that Leonardo and his colleagues never delivered the original commission to the Confraternity. The dispute began when the painters asked for more money; the panel was so beautifully painted, they argued, that an art collector was willing to pay 400 lire for it, well more than the contract price. It is possible that Leonardo sold the painting to this collector (both Ludovico Sforza and King Louis XII of France have been suggested) and then, with the help of Ambrogio, painted another version for the Confraternity, completing that work by 1508 (the aforementioned National Gallery, London version).

This image of the Virgin and her son departs radically from custom in its details, combination of figures, and setting. There are no halos, and the angel has no wings, omissions that suggest Leonardo intended to convey the divinity of his figures through other means. Mary kneels on the ground, gesturing protectively toward the Christ Child, the toddler on the right who is supported by an elegant angel. On the other side she clasps a young John the Baptist, who kneels in adoration of Jesus. Her embracing and reaching gestures gather John and Jesus together, emphasizing their parallel roles in biblical history. As her hand is suspended over her son's head, the angel's pointing motion, paired with Jesus's gesture of blessing, returns the attention to John. The group becomes a sacred family, their mutual awareness and care affirmed by both look and posture.

The desert where John and Jesus met is visualized by Leonardo as a misty grotto lost amid an untamed wilderness filled with jagged rock formations and verdant plant life. The rocks reflect geological forms known in the Alps, composed of a mix of sandstone and diabase, and the vegetation is native to this kind of wet habitat. The plants, shown with both seasonal and physical accuracy, include St. John's wort, jasmine, and acanthus, which connote martyrdom, resurrection, and victory. The *hortus conclusis*, or enclosed garden, of medieval Marian imagery is replaced by a moist rocky alcove—protected yet wildly fecund, a secret space with a timeless permanence. The new doctrine affirming Mary's own immaculate conception (sanctioned by the Church in 1477) may underscore Leonardo's creation of this pristine environment: the misty atmosphere and lush plants seem to suggest this is a place of fertility, a fount of all life touched only by sacred figures.

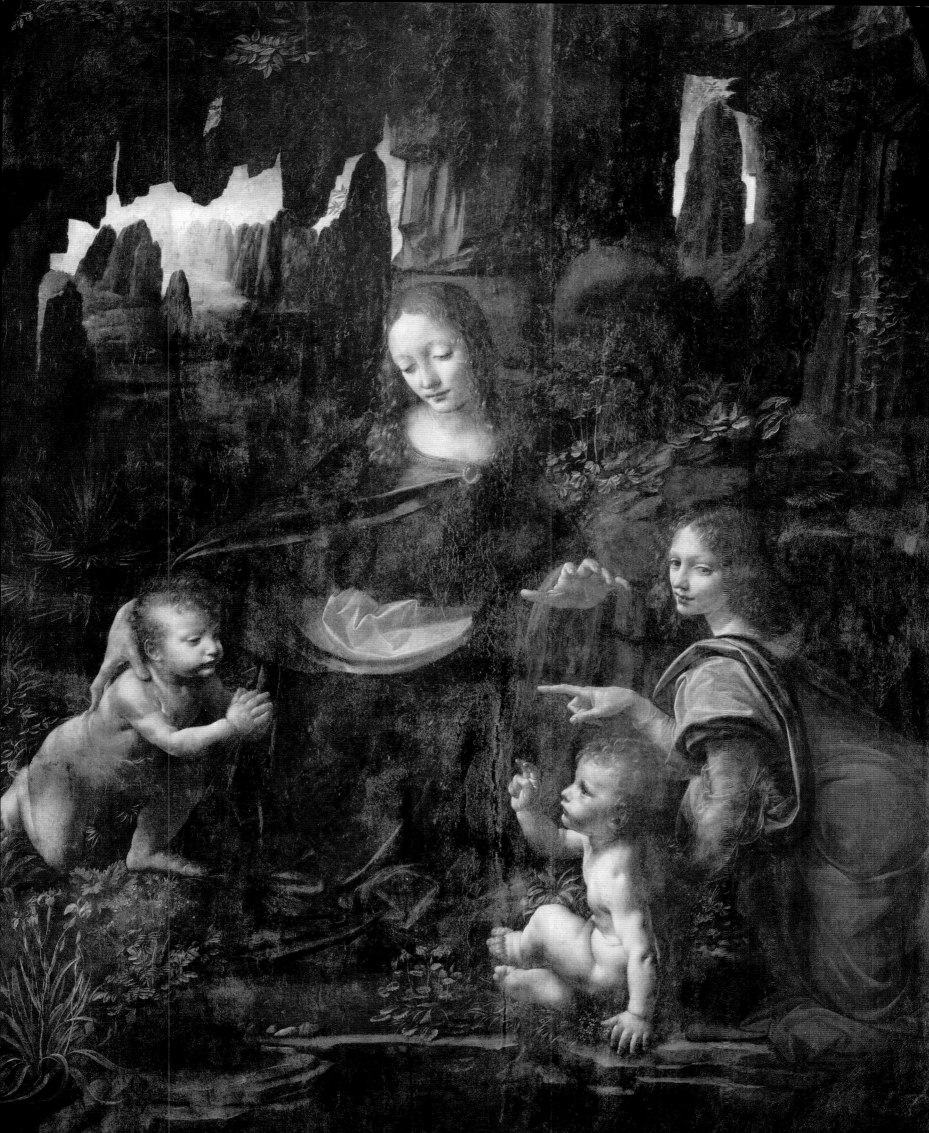

LEONARDO DA VINCI (AND WORKSHOP?)
(1452–1519)

Virgin of the Rocks (London version)

1491–1508

OIL ON PANEL
74 ½ X 47 ¼ IN (189.5 X 120 CM)
NATIONAL GALLERY, LONDON

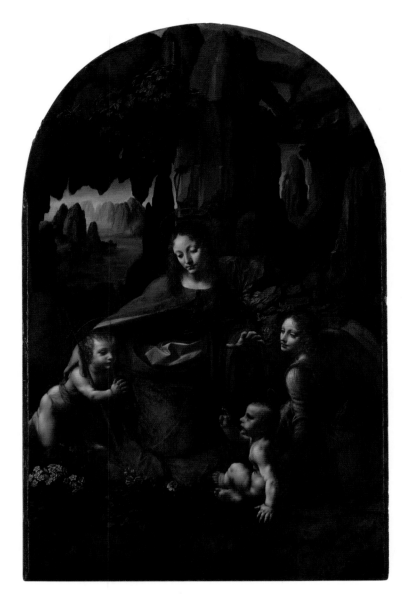

THIS PAINTING is Leonardo's second version of the *Virgin of the Rocks*. The earlier version, today in the Louvre, was never delivered to the original patrons. Instead, Leonardo appears to have created this work, which in 1781 was still in its intended site, serving as an altarpiece in the church of San Francesco Grande in Milan, along with two side panels of angels painted by another hand (probably Ambrogio de Predis). The legal wrangling between Leonardo and the patrons appears to have been resolved with this altarpiece. A 1506 settlement between the two parties describes the work as "unfinished," and in 1508 the completed painting was delivered. Since Leonardo had left Milan in 1499, others probably put the finishing touches on the panel (primarily the lower right corner and the figure of the angel, as well as the simplified landscape in the background), and therefore the exact amount of Leonardo's authorship remains debated. But the presence of Leonardo's fingerprints, visible in the topmost glazes on the flesh tones (as in the Virgin's face) suggests that he not only designed the image but also participated substantially in its execution.

This painting shows Leonardo's style at a moment in his later career. The tonality is crisper, the figures are more monumental and set back farther from the viewer, and their identities and roles have been clarified. Mary and the children now have haloes, and John the Baptist's traditional attribute, the reed cross, rests inside his arm (although these may be later additions). Most noticeably, the angel's pointing gesture has been eliminated. All these small manipulations focus the viewer on the Christ Child, rather than on John, and clarify the mother/son relationship between Mary and Jesus. The cleft rocks and enclosing grotto remain, but their message of sanctity and virginity are now more clearly connected to Mary in her role as mother, and thus to the new doctrine of the Immaculate Conception. Whether the changes were made because of problems with the iconography of the Louvre version or because Leonardo was able to use this second version to reconsider and improve the composition remains unknown.

At first glance, the landscape in this version appears to have been simplified dramatically, and much of the background *sfumato* seems to be lacking. Yet the London version has been recently cleaned, whereas the Louvre version is covered with layers of yellowed varnishes added by later hands. The aura of the varnishes enhances the effects that Leonardo espoused, but the cleaned pictures suggest how much the accretion of grime affects the clarity of the scene. Not all the plants are identifiable in this painting, but two (a narcissus and a pincushion flower) are prominently placed in the left foreground. Though not ecologically correct, these plants, with their associations to Satan and martyrdom, nuance the theme of birth and motherhood through the suggestion of death. Similarly, in this painting the rock formations are less geologically specific, but the sense of the grotto as a secret space carved from the earth is heightened. The earlier painting may be considered more revolutionary, as some scholars suggest, but this later version communicates its message more clearly, thanks to fewer obscure and mysterious elements. It certainly met the needs of its patrons, who kept it in the original chapel for more than 250 years.

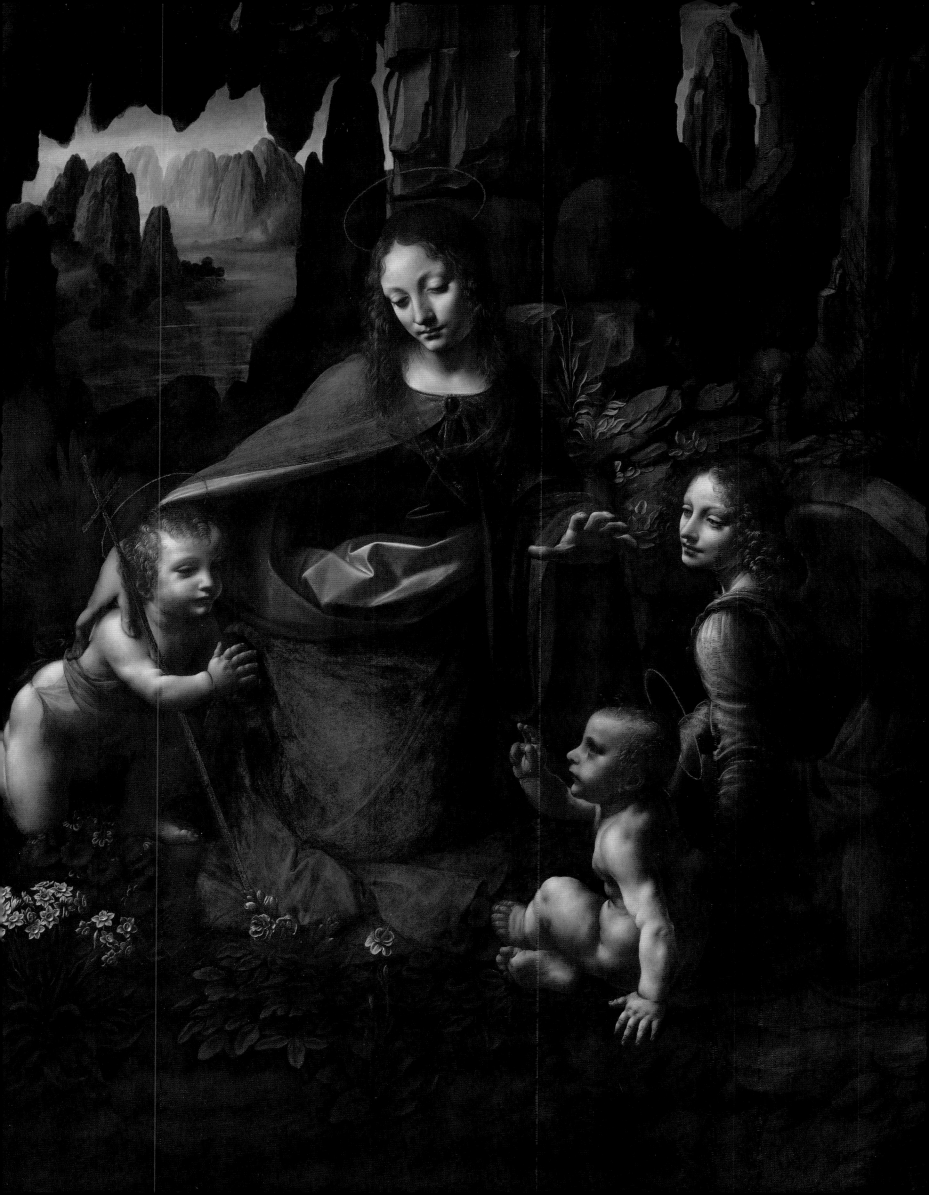

(LEFT)

LEONARDO DA VINCI
(1452–1519)

Virgin of the Rocks
(Paris version)
1483–86

(RIGHT)

LEONARDO DA VINCI
(1452–1519)
(AND WORKSHOP?)

Virgin of the Rocks
(London version)
1491–1508

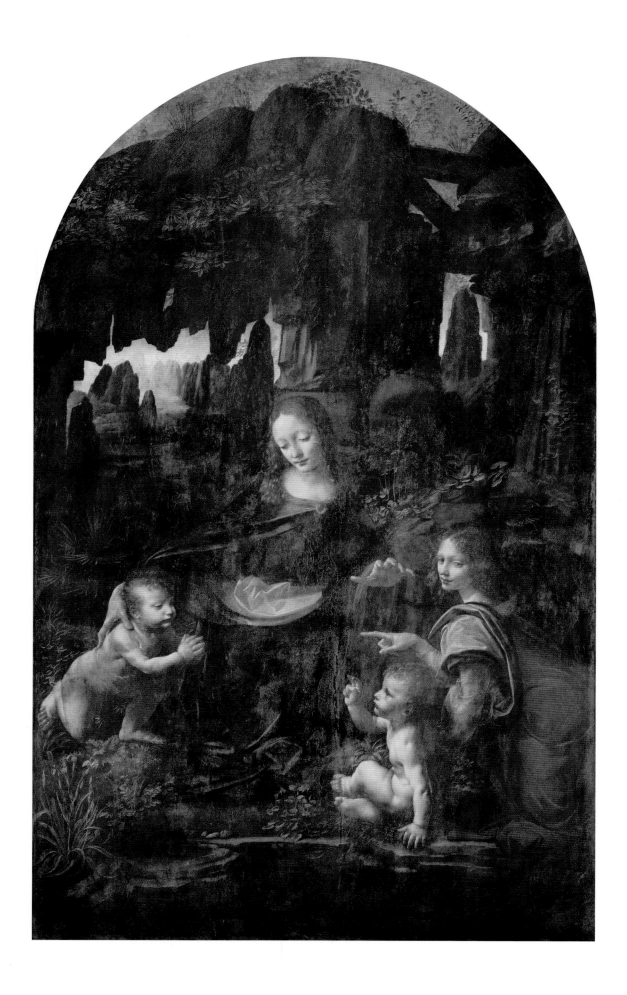

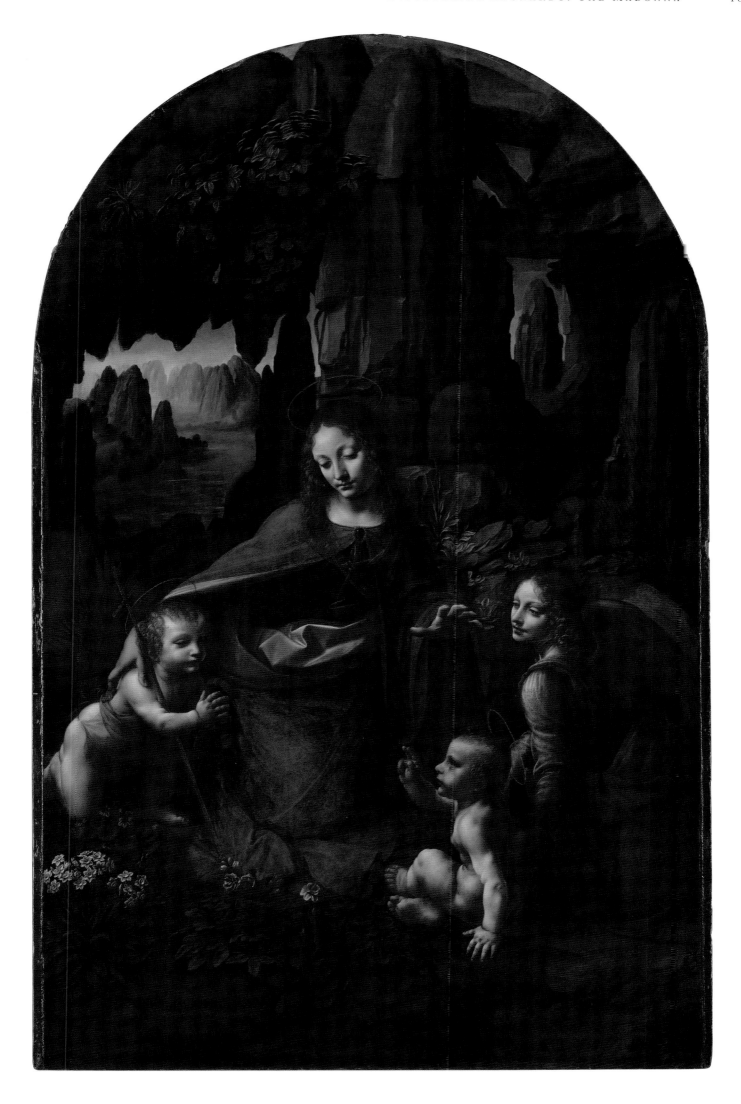

LEONARDO DA VINCI
(1452–1519)

Virgin and Child with Ss. Anne and John the Baptist (Burlington House cartoon)
CA. 1499–1500

CHARCOAL WITH CHALK ON PAPER, MOUNTED ON CANVAS
55 ½ X 42 IN (141.5 X 106.5 CM)
NATIONAL GALLERY, LONDON

THIS DRAWING—known as the Burlington House cartoon, after a prior owner—may have been commissioned directly by King Louis XII of France as a gift for his new wife, Anne de Bretagne, or sent to the king as either a gift or a proposal or solicitation for a painting commission. The drawing depicts the baby Jesus with his mother Mary, his cousin John, and his grandmother Anne. St. Anne was the patron saint of the French region of Brittany and often invoked by mothers. She would have been a particularly appropriate subject for Anne de Bretagne, whose first four children all died young.

A cartoon is a full-scale preparatory drawing for a painting or other manufactured work, such as a tapestry. This cartoon has not been incised or punctured and was never used to transfer the design to another support (a canvas or panel). Thus, the drawing represents Leonardo's plan for a painting that he never undertook. It is a good example of his intense process of experimentation and revision, for parts of the drawing are unfinished or show the artist changing his mind, whereas others are highly polished. According to accounts, in 1501 one of Leonardo's cartoons was displayed publicly in Florence, where it caused a sensation among the population, who flocked to see it. Although this cartoon is not the one described in the episode, it is probably the first in a series of images showing Mary with her mother and son that Leonardo worked on from 1499 to about 1516.

The cartoon is highly finished in some areas, such as the faces of Mary and Anne, and barely outlined in others, as in the background. Rather than working out the details of the setting, Leonardo appears most interested in developing the chiaroscuro to give the figures three-dimensional volume. He also focused on a new type of composition, departing from his normal stable pyramidal structure. Mary, perched on the right side of Anne's lap, twists and holds the body of Jesus, who reaches across the composition to bless a young John the Baptist on the right. The figures rotate around the central axis of Anne's body and thrust out into space in a variety of directions, giving the painting a remarkable sense of energy.

This is a family scene: a grandmother, mother, son, and cousin in an intimate moment of play. A copy by Leonardo's student Bernardino Luini shows the same composition with St. Joseph at the right; Leonardo chose instead to put women at the center of his painting. As the matriarch of this family, Anne is both literally and pictorially the axis on which they all depend. Although she is not mentioned in the New Testament, according to apocryphal literature Anne's bloodline derived from the house of David. She is often emphasized as a crucial member of Jesus's earthly kinship. Anne's finger pointing upward reminds the viewer of the role of the divine in Jesus's story. Tender affection is conveyed through gesture and gaze exchanged between the figures. The baby Jesus reaches out to caress John's chin while blessing his cousin with his right hand; the double gesture reiterates that this is no ordinary squirming infant, but a manifestation of the divine in human form.

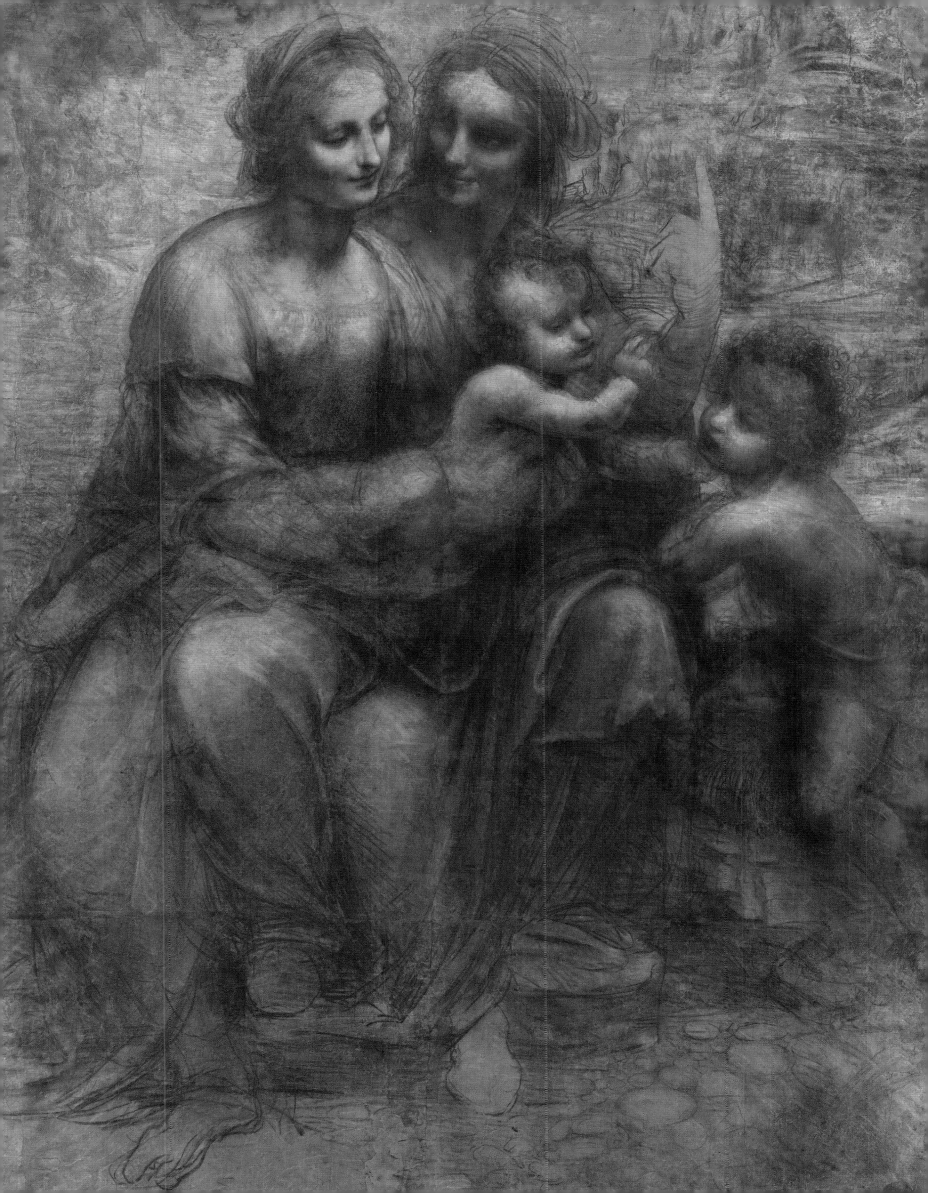

LEONARDO DA VINCI
(1452–1519)

Virgin and Child with St. Anne
CA. 1510–13

OIL ON WOOD
63 ¼ X 51 IN (168.5 X 130 CM)
LOUVRE MUSEUM, PARIS

A VISITOR saw this painting in Leonardo's workshop in Cloux, France, in 1517; Leonardo probably worked on it in Milan and Florence between 1510 and 1513 and then evidently took it with him in 1516 when he left for France, where he died in 1519. It remained largely unfinished and today is in poor condition. Though neither the patron nor the original location for this work is known, the composition was highly influential throughout both Tuscany and Lombardy.

The *Virgin and Child with St. Anne* represents Leonardo's active engagement with classical statuary. The style of drapery, and the way the folds convey the volume of the form underneath, may be variations on Hellenistic images of the Muses that had recently been excavated at the site of the Roman emperor Hadrian's villa in Tivoli. Leonardo's return to Florence in the early 1500s and his visit to Rome between 1513 and 1516 may have reinforced his interests in intertwined masses of figures; in Rome, younger artists such as Michelangelo and Raphael were also concerned with similar complex figural groupings. In addition, Leonardo may have used his long-standing technique of drawing from sculpted clay models to develop these difficult poses.

Ever experimenting, Leonardo here refines the composition of his earlier Burlington House cartoon: Mary, now fully supported by Anne, is seated over both of her mother's legs rather than resting on one. Like the segments of a chain, all the figures are interlocking and interrelated. Thus the image of an adult daughter sitting on her mother's lap registers not as incongruous but as an easy, harmonious, and graceful moment and serves as a striking visual metaphor for progeny. The genetic relationship between the women is obvious. They appear to be virtual copies of each other, with their natural age difference erased. In this way, Leonardo suggests that Anne and Mary are of the same body—the House of David, the bloodline of kings. This heritage literally supports the baby Jesus as he straddles a lamb, symbol of sacrifice.

Though Leonardo presents his holy figures with a high degree of naturalism, they are set in a world apart from the viewer. A pool of water and a sharp cliff at the front of the painting separate the women from the viewer's space, and an unusually sharp break divides the foreground embankment from the background expanse. The lightly brushed mountainous countryside represents a magical place well beyond our reach. It is one of Leonardo's most extensive, and most admired, landscapes. Though the entire image is suffused with a luminous light, the misty quality of the background scenery contrasts with the barren earth on which the figures rest.

These opposed but reconciled elements (light/dark, verdant/barren, vertical/horizontal, still/moving) have parallels in late medieval and Renaissance devotional poetry about the Virgin Mary. Such poetic elements encouraged viewers to contemplate Mary's virtues as well as her role as the bridge between the human and the divine. On another level, the painting resolves difficulty in effortless fashion and presents a compelling view of the natural world. These accomplishments highlight the artist's exceptional skill and showcase his boundless imagination. Such overt display of virtuoso artistic and intellectual ability, combined with creative genius, was highly admired in art at the time.

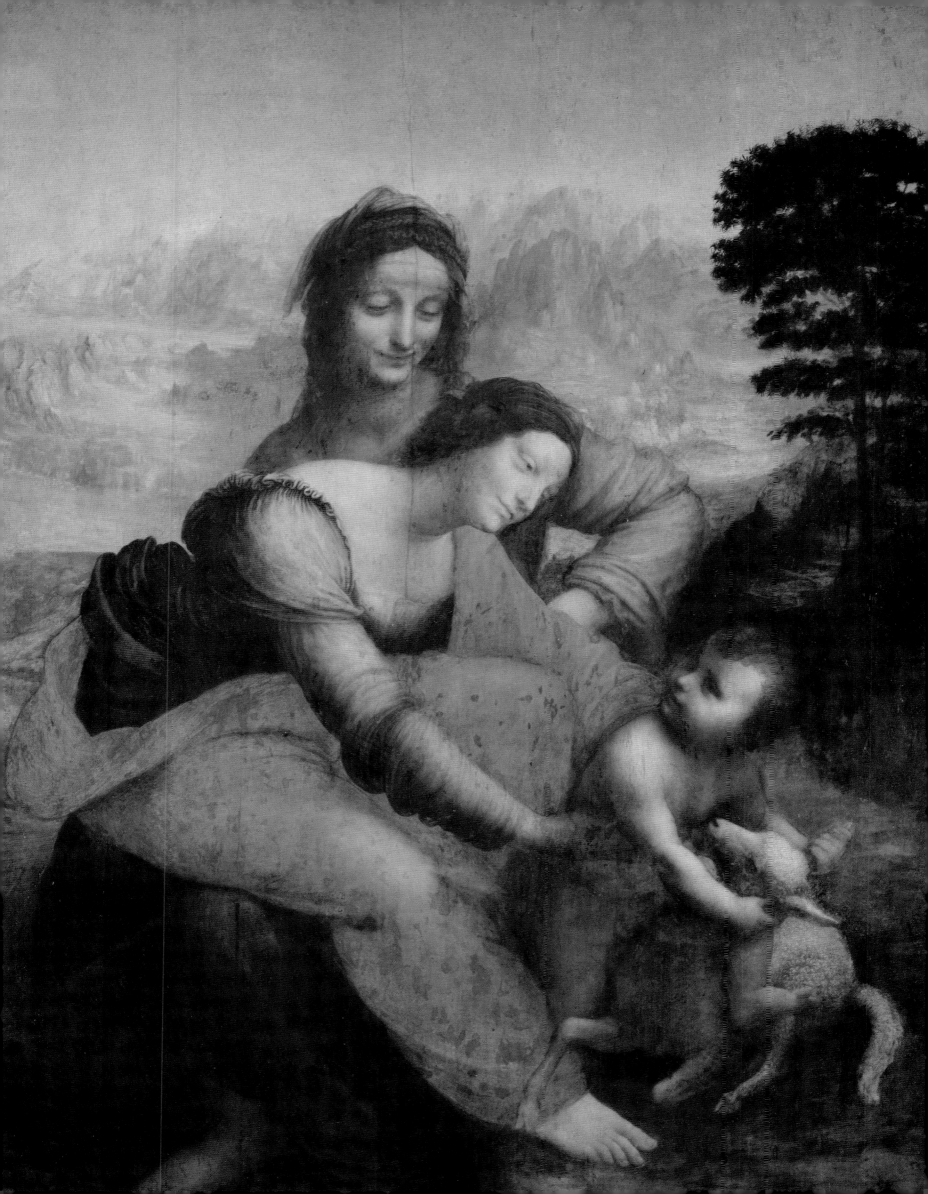

LEONARDO DA VINCI
(1452–1519)

St. Jerome

CA. 1480–82

OIL AND TEMPERA ON WALNUT PANEL
40 ½ X 29 IN (102.8 X 73.5 CM)
VATICAN MUSEUMS, ROME

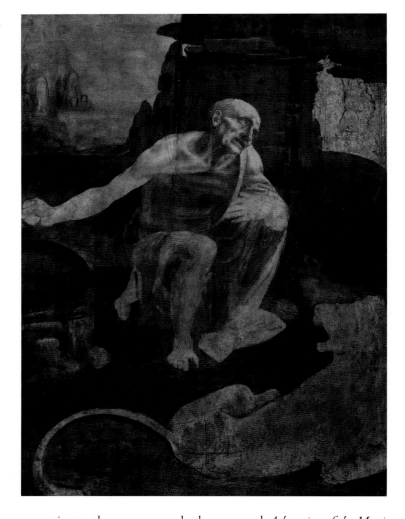

ST. JEROME, the fourth-century Doctor of the Church, wrote about his four-year penance in the desolate desert of Chalcis, beyond Antioch. He described his companions as scorpions and wild beasts, his home as a recess among the caves and precipices, his limbs roughed by sackcloth, and his skin so scorched that he might have been mistaken for an Ethiopian. In this work, Leonardo has presented us with a gaunt, ascetic old man, demonstrating his early interest in the aged human form and his supreme understanding of exterior anatomy, even at the dawn of his career.

Like the *Adoration of the Magi*, this painting was left by Leonardo at an early state of completion. In fact, the terms of the contract for the *Adoration*, which demanded that he work exclusively on that painting, may have caused him to halt work on this one; he never recovered it once he left Florence about 1482/83. The most developed portions are the head and the right leg of the saint as well as various elements of the landscape; other areas remain barely sketched. The painting seems to have been conceived directly on the panel, since it bears no signs of a drawing transfer. Certainly, Leonardo would have prepared numerous sketches of his figure study, but to begin a fairly large panel without a fully worked-out plan was an audacious undertaking for a young artist. The crucifix on the far right edge of the scene is scored into the ground layer, with the body of Christ painted quickly over it, along with the church and other distant details. The application of marks on the panel is vigorous and free, as Leonardo used smudges and smears in the landscape and then emphasized the forms of the mountains with thick strokes of darker pigment. Radiography reveals that a palm tree was once included in the background.

Leonardo's 1495 inventory in Milan lists "certain figures of Saint Jerome," so this subject clearly intrigued him. We cannot be certain that any of those works relate directly to this project, although there exist several sculptural heads from the workshop of Verrocchio that appear to be the same model. One of these may even have been sculpted by Leonardo himself.

Although this painting cannot be traced directly to a patron or any early owner before the nineteenth century, two paintings of St. Jerome were mentioned in the 1525 inventory of Leonardo's pupil and heir, Salai. The attribution of this painting to Leonardo has never been questioned, for it is so close in its materials and execution to the more securely documented *Adoration of the Magi*. The connection between the rock formations in the background and those seen in the later *Virgin of the Rocks* has led some scholars to suggest that Leonardo carried the *St. Jerome* with him to Milan and continued to work on it there. Although one might suppose he would have brought it to a more finished state were that the case, there was a taste developing by the sixteenth century, and possibly earlier, for such incomplete works. They were highly valued by connoisseurs, especially in the wake of Michelangelo's unfinished sculpture and an emphasis on the process that reveals a *non-finito*, or "unfinished," look. Indeed, already in antiquity Pliny had praised those works left in progress by artists at their deaths, because in them the mind of the artist was revealed.

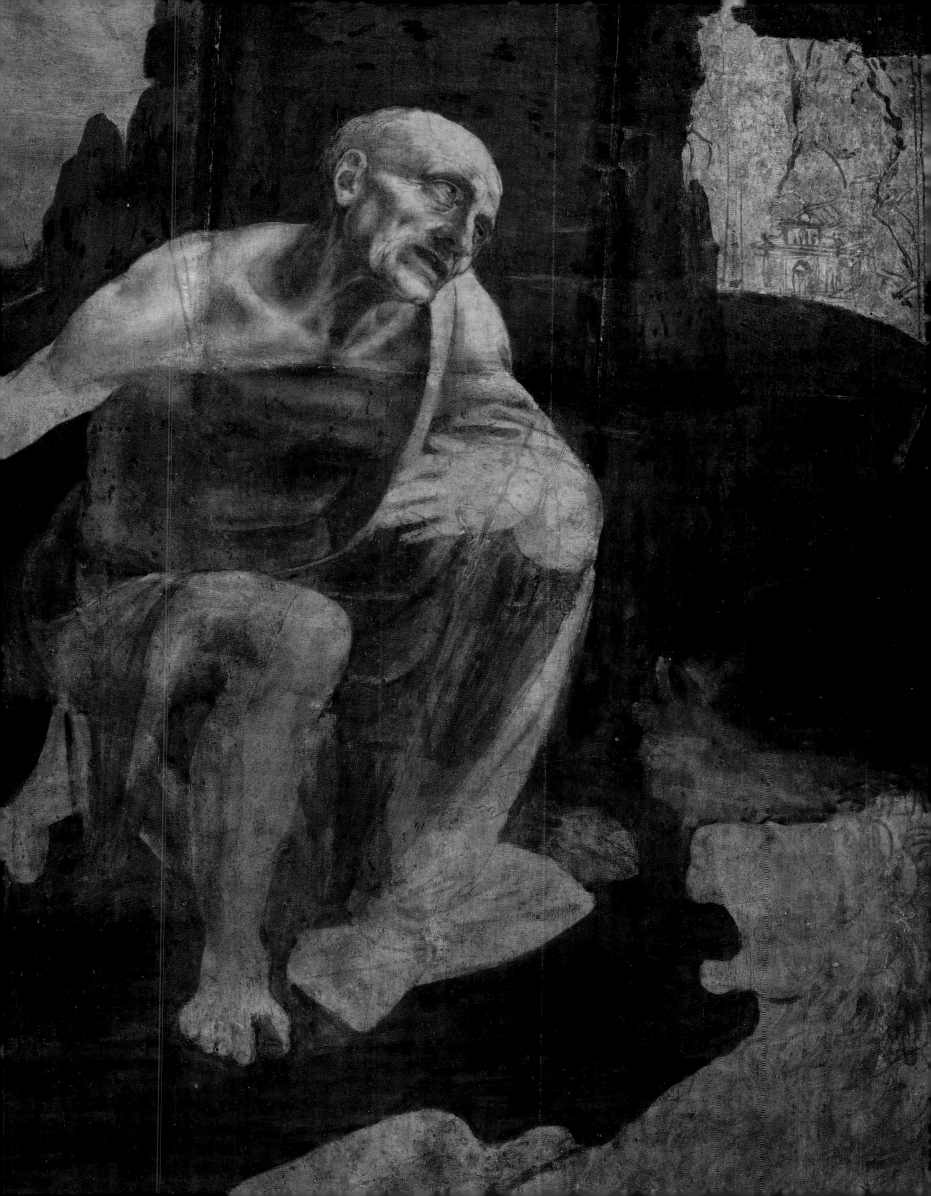

LEONARDO DA VINCI
(1452–1519)

St. Jerome, detail
CA. 1480–82

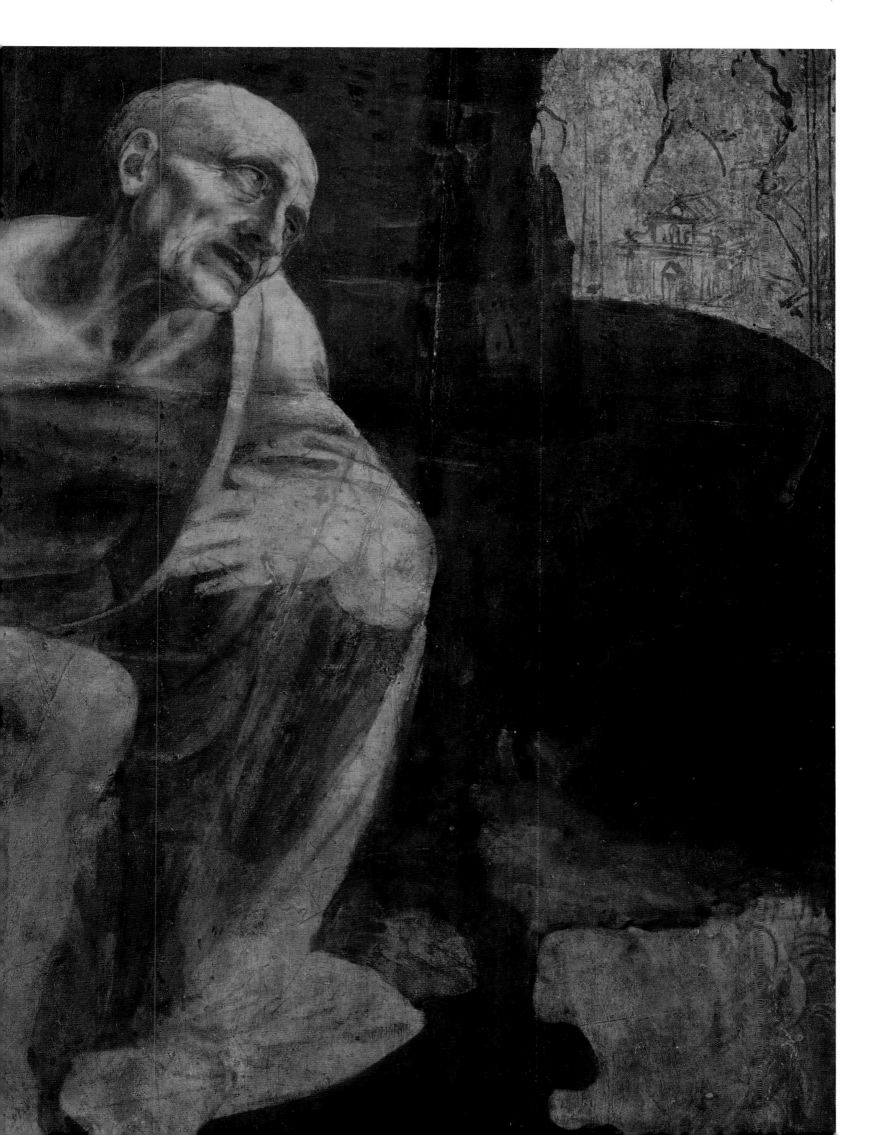

SANO DI PIETRO

(1405–1481)

St. Jerome in the Wilderness

1444

TEMPERA ON PANEL
9 X 14 IN (23 X 36 CM)
LOUVRE MUSEUM, PARIS

FAR FROM a household name today, Sano di Pietro was nonetheless copiously documented as an artist in the middle decades of the fifteenth century in the commune of Siena, the principal economic and cultural rival to Florence, in the region of Tuscany. He was a follower of the equally charming and more famous painter known as Sassetta and was probably aware of the latest developments in Florence by Fra Angelico and Paolo Uccello. Sano's depiction of St. Jerome, made in 1444, offers an opportunity to compare Leonardo's painting of the same subject, left unfinished almost forty years later, against a norm. Italian painting of the Quattrocento shows a generational trend that progresses steadily toward greater anatomical, spatial, and textural accuracy; the prodigious talent of the young Leonardo marks the culmination of this progression.

Sano's painting *St. Jerome in the Wilderness* is a predella panel (one of the smaller scenes below the main part of an altarpiece) that was once part of his masterpiece, the *Virgin and Child with Saints Adored by the Blessed Giovanni Colombini*. It was made for a monastery of the Jesuati. Not to be confused with the Jesuits, whose order was founded in the 1500s, the Jesuati order was founded in 1360 by Colombini (about 1300–1367) in Siena. Colombini forms an odd presence in the main altarpiece, for he was beatified but not yet a saint and was not the painting's donor (customarily shown adoring the main figures). This period of isolation and penitence in Jerome's life became a key subject for the Jesuati, who professed vows of poverty and administered a daily flagellation. They did not promote monastic separation from society, however, and were prominent locally as preachers and servants in hospitals.

The main altarpiece remains in Siena, but the predella panels depicting the life of Saint Jerome are today in Paris. In addition to the penitent Jerome, there are four other paintings. The narrative told in these panels focuses on the story of Jerome and the lion; according to the Golden Legend, Jerome pulled a thorn from the paw of a lion, which then became his devoted friend and accomplice. Other scenes show visionary experiences. Jerome had visions, which encouraged him to practice self-mortification in order to rid himself of human desires. By beating himself with a rock, living a hermit's life, and devoting himself to divine study, he conquered his sensual urges, fiery nature, and intellectual pride.

As the fifteenth century progressed, the two most common representations of Jerome came to be his penitence in the wilderness and the scene of him alone in his study translating the Vulgate, the Latin version of the Bible. Leonardo was commissioned to represent the wilderness theme, and he picked up on currents already set in motion by artists like Sano. The serious countenance of a weather-worn and wizened older man is evident in both paintings, and although the degree of anatomical knowledge on display by Sano is minimal, there is at least a semblance of skeletal structure in the bared chest where the saint beats himself with the rock. Although Leonardo's advancements are certainly stunning against this tradition, Sano's work embodies a quality that must be recognized: a charming simplicity in the wondrous landscape, a sympathetic piety, and a soothing pastel color scheme that validates one's faith.

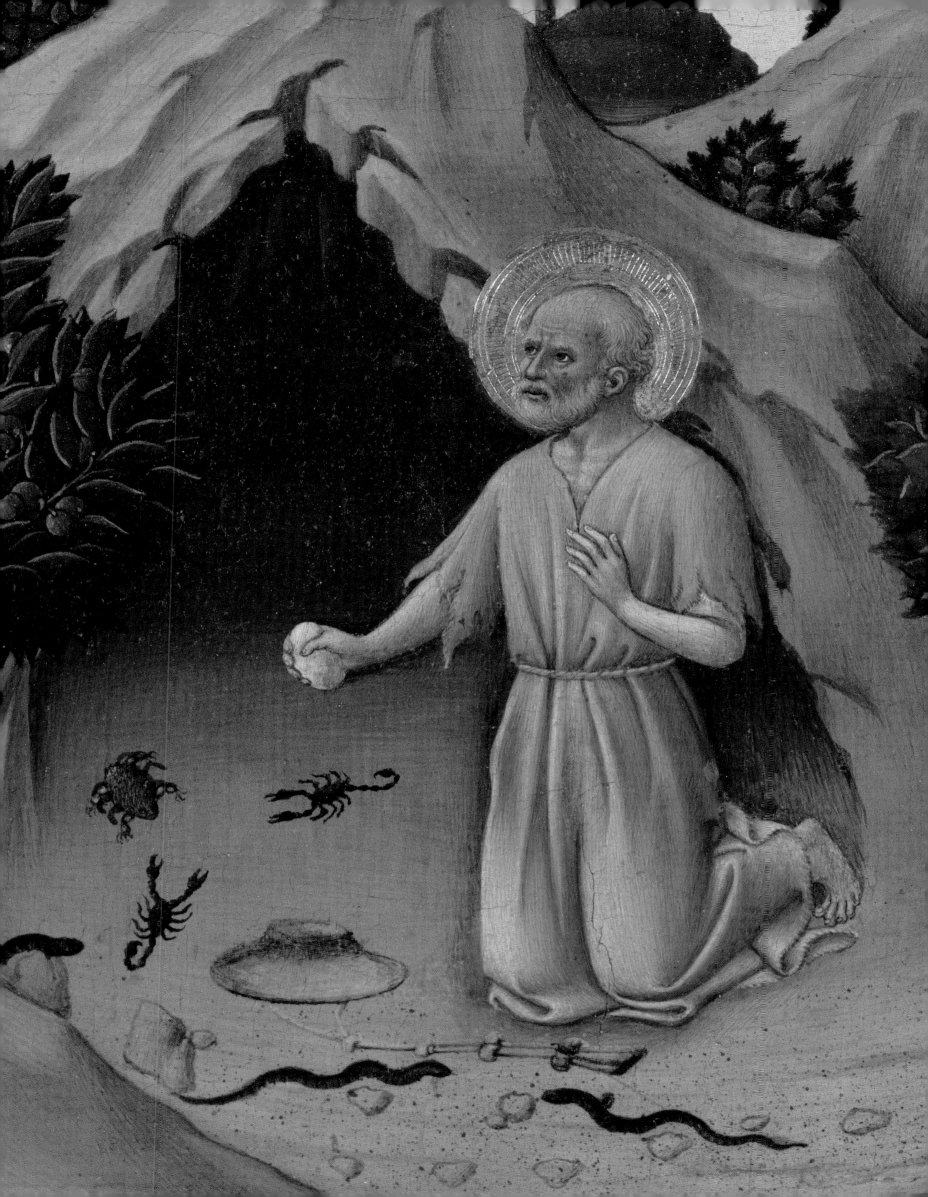

ANDREA DEL CASTAGNO

(1417/19–1457)

The Last Supper

1447

TEMPERA ON PLASTER
15 FT 1 IN X 31 FT 10 IN (4.53 X 9.75 M)
REFECTORY, SANT' APOLLONIA, FLORENCE

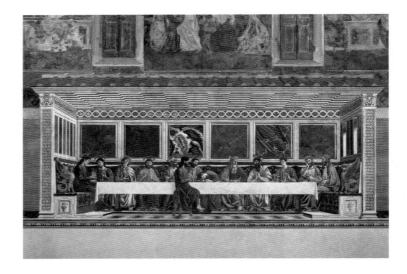

THE LAST SUPPER was a popular subject in Renaissance painting. In the fifteenth century it was sometimes the main subject of altarpieces, though more commonly in Northern Europe than in Italy, where it was usually relegated to a predella panel, one of the smaller paintings, often oriented horizontally, that were situated below the main scene of an altarpiece. In this context, the central theological theme was the transubstantiation of the bread and wine into the body and blood of Christ, the primary event of the Last Supper that is reenacted in every Mass. The other location where representations of the Last Supper were often found was the refectory of monasteries and convents, where the subject was a natural choice for the halls in which the priests, monks, or nuns took their meals. In these places, the main theme was communal, the dedication of the community of the apostles to Christ, and the betrayal of one of their own, Judas. To isolate and highlight his duplicity, Judas was usually situated on the opposite side of the table from the other apostles. Andrea del Castagno has followed that custom here.

The refectory-based Last Supper scenes by Castagno, Leonardo, and Veronese illustrated in the following pages offered these painters the opportunity to work on a large scale and to incorporate multiple figures into a spacious setting. The difficulty with the subject was to avoid boredom, since the narrative contains no innate action. Castagno struggled with this problem, and his figures remain stiff and lifeless. By contrast, Leonardo spectacularly solved the dilemma by having the apostles respond individually and collectively to Christ's announcement that one of them would betray him. Veronese resorted to including myriad subsidiary and extraneous figures.

Although Castagno's figures remain somewhat constrained by strong outlines and harsh lighting, his work was nonetheless groundbreaking in its time. He was one of the first to use the system of one-point linear perspective in this subject to clearly articulate the space of the room around the table. Given its placement on the wall of the convent of Sant' Apollonia in

Florence, with the viewer's eye level just higher than the feet of the apostles, Castagno has given us a room that appears to project sharply into and out of the wall. In fact, he has subtly manipulated the perspective by deviating from a single vanishing point. Perhaps he did so because the systems developed by Filippo Brunelleschi and Leon Battista Alberti in the preceding decades depended on a viewer looking from a fixed location, whereas this refectory was an expansive space with viewers seated all around. Leonardo was more rigorous in his perspectival treatment in his painting for Santa Maria delle Grazie, even though the room was about the same size. The fictive architecture features slabs of stunningly colored granite patterns. Overall, the surrounding—a one-story structure with a simple Tuscan tile roof—is reminiscent of the designs of Alberti, a contemporary architect and theorist.

The coarse features of many of Castagno's figures gave rise to a legend that he was a crude and even violent-tempered man. Vasari relates a tale that Castagno killed fellow artist Domenico Veneziano in a duel, a story disproved by archival evidence demonstrating that in fact Veneziano (about 1410–1461) outlived Castagno.

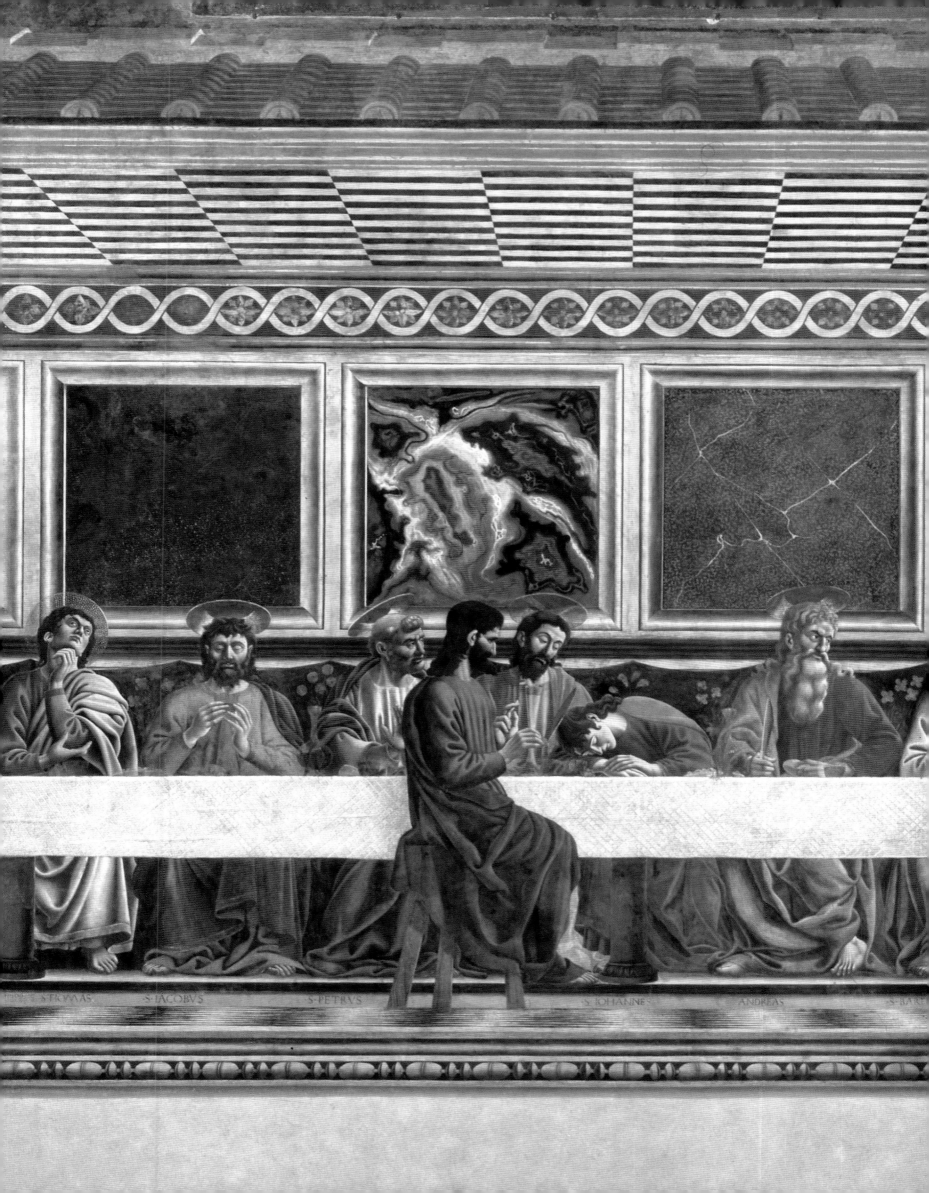

LEONARDO DA VINCI
(1452–1519)

The Last Supper
CA. 1495–97

TEMPERA AND OIL ON PLASTER
15 FT 1 IN X 28 FT 10 ½ IN (4.6 X 8.8 M)
REFECTORY, SANTA MARIA DELLE GRAZIE, MILAN

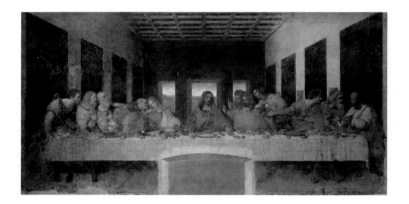

THE *Last Supper* was considered Leonardo's most famous work in his own day, despite that it was already deteriorating by 1517, two years before the artist's death. The technique that he employed to create the work is not true *(buon)* fresco, in which water-based pigment is painted directly into wet plaster and the two bond together as they dry. Rather, he applied egg tempera on top of a chalk ground bound with glue and a small amount of oil. At an early stage moisture crept between the layers, causing a rapid deterioration. Leonardo made a rough compositional sketch using a thin reddish color, similar to a *sinopia* design used for fresco. There is no evidence of *spolvero*, or the transfer of a drawn design by pouncing. He also scored basic perspective lines into the surface, although these do not always correspond to the ones in the finished scene. Nothing more can be done through conservation efforts to mitigate the mottled effects of the surface. During the latest restoration, several sections became more visible, including details of the wall hangings, the views to monastic cells on the sides, and several objects on the table. Moreover, restorers found a nail hole in Christ's forehead that was used to pinpoint the perspectival illusion.

The *Last Supper* was probably commissioned not by the Dominican monks of Santa Maria delle Grazie but rather by Ludovico Sforza, as evidenced by the arms of the ducal family that appear in the lunettes above the painting. On the opposite wall of the refectory, Giovanni Donato da Montorfano painted a crucifixion, signed and dated 1495, that includes donor portraits of Ludovico, his wife, Beatrice d'Este, and their children.

The *Last Supper* was mentioned as early as 1497 in Luca Pacioli's *De divina proportione*. Pacioli, a mathematician, was interested mainly in the work's perspective but also noted that the narrative focuses on the moment at which Christ pronounced, "One of you shall betray me" (Matthew 26:21). The earliest engraved reproductions also refer to this biblical verse. Many scholars have stressed that the primary concern of the painting must have been the introduction of the Eucharist, emphasized by the placement of Christ's hands pointing to the bread and the wine, but that is not necessarily the case. The majority of fifteenth-century representations of the Last Supper emphasize the Eucharistic elements far more than Leonardo has here. That fact reveals no personal inclination on the part of the artist but is simply a matter of function: because the painting was not an altarpiece, the Eucharistic elements were secondary in importance; indeed, in the mixed context of ducal patronage and monastic living, the narrative elements of betrayal and loyalty may have been paramount. The most innovative aspect of Leonardo's composition is not the perspective but rather the collective movements and individual emotional responses of the apostles to Christ's words. His followers reel backward in clusters of wavelike movements, reminiscent of Leonardo's later studies of deluges. In turn, each response differs from the other.

The apostles are identified on the basis of inscriptions on a contemporary painted copy now in Ponte Capriasca (Lugano). They are, from left to right: Bartholomew, James the Younger, Andrew, Judas, Peter, John, Thomas, James the Elder, Philip, Matthew, Thaddeus, and Simon the Zealot.

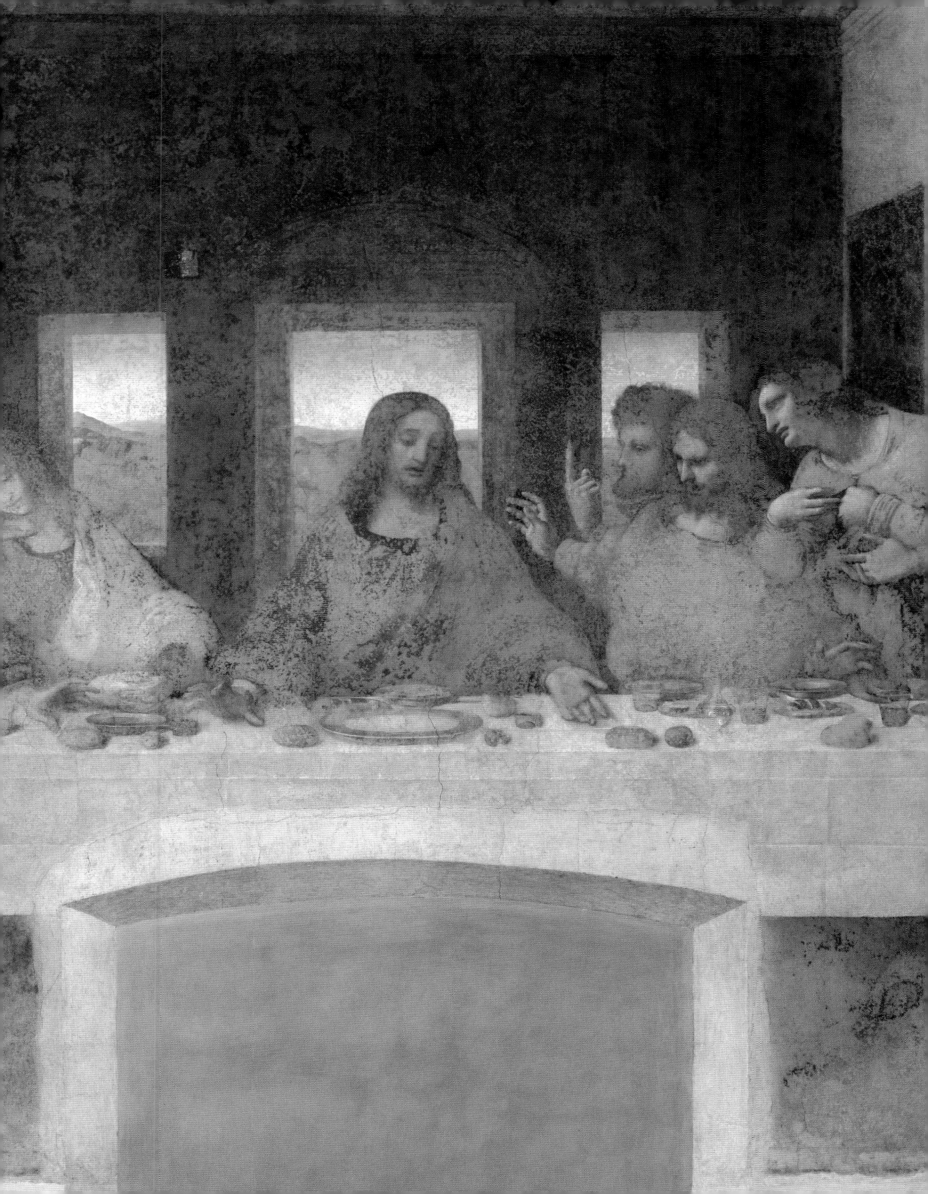

LEONARDO DA VINCI
(1452–1519)

The Last Supper
CA. 1495–97

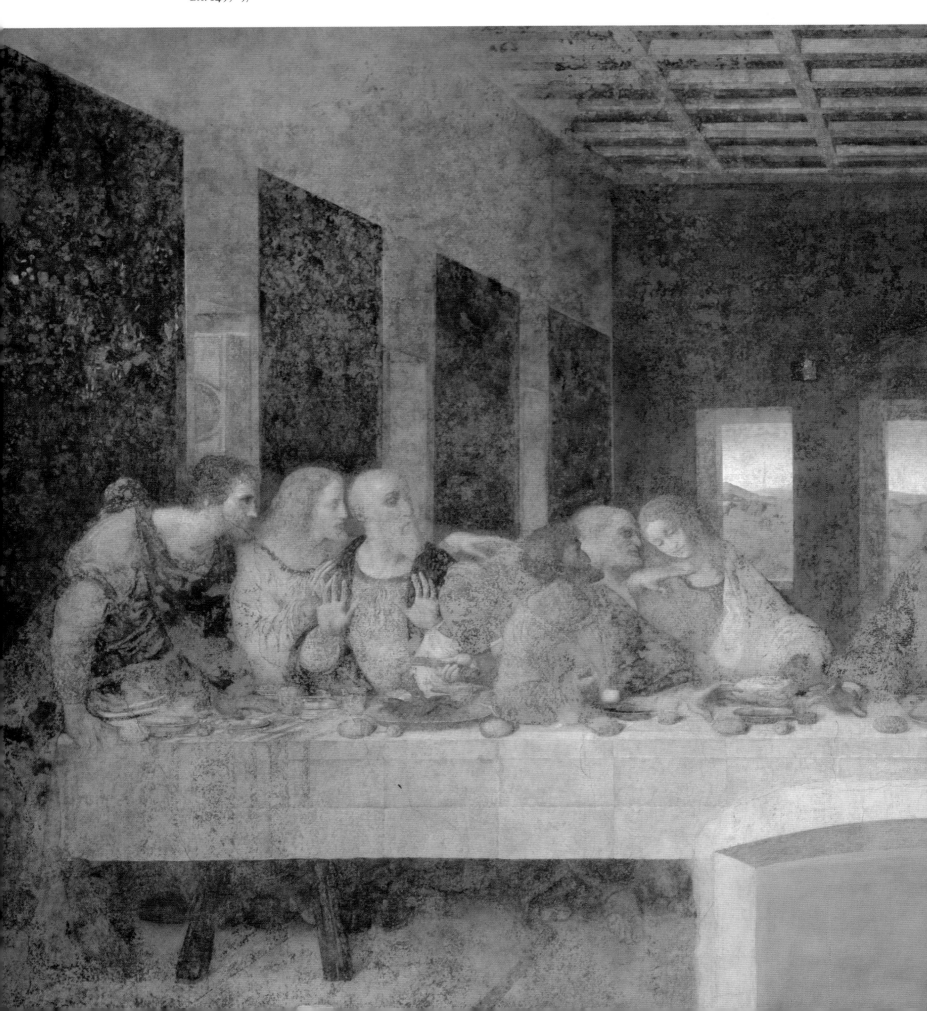

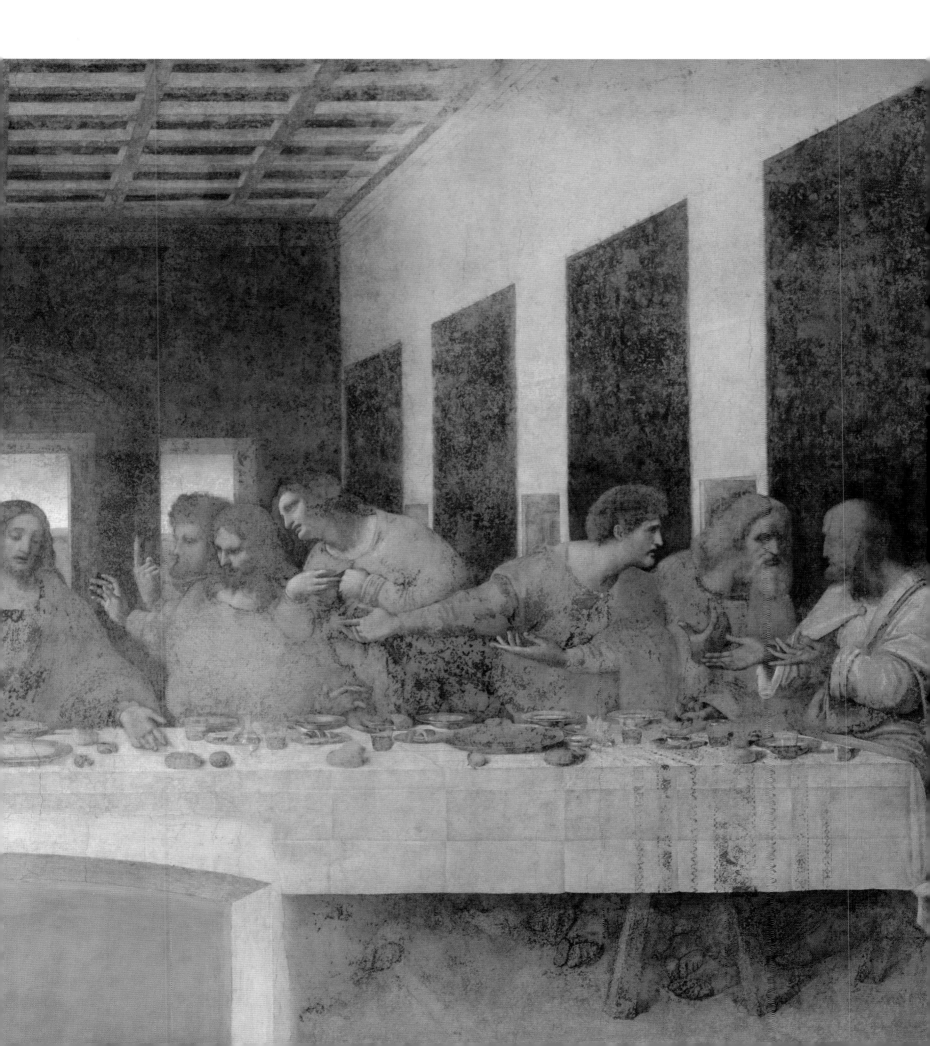

PAOLO CALIARI, CALLED VERONESE
(1528–1588)

Feast in the House of Levi

1573

OIL ON CANVAS
18 FT 2 IN X 42 FT (5.55 X 1.28 M)
ACCADEMIA GALLERY, VENICE

THE instantaneous success of Leonardo's *Last Supper* was not lost on succeeding generations. In order to surpass the balanced space and dramatic unity of Leonardo's treatment of the subject, later artists turned to more dynamic compositions, lighting effects, and outlandish extraneous characters. But by the third quarter of the sixteenth century, the religious climate had changed radically, and, with the onset of the Counter-Reformation (the Catholic response to the Protestant Reformation), appreciation for this kind of artistic license came to a devastating halt. On July 18, 1573, Paolo Veronese was called before the Holy Tribunal of the Inquisition to account for improprieties in his enormous forty-two-foot-long painting installed just a few months earlier in the refectory of the convent of SS. Giovanni e Paolo in Venice. He had been commissioned to paint a Last Supper.

Given a vast expanse to fill, Veronese incorporated into the scene many other figures besides Christ and his disciples, and he was called upon to enumerate them. Veronese recalled placing Simon, the owner of the inn, in front of the right center column; he wears a striped shirt and is attended by an African in red clothing and hat. Before the left center column is a steward, dressed in black and green, who, the painter imagined, "had come there for his own pleasure to see how things were going at the table." The tribunal took great offense at these trivialities. Additional figures include a man whose nose is bleeding, seen descending the stairs to the left; German mercenaries with halberds, found in the right foreground; and, on the left, a man dressed as a buffoon with a bird on his wrist. These were deemed to be ornament by the artist, but the Holy Officers felt that the inclusion of jesters and German soldiers, whom they equated with Protestants, was inappropriate for this subject. Moreover, they charged that even the primary figures were treated less than reverentially. St. Peter, left of Christ, is depicted carving the lamb

in order to pass it to the other end of the table. Theologically, the sacrificial lamb had a place in the narrative, but Veronese made it seem like a mundane routine, showing other apostles simply waiting to receive their plates—one even picks his teeth. Veronese had moved far from the grave concern of the apostles and the singular moment depicted by Leonardo.

The Inquisitors questioned Veronese's discretion and judiciousness. The painter recoiled by claiming that others had preceded him in taking such license, mentioning Michelangelo's nudes in the Sistine Chapel, painted in different poses with little reverence. The Inquisitors rejected the comparison, claiming that "in painting the Last Judgment in which no garments or similar things are presumed, it was not necessary to paint garments, and that in those figures there is nothing that is not spiritual. There are neither buffoons, dogs, weapons, or similar absurdities."

Veronese escaped imprisonment, meekly admitting that he had not considered all these concerns and had not intended to confuse anyone. He was obliged by the tribunal to make appropriate changes to the painting within three months, at his own expense. He did not, instead mollifying his critics by changing the title from the *Last Supper* to *Feast in the House of Levi*, named for the tax collector who followed Christ as the disciple Matthew.

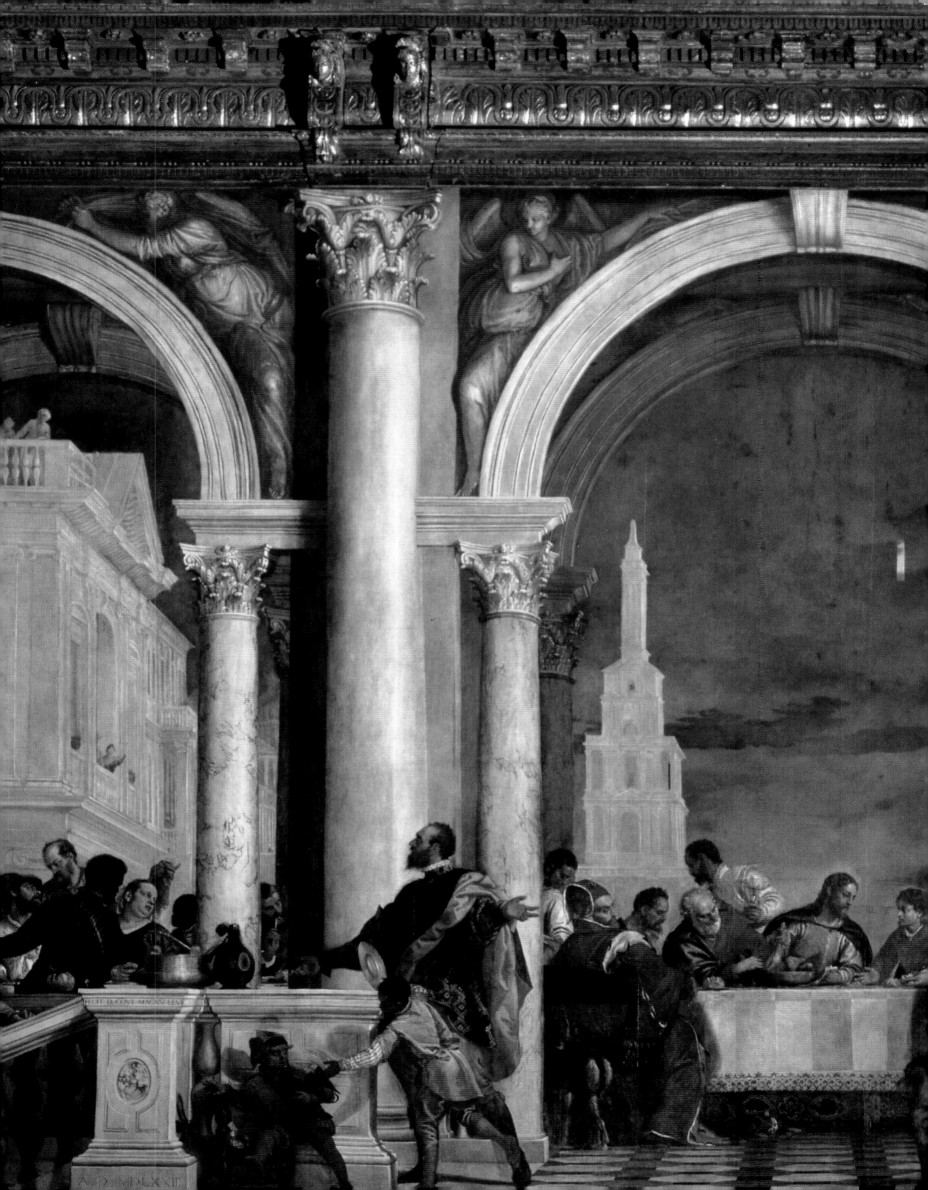

LEONARDO DA VINCI
(1452–1519)

St. John the Baptist
CA. 1513–16 (?)

OIL ON WALNUT PANEL
27 X 22 ½ IN (69 X 57 CM)
LOUVRE MUSEUM, PARIS

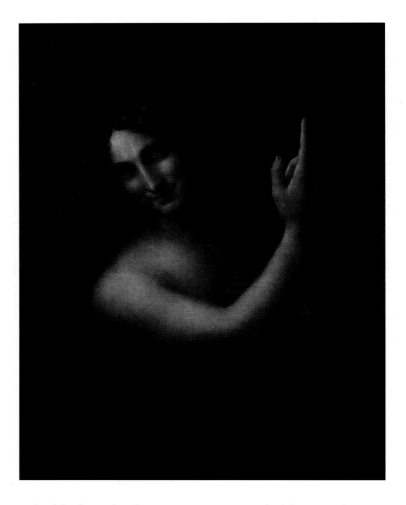

WHILE THE smile of the *Mona Lisa* has engendered praise and speculation over the centuries, the visage of *John the Baptist*, a late painting by Leonardo, is arguably the odder and more unexpected foray among all the facial expressions in his oeuvre. The smile seems archaic—not generically out of date, but specifically related to the type of smile seen on the standing *kouroi* figures in early Greek art (referred to in modern times as the Archaic period). Though it is unlikely Leonardo knew any original Greek art of that era, it is possible he had seen later Roman revivals of this sort or, possibly, even early original Etruscan art that reflected contemporary Greek traditions. Such Etruscan works became known to Florentines in the fifteenth century and were sought after as affirmations of Tuscan heritage that ran parallel to, and in some senses intersected with, ancient Roman culture. The typical look is an artificially arcing smile accompanied by a straightforward gaze. Leonardo has accomplished that effect here and yet tempered it with a naturalism conferred mainly by the soft lighting, smooth skin, and overall puckish familiarity of this figure.

Set against an austere and dark background, the figure of John the Baptist moves forcefully into the viewer's own space, foreshadowing the baroque pictorial developments of the seventeenth century, particularly the pioneering illusionistic naturalism of Caravaggio. Leonardo's *sfumato* effects were clearly a precursor to Caravaggio's later *chiaroscuro*, or stark contrasts of light and shadow; in most of his work, however, Leonardo concentrated on subtle gradations of light rather than sharp juxtapositions. Yet, in his last years, there is a movement toward setting figures in greater relief, which he accomplished by darkening the backgrounds. One also sees such smoothly polished surfaces, porcelain-like skin, and dark negative spaces around the same time—the 1510s—in the late work of Raphael, but it is difficult to ascertain who was influenced by whom at that point, or whether their objectives in figural and spatial style were simply in sync as Leonardo witnessed the ascendance of the much younger painter in Florence and Rome after the dawn of the new century.

The illusionistic effects are enhanced even further by the tangibility of certain aspects, such as the finely curled locks of hair that frame John's face and cascade over his shoulders. Leonardo's interest in idealized beauty certainly did not wane in his old age;

indeed, he formulated an ever-more insistent link between divinity and human bodily perfection. The half-length format was also beneficial to the illusion. Though not a new formula, it would be adopted over and over again by generations of artists who wished their images to have a "speaking" sense; presented right in front of the viewer, such representations, as many poetic clichés of the period pointed out, needed only air to breathe for them to come alive. These half-length, single-subject paintings of saints and holy personages were the new equivalent to earlier Byzantine icons— close enough to formulate a personal relationship. But rather than the way in which iconic figures were separated from the earthly realm by the glitter of gold and their eternally frozen stances, these newly natural, humanized saints were tangible, present, alive to the touch and to human experience.

This composition was widely copied in Italy after Leonardo's lifetime, and he may have carried the original with him to France at the end of his life.

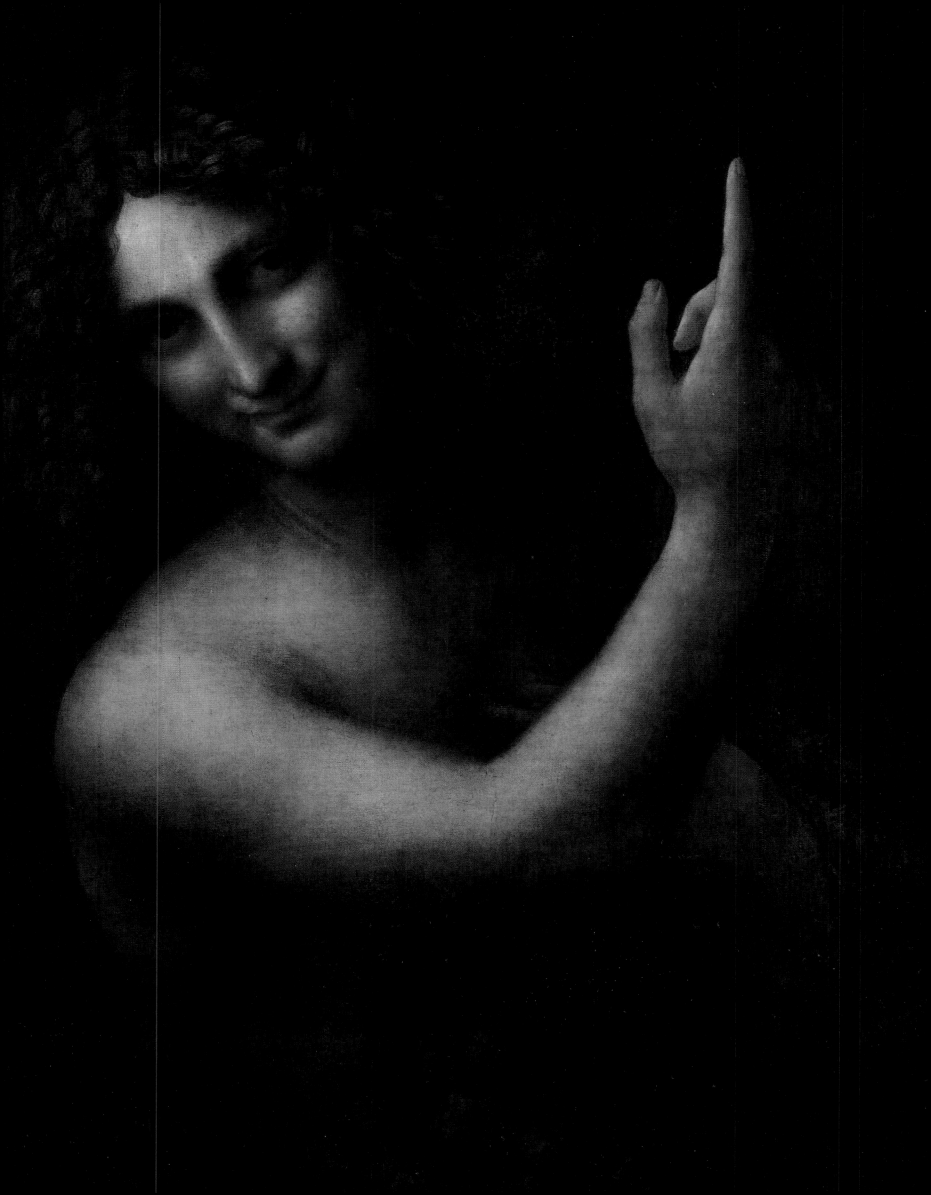

WORKSHOP OF LEONARDO DA VINCI
(1452–1519)

St. John the Baptist (with Attributes of Bacchus)

CA. 1510–19, WITH LATER ADDITIONS

TEMPERA AND OIL ON PANEL, TRANSFERRED TO CANVAS
69 X 44 ⅞ IN (177 X 115 CM)
LOUVRE MUSEUM, PARIS

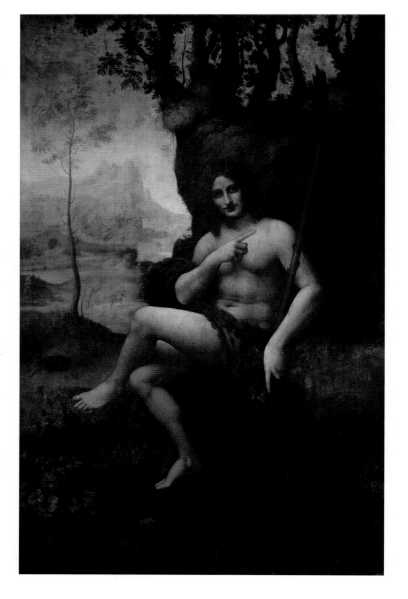

LEONARDO kept for himself, and took with him to France at the end of his life, a number of paintings begun earlier in his career. At some point in 1515, perhaps in Bologna or Milan, he encountered the young king François I and impressed him with a mechanical lion that walked forward several paces before opening its chest to reveal a fleur-de-lis, symbol of the French crown. According to the sculptor Benvenuto Cellini, the king once remarked, "He did not believe that a man had ever been born who knew as much as Leonardo, not only in the spheres of painting, sculpture, and architecture, but also in that of philosophy." Leonardo's last three years were comfortable financially; he was met by an appreciative court audience and allowed free reign to explore his natural investigations, even though his health began to decline. Antonio de Beatis, secretary to Cardinal Luigi of Aragon, visited Leonardo in France and recorded in his diary that the old master, then turned seventy years old, painted little because of paralysis in his right hand. The secretary noted among the artist's possessions a painting of a young St. John—perhaps this work but more likely the previous entry, both of which remained in France through the centuries, along with a portrait of a certain Florentine lady (that is, the *Mona Lisa*) and the *Madonna and Child Seated on the Lap of St. Anne*. Antonio also remarked that even when Leonardo could not paint, he made drawings and instructed his very capable Milanese assistant (probably Francesco Melzi). This painting may be a product of Leonardo's close instruction to his pupil.

Parts of the painting seem to have been added later, and that has presented some confusion about the subject. While not quite so androgynous as the other late painting of St. John the Baptist (see the previous entry), this one is no less beguiling in his masklike visage, oddly crossed legs, oppositely pointing hands, and surprisingly lush surroundings. The seventeenth-century antiquarian Cassiano dal Pozzo saw this painting at Fontainebleau in 1625 and decried that it lacked devotion, decorum, and similitude. Perhaps the lack of clearly spiritual qualities led a later seventeenth-century painter to amend the figure with the crowning wreath of grape leaves and a leopard-skin kilt, transforming it into a Bacchus, the god of wine and revelry, for which the general characteristics would not have been inappropriate. The Baptist's cross-topped staff was also changed into a thick thyrsus wrapped with grapevines, a sacred instrument of Bacchus at his fetes.

Why would Leonardo have sought so sensuous a form in his late images of St. John? The prophet's association with the wilderness and the purity of baptism may have had something to do with the artist's quest to portray an idealized youthful form. For Leonardo, natural human beauty, unadorned by clothing or jewelry, set amid an unspoiled landscape may well have bespoke an ideal, even reverent, formulation for this holy man. Other artists, too, especially in Florence but throughout Italy, sought idealized and youthful representations of the Baptist, including an image by Raphael (today in the Uffizi Gallery) that was clearly inspired by Leonardo's representation and culminating in the 1590s with several overtly sexual images of a teenage John the Baptist by Caravaggio.

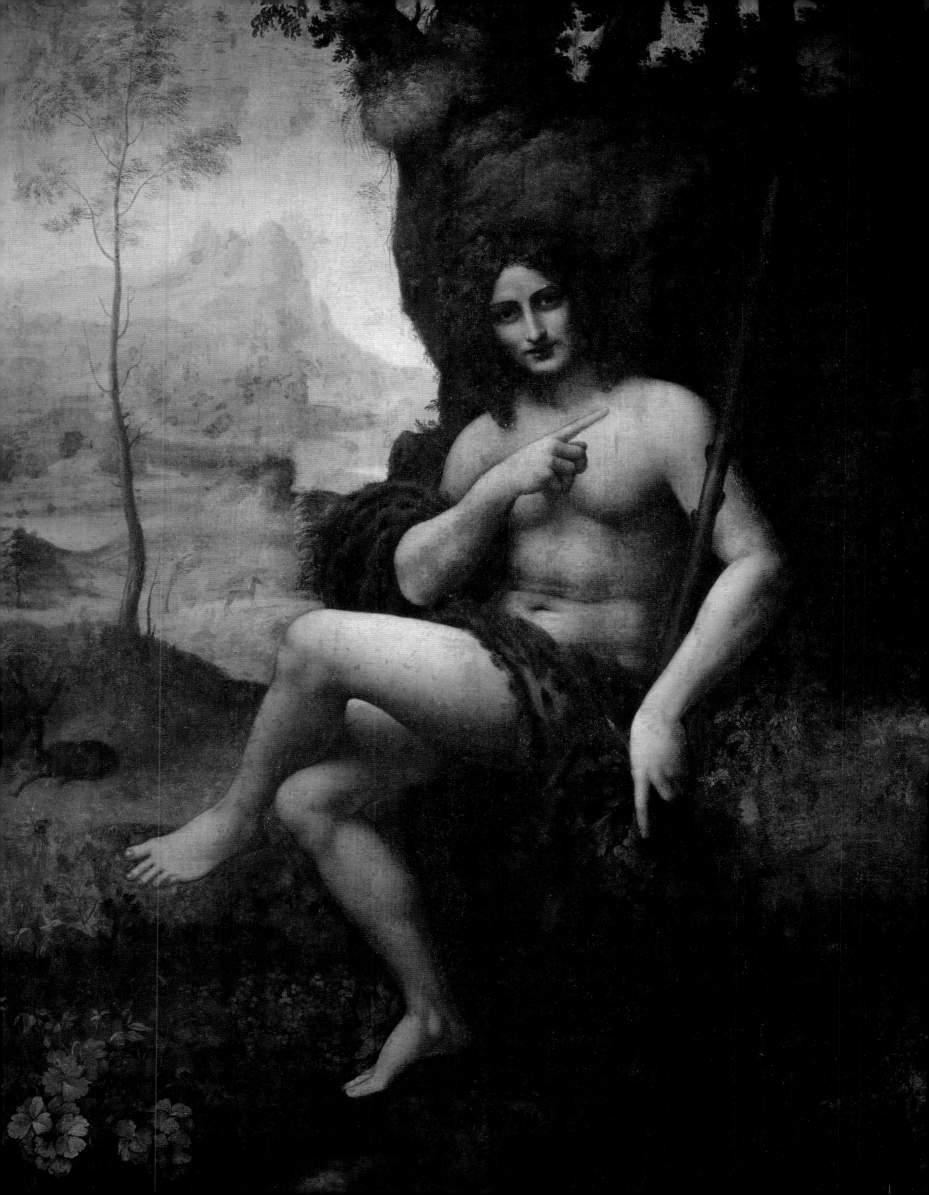

WORKSHOP OF LEONARDO DA VINCI
(1452–1519)

St. John the Baptist (with Attributes of Bacchus), details
CA. 1510–19, WITH LATER ADDITIONS

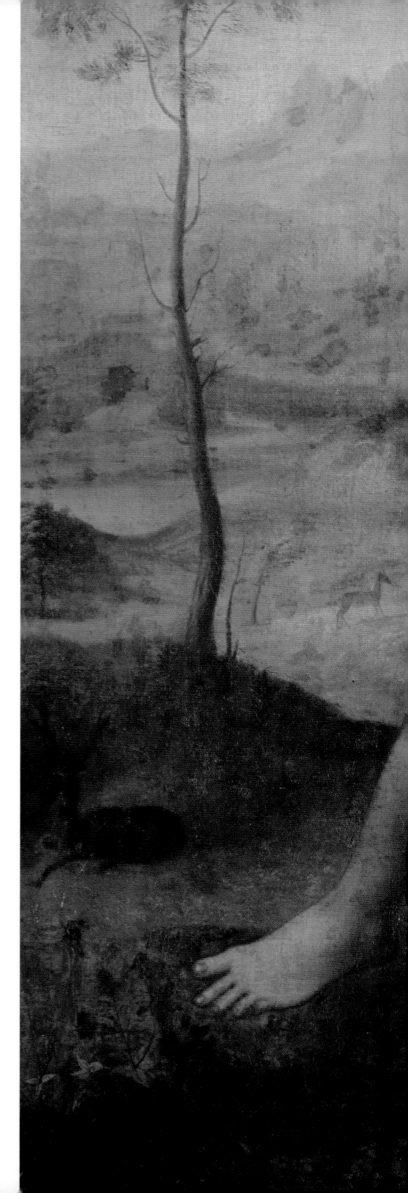

St. John the Baptist (with Attributes of Bacchus), details

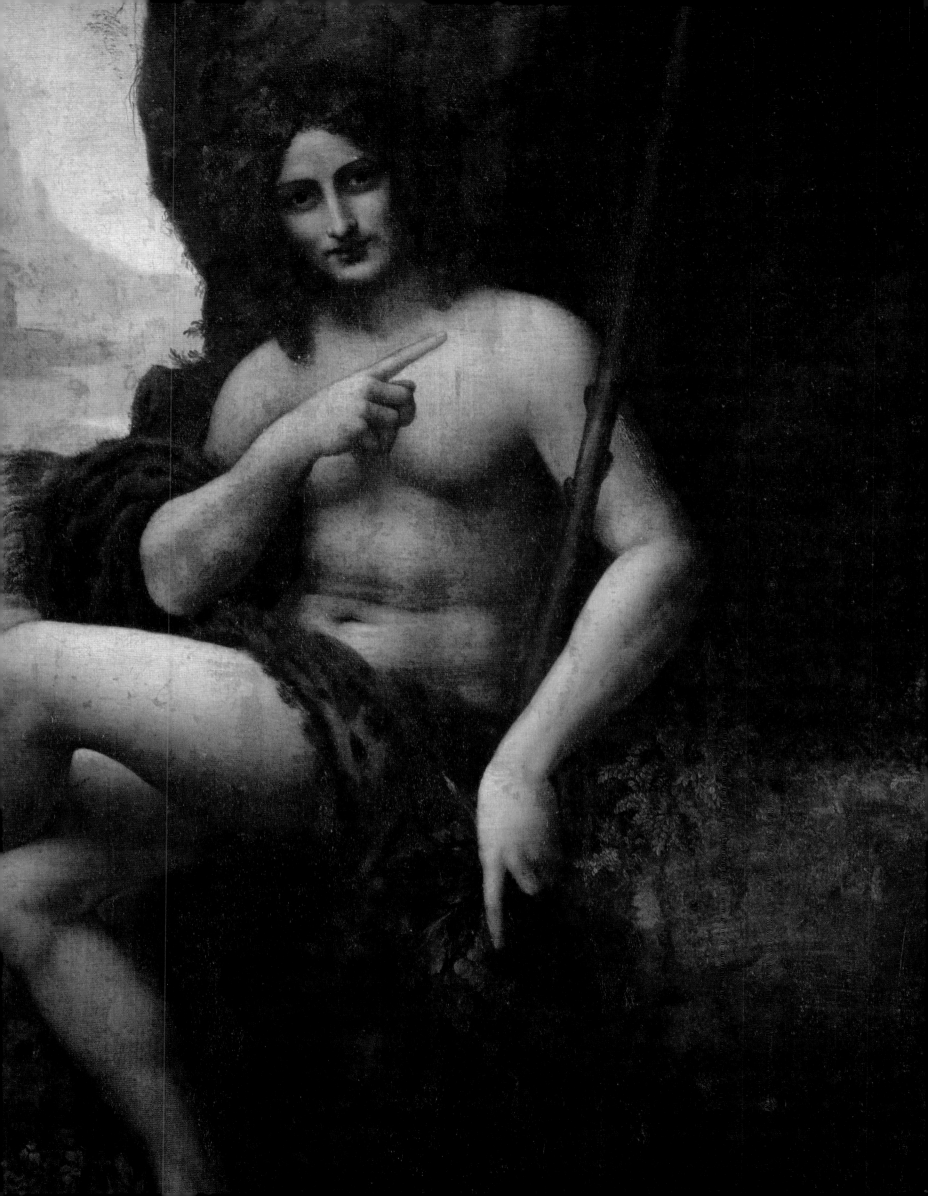

LEONARDO DA VINCI

(1452–1519)

Vitruvian Man

CA. 1490

PEN AND INK
13 ½ X 10 IN (344 X 255 MM)
ACCADEMIA GALLERY, VENICE

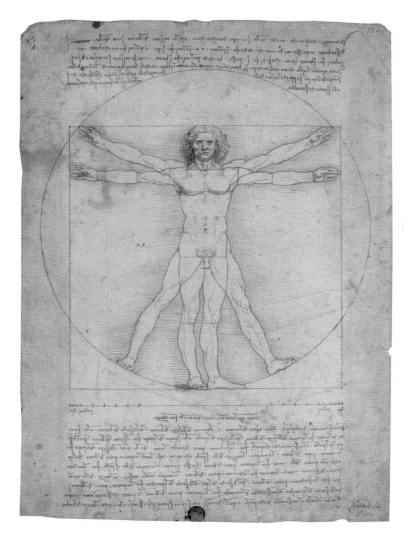

IN HIS book *De architectura*, the Roman architect Marcus Vitruvius Pollio (ca. 80–20 BC) wrote about the underlying geometry of the classical orders of temples and related these ratios to the human figure. The harmonious proportions of the human body, he said, can be geometrically understood by inscribing a figure in both a circle and a square. The text around the drawing is Leonardo's transcription of Vitruvius's text (in mirror-writing). Like other humanist enterprises, Leonardo's drawing engages directly with classical antiquity, striving to resolve the inherent problems in Vitruvius's challenge.

Leonardo's solution derived from empirical approaches. While working on an equestrian statue for the Duke of Milan, Leonardo became deeply engaged with proportional studies of horses and men (see the studies for the Trivulzio monument). During 1489, he made a series of measurements from several local men, recording their forms in meticulous detail in his notebooks. His agenda was, in his own words, to find "the proportionality of the component parts . . . from which human beauty is composed." His method drew from the particular (via scientific observation of the individual) in order to understand the general—the perfect human figure. Leonardo then used this data to test his own observed knowledge of the human form against Vitruvius's age-old problem. This drawing has been called the triumph of empiricism over the authority of antiquity. In it, Leonardo showed how Vitruvius's theory of geometric harmony could be achieved not by following accepted mathematical theories but via scientific study of the physical human body.

Leonardo's solution was a revolutionary break with traditional ways of thinking. Rather than trying to set the circle and square in relation to each other, as ancient and medieval theorists had done, he began with the figure itself. Straight lines mark the shoulders, groin, knees, brow, and elbows; the distances between these parts register the result of Leonardo's intense study of human measurements. Once his perfect figure was formed, he moved the limbs to different angles, thereby aligning it with Vitruvius's geometric forms. Harmonious and symmetrical, the drawing (and the line of thought it represents) is a visual statement of an anthropocentric mindset. Here, man is at the center of all things, and the human form registers nature's perfect mathematical foundations.

In the Renaissance, math and geometry enjoyed high status as two of the seven liberal arts. Leonardo did not have a liberal arts education, which was reserved for the elite, so his knowledge of anatomy, mathematics, and Latin must have been acquired as an adult. Though Leonardo clearly had a natural attraction for the work of observation, he may have had another agenda as well. By showing the mathematical and scientific components of art, he transformed its status from mere artisanal craft to respected intellectual endeavor. As someone with humanist credentials, rather than a simple artisan, Leonardo would have enjoyed higher status at court. He could have competed more effectively for the many commissions the Duke of Milan offered in sophisticated industries such as engineering, architecture, and military strategy. This drawing, then, is not just a solution to an age-old puzzle. Rather, by incorporating the work of scientists and rivaling the achievements of poets and philosophers, art could become an avenue to access both human understanding and the timeless truths of divinely ordained nature.

LEONARDO DA VINCI

(1452–1519)

Landscape

1473

PEN AND INK OVER A PARTIALLY ERASED PENCIL SKETCH
7 ½ X 11 ¼ IN (190 X 285 MM)
UFFIZI GALLERY, FLORENCE

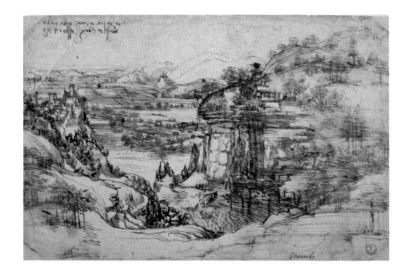

THE INSCRIPTION on the upper left of this drawing, written in Leonardo's characteristic mirror writing, explains that it was done on August 5, 1473, the day known as Holy Mary of the Snow (referring to a miraculous snowfall in Rome on that date in 352). This is the earliest dated work by Leonardo; it is also one of the first autonomous landscape sketches in the history of art.

It is no coincidence that Leonardo's first work is a landscape; his interest in the study and depiction of nature lasted throughout his life. In this drawing, we already see the two main components of both his artistic and scientific endeavors: direct observation of the natural world combined with systematic study of individual elements. This drawing was sketched in pencil, probably on site, and then reworked with pen and ink in the studio. In particular, Leonardo used dark ink to strengthen his observations of the profile of the cliff on the right and the contours of the valley at the center. These reworkings clarify the spatial organization of the drawing while adding visual interest by specifying the different shapes of earth, rock, water, and trees. On the right side, a quickly brushed hillside turns into a steep cliff; a waterfall cascades off its near side. At the left, a fortified structure perches on craggy hills, overlooking a fertile valley of fields and rolling hills. The vista ends with a view of the sea in the distance.

Leonardo appears to capture the landscape of his native territory, the hills outside Florence near Vinci. Some scholars speculate that this scene may show a real place, experienced while Leonardo was on a walk or horseback ride; the path from Vinci to Pistoia and the area near Papiano have been suggested. Alternatively, the scene could also be a construct from Leonardo's observations, pulling together typical regional forms to create a compelling view of the countryside. Either way, in this unusual drawing the young Leonardo ventured into new territory, insisting on the representational accuracy of the scene. His skills at depicting nature served him well later, when he helped paint background landscapes in several of Verrocchio's works. In

Leonardo's own *Annunciation*, similar hills frame a distant view into a glowing, barely rendered sky.

Leonardo's drive to meticulously capture and record the visible world also referenced Christian ideas of nature as a manifestation of the divine. The land, as the creation of God, was seen as the physical record of the divine order of the universe. Leonardo's loving transcription of the beauties, rhythms, and varieties of nature, from the crashing fall of water to the texture of rock, connects to such theological beliefs as well as to poetic and emblematic truths. By studying nature, Leonardo believed, one could achieve a deeper understanding of how the physical world operates—and, by extension, access the spiritual realm. In terms of art, the drawing argues for Leonardo's belief in the primacy of sight among the senses. It provides for both a quick yet sweeping view and detailed investigation, qualities that Leonardo deemed essential for understanding.

Studies of nature like this drawing were one of the foundations of Leonardo's art and remained a mainstay of his practice. In a later notebook, he commented on the importance of observation: "the painter [who] learns from natural things, he will bear good fruit."

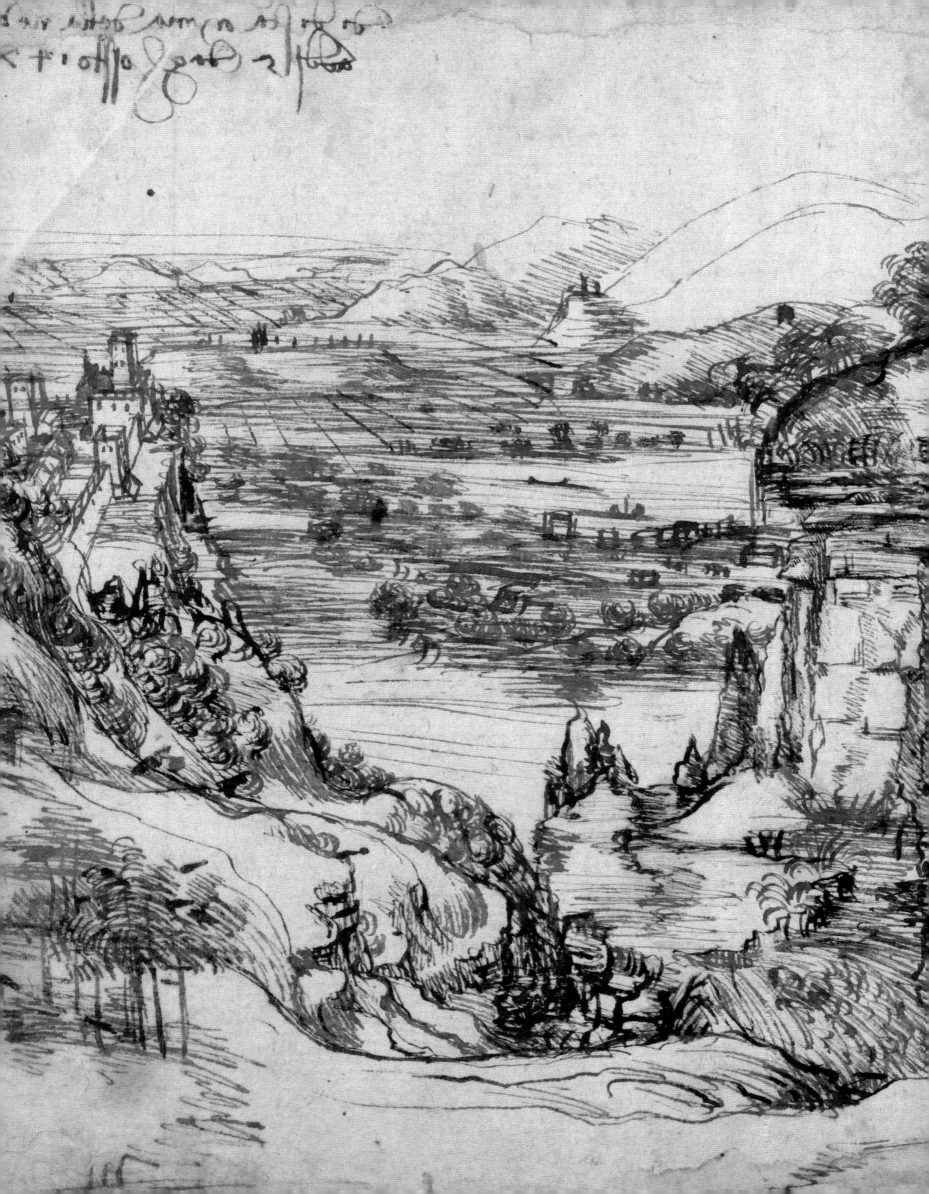

LEONARDO DA VINCI
(1452–1519)

Bird's-Eye View of the Chiana Valley
CA. 1502

WATERCOLOR AND PEN AND INK
13 ⅓ X 19 ⅓ IN (338 X 448 MM)
ROYAL LIBRARY, WINDSOR CASTLE, LONDON

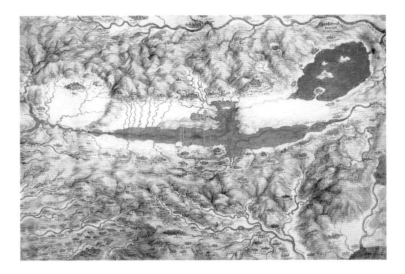

I N 1502 Leonardo joined the staff of Cesare Borgia (1475/76–1507). As commander of the French and papal armies, Borgia was responsible for a string of important military victories throughout the Italian peninsula, including the subjugation of the region known as the Romagna. According to Niccolò Machiavelli, Borgia represented an ideal type of prince: violent and cruel in dealing with potential enemies, but also a brilliant leader who inspired the loyalty of many of his subjects. In the summer of 1502, Borgia was on campaign in the Marche, besieging Urbino. He was also dealing with a plot against him. Yet, despite these distractions, Borgia hired Leonardo as a military engineer, looking ahead to the next campaign, in Tuscany.

This map shows the region of the Chiana Valley, stretching south from Florence toward Perugia. The bird's-eye perspective provides a sweeping overview of the region, with its ranges of hills carefully shaded to provide relief and suggest relative height. Flat geographic features such as marshes, rivers, and the contours of lakes are also carefully delineated. The aerial perspective allows the viewer to see the land as would a bird (or divine being). However, the cities and towns that dot the area (Siena, Arezzo, Perugia, and Volterra appear) are shown only as quick schematic sketches: the land is more important. According to accounts at the time, Leonardo personally walked much of the territory, measuring distances, charting the hills, and sketching the shores of lakes. A design for a hodometer (a rolling device used to measure distance) in Leonardo's notebooks may be related to this project.

Maps such as these were rare and functioned as valued tools in the frequent wars of the period. Unlike some of Leonardo's other maps (such as the plan of the town of Imola), which are prized in the history of mapmaking for their revolutionary cartographic accuracy, this bird's-eye view manipulates the existing geography to serve a greater purpose. In the image, the long lake and marshes of the Chiana Valley are placed in relation to other strategic bodies of water. The Tiber River flows along the

margin at the top while, to the left, the Upper Arno bends into the scene. At the bottom, Leonardo includes a slice of Lake Bolsena and manipulates the shape of Tuscany to show the Tyrrhenian coast. Within this frame, the map delineates all the rivers and watersheds of the region, carefully tracking the relationships between the hills, streams, and waterways. The interest in water seen here connects this map to one of the era's largest hydro-graphic projects: the regulation of the Arno. Shallow sections and seasonal flooding made the river unsuitable for shipping, thus depriving Florence of a reliable connection to the sea. In this project, dams would have been built along the northern end (left side in this drawing) of the Chiana River. The enormous reservoir thus created would have stretched all the way through the valley to Lake Trasimeno (shown in the upper right); careful release of water through the dams would have made the Arno navigable year-round. Such a project would have allowed Florence to consolidate its mercantile and military positions at the expense of the cities carefully labeled on the map.

Leonardo had worked on shipping and irrigation canals for Ludovico Sforza; the sheer scale of this project, though, defied the technology of the period to complete.

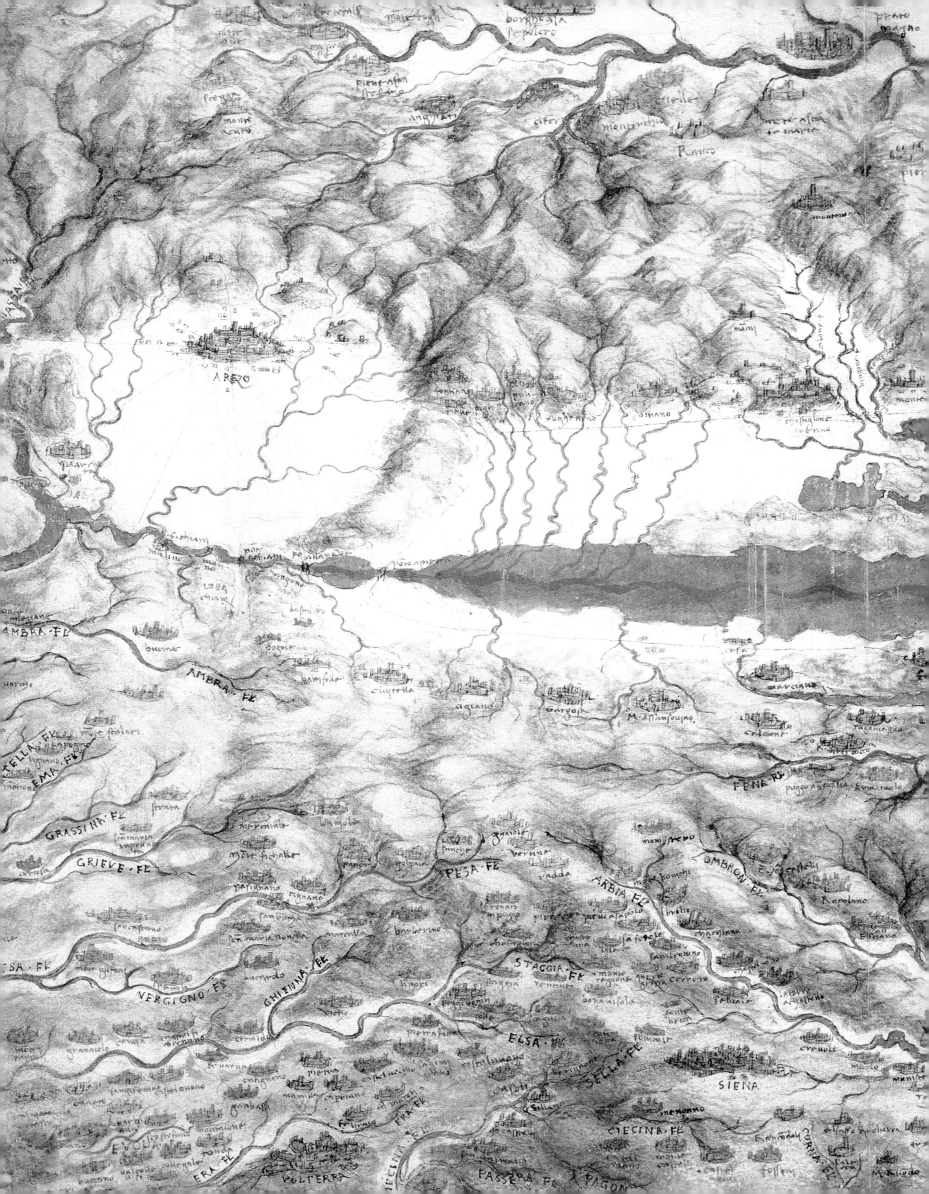

LEONARDO DA VINCI
(1452–1519)

*Bird's-Eye View
of the Chiana Valley*
CA. 1502

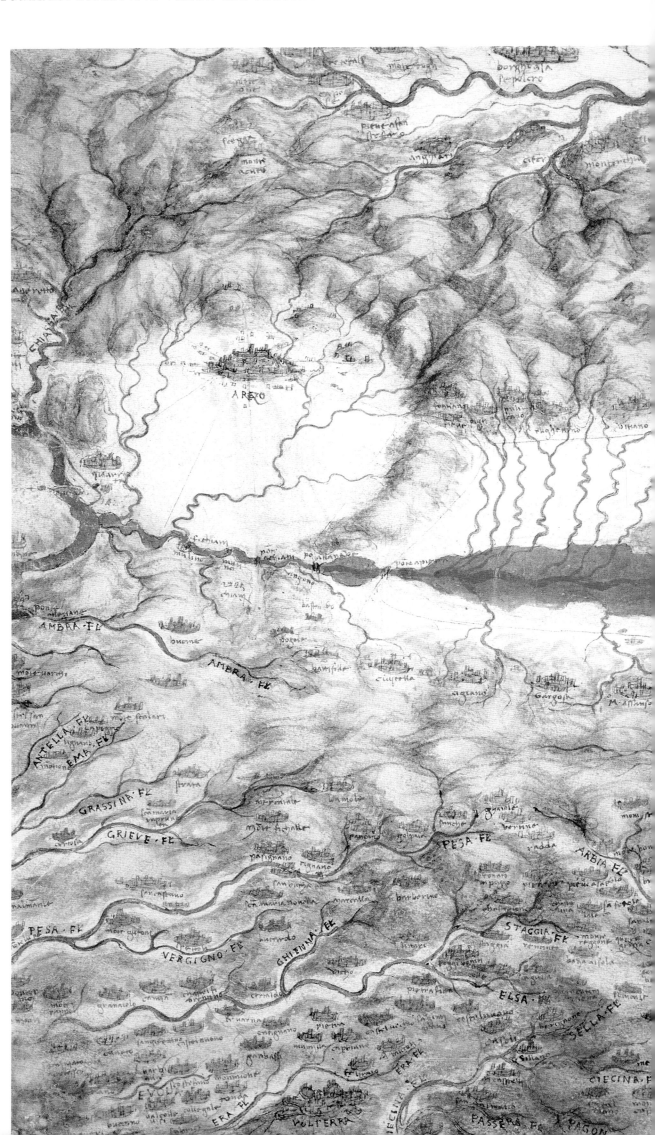

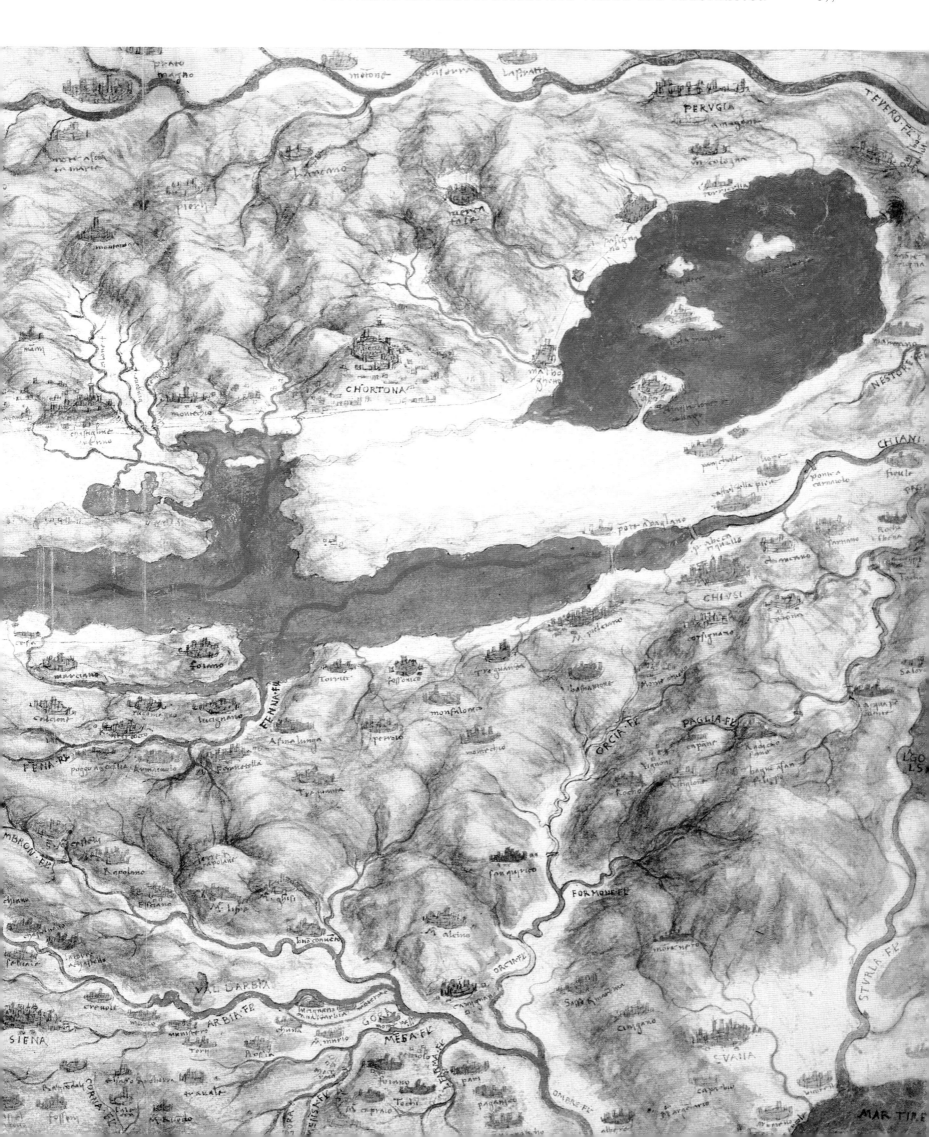

LEONARDO DA VINCI
(1452–1519)

Storm in the Alps

CA. 1499 OR CA. 1508–10

RED CHALK
7 ¾ X 6 IN (198 X 150 MM)
ROYAL LIBRARY, WINDSOR CASTLE, LONDON

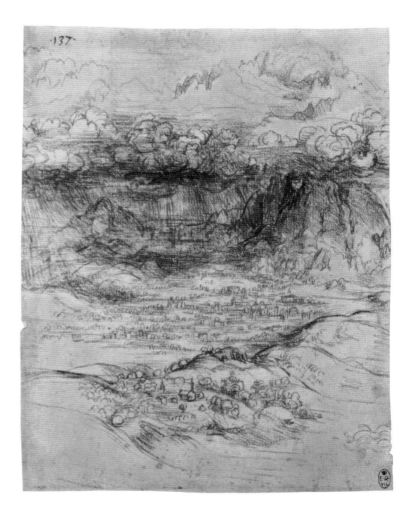

ON MORE than one occasion in the 1490s, and possibly again on his second stay in Milan around 1508–10, Leonardo headed north of the city to ascend the steep slopes of the Alps to see what he could see. He had taken similar journeys in the hilly environs of Tuscany as well since the dawn of his career, as noted in the entry discussing his landscape drawing of 1473. Where his earlier landscape interests seem to focus on the variety of natural habitats—hills, river valleys, forests, and the like—and the hazy effects of atmospheric perspective, his Milan-era observations take on more specific objectives. They display a scientific rigor in Leonardo's observations of natural phenomena and reveal his attempts to genuinely make sense of how things work and how they came to be formed in the manner that he found them. He recorded small-scale items such as plants and animals and looked into the air to note the flights of birds. In these notes, the minutiae of fossils and records about rock strata accompany some of the earliest commentary on geological formations and natural history. In fact, Leonardo speculated that the earth was far older than the conventional view held at the time, and he cast doubt on the biblical narrative of the Great Flood, noting that tremendous flows of water would not have been able to escape the mountains. Rather, he proposed that the earth thrust gradually out of the waters, allowing clearly stratified deposits of sediments and layers of fossilized remains. He also observed the panoramic phenomena of natural and meteorological events, including odd cloud formations and freak storms. He described hail on the mountains in the middle of July, lying unmelted on the ground, and noted that the sunlight hitting the mountains could be darker than the light on the plains far below.

In this drawing, known as the *Storm in the Alps*, Leonardo presents a macrocosm of a valley and a thunderstorm hovering above that seems almost unimaginable in its awesome breadth. The violent downdraft forces of wind shear and torrents of sheets of rain are documented with accuracy. Nonetheless, it is clear that Leonardo embellished his bird's-eye point of view to encapsulate the scene before him.

Although Leonardo never incorporated into a painting such a phenomenal and violent act of nature as this storm, his observations of light and the meandering pathways of the landscape surely enhanced his approach to the complex landscape backgrounds of later works. In fact, some scholars consider this drawing to be a study for the landscape of the *Mona Lisa*, but so direct a connection is tenuous at best. Later still, Leonardo would embark on a study of the violence of water, explored in a sequence of deluge drawings.

A sheet in the *Codex Atlanticus*, written by Leonardo's student Francesco Melzi almost certainly under the dictation of the master, describes the movement of wind, the courses of rivers, and the fluttering trajectory of smoke in the air.

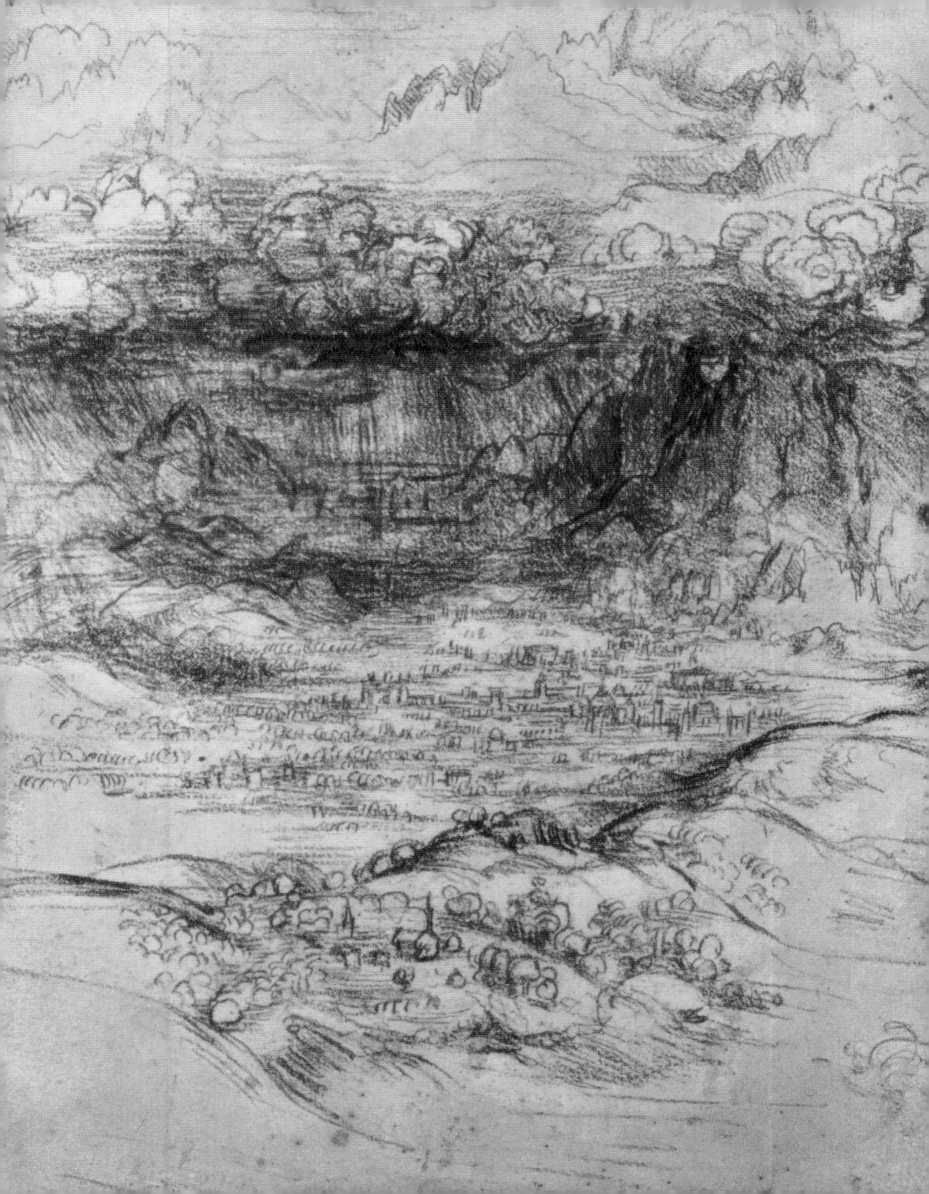

LEONARDO DA VINCI
(1452–1519)

Allegory with Sun, Mirror, and Dragon Fight
CA. 1490S (?)

PEN AND INK ON PAPER
4 X 5 IN (104 X 124 MM)
LOUVRE MUSEUM, PARIS

A MAN SEATED amid outcroppings of rocks, or perhaps the ruins of an ancient arched structure, holds a large oval mirror that reflects a brilliant sun, with the light illuminating a battle of creatures both fantastic and real. Among the animals are a dragon and a lioness, an allegorical battle theme that Leonardo treated by itself on several occasions. Also present are a bear, a unicorn, another leonine figure on its haunches preparing to spring forth, and a boar in the background. It would appear that the dragon is the central figure, perhaps defending itself from (or attacking?) all of the others.

A dragon was featured on the Sforza family coat of arms, and the trees growing from the top of the stone outcropping may be a reference to the mulberry (*gelso-moro*, in Italian), which was sometimes used as an emblem for Ludovico Sforza, called "Il Moro" by his contemporaries. A blazing sun was also used in imagery associated with the Sforza. Thus the drawing likely dates to the 1490s and may refer to the powerful military position of Milan vis-à-vis the other major Italian city-states.

The sixteenth-century Milanese painter Giovanni Paolo Lomazzo referred to a letter by Leonardo's pupil Francesco Melzi describing a scene of a dragon devouring a lion as, *"Cosa molto mirabile à vedere"* (A thing quite miraculous to see). Such an image is known in several extant drawings from the Leonardo school, and it was also copied in engravings, a testament to its popularity. The chapter in which Lomazzo mentions the Leonardo composition also describes anamorphic images, pictures that were stretched or otherwise deformed but that could be recomposed or "corrected" by viewing them from a peculiar angle or through a lens. Indeed, the function of the mirror in this drawing serves not only to reflect the sunlight but literally to illuminate, as if to present a truth, albeit one veiled by the associations of the animals in the allegory.

In one of his notebook entries, Leonardo explains the following: "How you should make an imaginary animal look natural. You know that you cannot invent animals without limbs, each of which, in itself, must resemble those of some other animal. Hence if you wish to make a chimerical animal appear natural—let us say a Dragon—then take for its head that of a mastiff or hound, with the eyes of a cat, the ears of a porcupine, the nose of a greyhound, the brow of a lion, the temples of an old cock, the neck of a water tortoise." Leonardo is certainly to be given his due for the objectivity of his observations of the natural world, but clearly he also delighted in these fantasies and sought to make them appear as tangible and true as possible. In contrast to other Renaissance artists, such as Hieronymus Bosch in the Netherlands or Piero di Cosimo in Italy, whose imaginations ran wild into realms of incoherent and often nightmarish surrealities, the invented creatures of Leonardo occupy land that is believable and obey the laws of nature in their movements and instinctual actions.

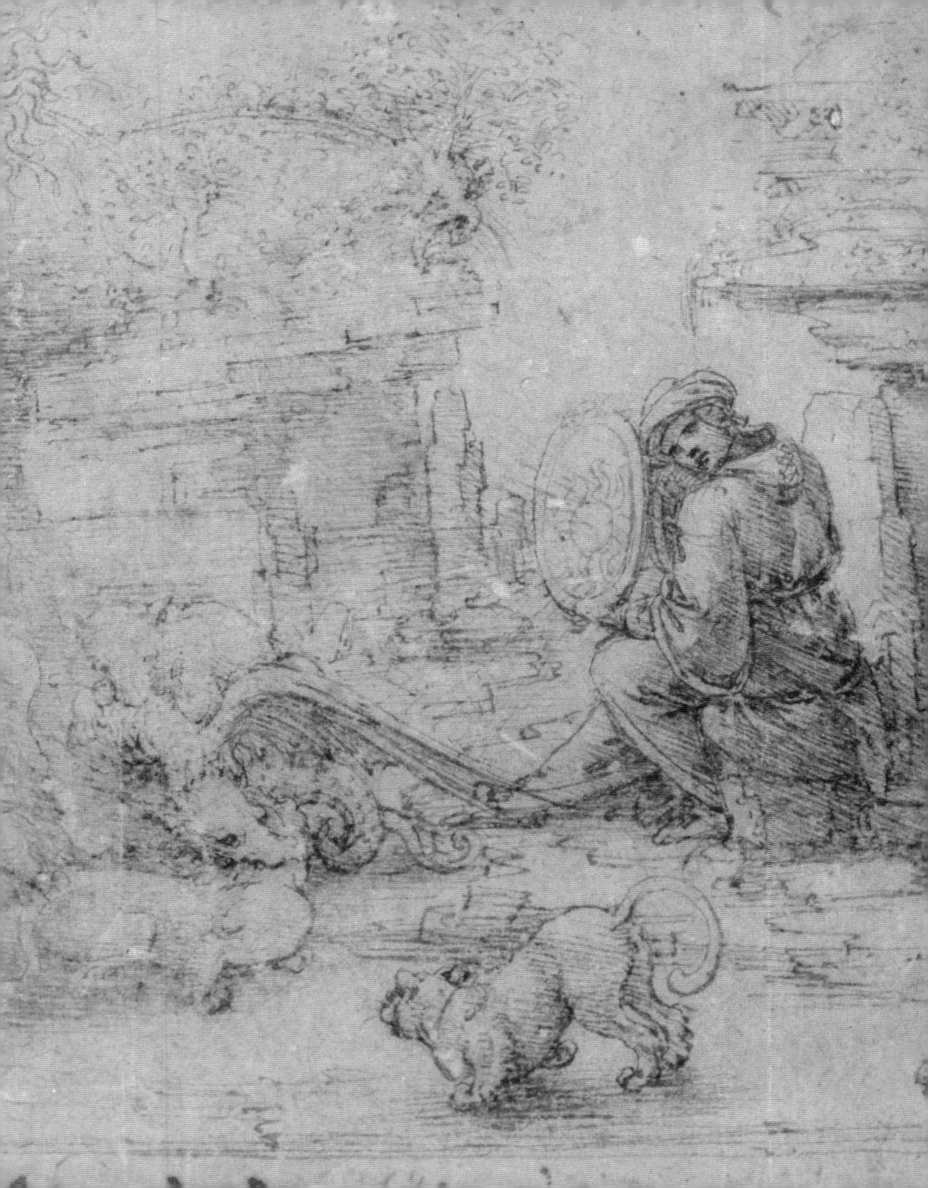

LEONARDO DA VINCI

(1452–1519)

Five Grotesque Heads

CA. 1494

PEN AND INK
10 ¼ X 8 IN (261 X 206 MM)
ROYAL LIBRARY, WINDSOR CASTLE, LONDON

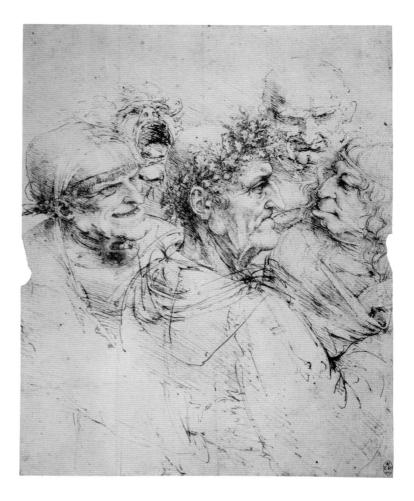

THIS SHEET of heads, in a certain sense, represents the opposite end of the spectrum from Leonardo's studies of idealized human proportions and beauty, such as the *Vitruvian Man* (see the earlier entry). Indeed, at first glance the implication would seem to be that our individuality—the characteristic imperfections that distinguish us from one another—is an aspect of the brutal ugliness of the natural world. On closer inspection, however, we can see that Leonardo used similar figures elsewhere—or, rather, derived the composition here from individual studies made for other purposes, making this a deliberate constellation of caricatures, figures with deformities and features exaggerated for the effect of humor or satire. To what end? The grouping has the appearance of a mocking of Christ, but surely the central character, old and disheveled, cannot be Jesus. His garments are similar to a monk's robe, and the laurel wreath makes him appear to be a Roman emperor. (Could it represent the attack on Julius Caesar on the Ides of March?) Any sense that this study might have been meant as a specific political allegory is complicated by the imprecise dating as well as the shifting political fortunes of Milan in the 1490s. The man to the left wraps his arm around the back of the central figure, giving a sense of leading him through a jeering crowd. The comedic aspects are highly theatrical. Most likely, as with much caricature, it is a composite of stereotypically derided and ridiculed characters.

The central subject is essentially the same as the profile seen in the *Man in Profile, Squared for Proportion.* The prominent nose, midcheek depression, and strong jawline broken by a dangle of flesh are similar in the two drawings. Likewise, the froglike personage on the far right is known from a separate drawing that was called by Vasari a portrait of Scaramouche, a clownish rogue stock character of the commedia dell'arte, a traveling improvisational group. Nonetheless, all of these studies grew out of natural observations of live models. Vasari wrote that Leonardo was "so delighted when he saw people with curious features, whether bearded or hairy, that he would follow anyone who had attracted him thus for a whole day, gaining a clear idea of him so that when he went home he would draw the head from memory as well as if the man had been present." Other caricatures by Leonardo seem to be hybrids of men and beasts. As political satire developed over the succeeding centuries, it became more common for such distorted portraits to be derived from the appearance of specific, and usually prominent, individuals.

Some of the recurrent facial features in Leonardo's many caricatures can be found in this sheet: a widely opened mouth with teeth showing, an underbite with protruding jawline and concomitant leering smile, and the incoherent juxtaposition of an ugly figure with elegant articles of clothing. Leonardo's grotesque heads were especially popular in Northern Europe, where they were copied and varied by many artists in drawings, prints, and paintings. Leonardo had a keen sense of humor, displayed not only in works like this but in various jokes, rebuses, fables, observations, and allusions sprinkled throughout his notebooks.

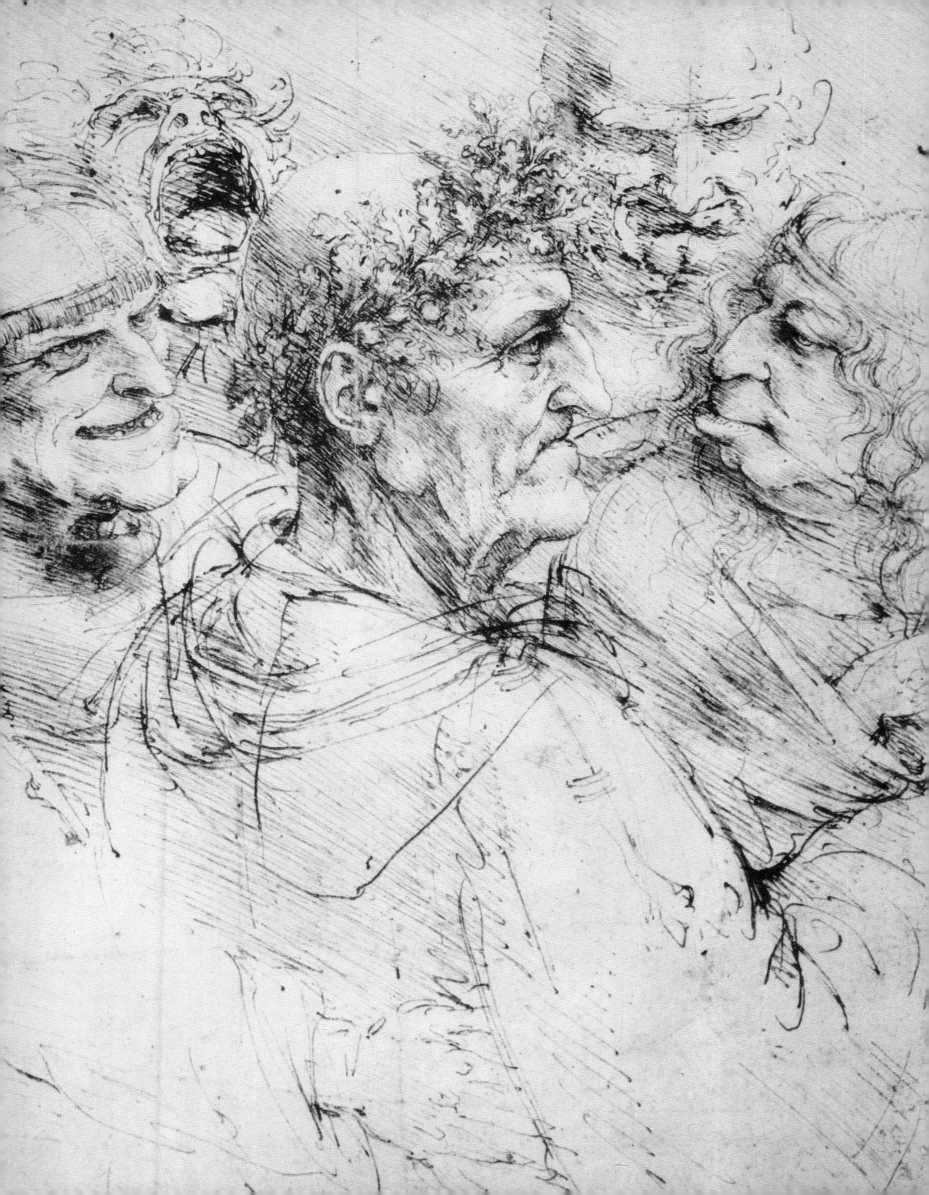

LEONARDO DA VINCI
(1452–1519)

Five Grotesque Heads, detail
CA. 1494

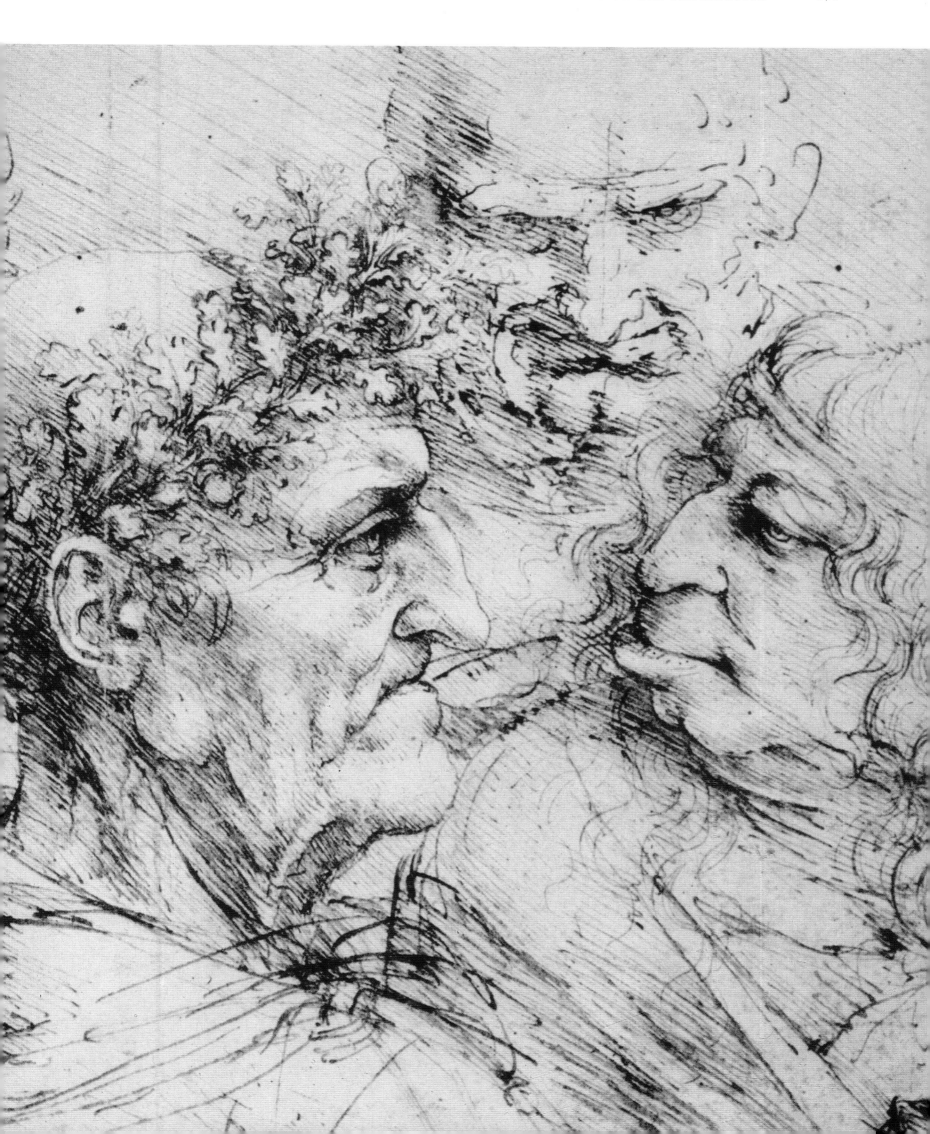

LEONARDO DA VINCI
(1452–1519)

Studies for the Head of Leda
CA. 1508

PEN AND INK OVER BLACK CHALK
7 X 5 ¾ IN (177 X 147 MM)
ROYAL LIBRARY, WINDSOR CASTLE, LONDON

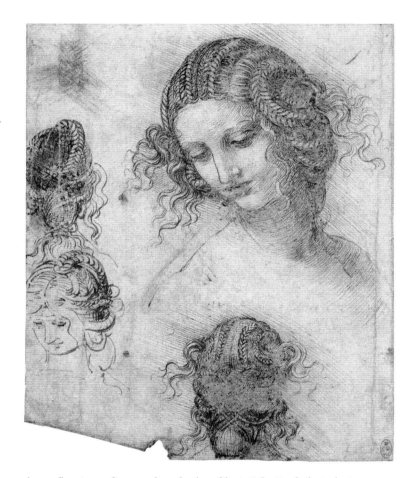

THIS SHEET contains four studies for the head of Leda in Leonardo's lost painting of *Leda and the Swan* (see the next entry). Leda was a queen of ancient Sparta, and one of her offspring with Zeus, who came to her disguised as a swan, was Helen of Troy, the most beautiful woman of the ancient world. It seemed reasonable that Leda, too, must have been extremely attractive, but how best to capture that height of loveliness?

An ancient story told that Zeuxis, a later Greek painter, could not find a model suitable to portray Helen, so he chose the best parts from various women to create an idealized composite. Leonardo wrote something similar in his notebooks: "Look about you and take the best parts of many beautiful faces, of which the beauty is confirmed rather by public fame than by your own judgment; for you might be mistaken and choose faces which have some resemblance to your own. For it would seem that such resemblances often please us; and if you should be ugly, you would select faces that were not beautiful and you would then make ugly faces, as many painters do. For often a master's work resembles himself. So select beauties as I tell you, and fix them in your mind."

Leonardo's multiple sketches on this sheet work in a similar fashion, but rather than showing different models he shows different vantage points of the same model. It is an exercise in perspective appropriate to the Renaissance sensibility. Among Leonardo's writings are references to the *paragone*, or debate, comparing painting and sculpture. Among the challenges inherent in sculpture was the task of accurately rendering forms from all angles, because viewers could see a sculpture from all sides. Painters often responded by demonstrating similar figures from different vantage points. Although Leonardo surely never intended to represent Leda in multiple views in the final painting, it is curious that he felt the need to study this model from both front and behind. Perhaps it was due to the complexity of the coiffure, with braids coiled on the side of the head (anyone wondering where the hairstyle of Princess Leia in *Star Wars* originated need look no further!), parallel arcing vertices on top, and a crisscrossing pattern in the rear. Most of Leonardo's beautiful figures, both male and female, present a natural look, with long, flowing, often curling locks of hair. The Leda hairdo is more complex than what he normally attempted. Still, he could not resist adding a flair of nonchalance as the coils gently unravel at the ends and allow the tips to unfurl in a gentle breeze. Here, too, Leonardo perhaps anticipated the atmospheric context of the natural surrounding seen in the painting; he noted in his writings that the wind is not seen directly, but only its effect on what is blown is experienced.

Leonardo's shift toward this type of hairdo may have been prompted by changing tastes and his return to Florence, where Michelangelo and other artists readily experimented like salon stylists with their female figures. They even coined a term for such studies of exquisite refinement in hairstyles: *teste divine*, or "divine heads."

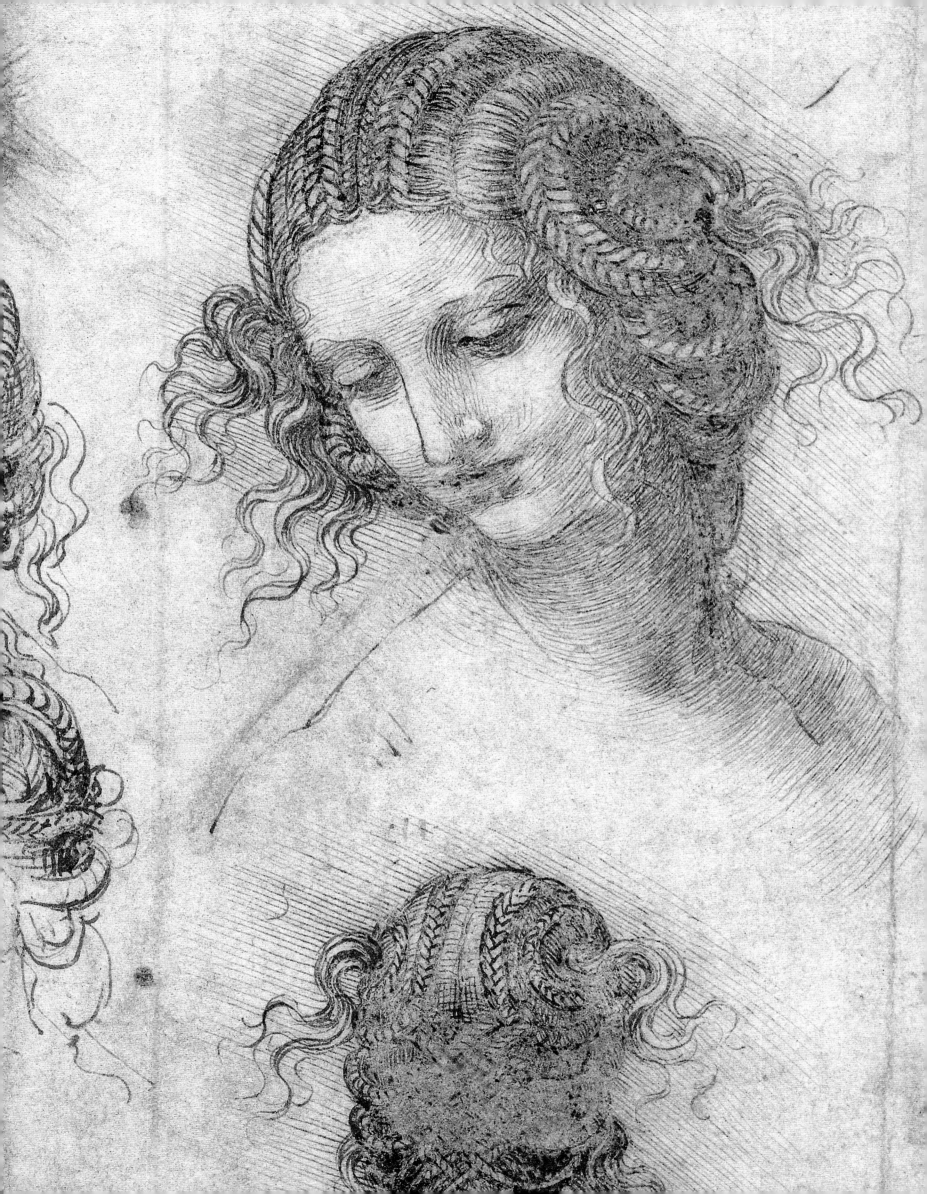

FOLLOWER OF LEONARDO DA VINCI

Leda and the Swan

AFTER 1508

TEMPERA ON WOOD
45 ¼ X 39 IN (115 X 86 CM)
GALLERIA BORGHESE, ROME

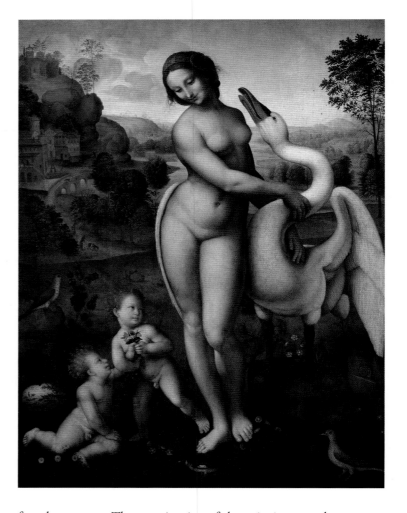

THE STORY of Leda and the swan, told in many ancient tales including Ovid's *Metamorphoses*, was much admired in the Renaissance for its erotic overtones. Zeus came to Leda in the form of a swan, and she bore four children simultaneously. Two were the offspring of Zeus, Helen and Pollux, while the other two, Castor and Clytemnestra, were the products of Leda's marriage to Tyndareus, the king of Sparta. Renaissance representations of this subject almost invariably show the couple lying down, engaged in coitus. Leonardo was not interested in such pornographic allusions but took the subject in a different direction in two projects.

Leonardo's first composition of Leda was begun about 1504 and may have never been executed by him in paint; but because others were influenced by his studies, the general composition is known. This version shows Leda crouching, an investigation of the type of figure that Michelangelo came to call a *figura serpentinata*, or a figure coiled like a serpent. The pose may have been inspired by a description of a painting by the ancient Greek artist Apelles that showed Venus crouching and wringing out her hair. The second version by Leonardo was completed as a painting. The antiquarian Cassiano dal Pozzo saw the original at Fontainebleau in 1625 and described it thus: "A standing figure of Leda almost entirely naked, with the swan at her feet and two eggs, from whose broken shells come forth four babies. This piece, though somewhat dry in style, is exquisitely finished, especially in the woman's breast; and for the rest the landscape and the plant life are rendered with the greatest diligence. Unfortunately, the picture is in a bad way because it is done on three long panels, which have split apart and broken off a certain amount of paint." The painting was lost or destroyed in the eighteenth century, but no less than nine extant copies or variations give a good idea of how it looked. The Galleria Borghese version illustrated here differs from the original in its representation of only two of Leda's children, rather than four. One may also assume that it differs because it is rendered in tempera, giving it a somewhat brighter color palette than what one would have expected from Leonardo's own hand.

Leonardo's studies for Leda occur at the same time, and sometimes on the same sheets of paper, as his examinations of female anatomy. The germination of the painting was also accompanied by many studies of plants and flowers in the artist's notebooks. Leda as an embodiment of natural fecundity seems to have been a sprawling idea in Leonardo's conception. This union of beautiful woman and elegant creature may have appealed to his receptivity to comparing and distinguishing the traits and characteristics of humans and all manner of animals. His caricatures often mocked human traits with animal overlays, creating grotesque hybrids. Moreover, he sometimes filled in with studies of animal anatomy those parts of his human anatomical studies that he understood poorly or lacked the time to properly observe. Long before the advent of Darwinian theories of biological transformation, such natural amalgam results of the Leda tale—the children were born from eggs—were expressions of an evolved type of natural beauty.

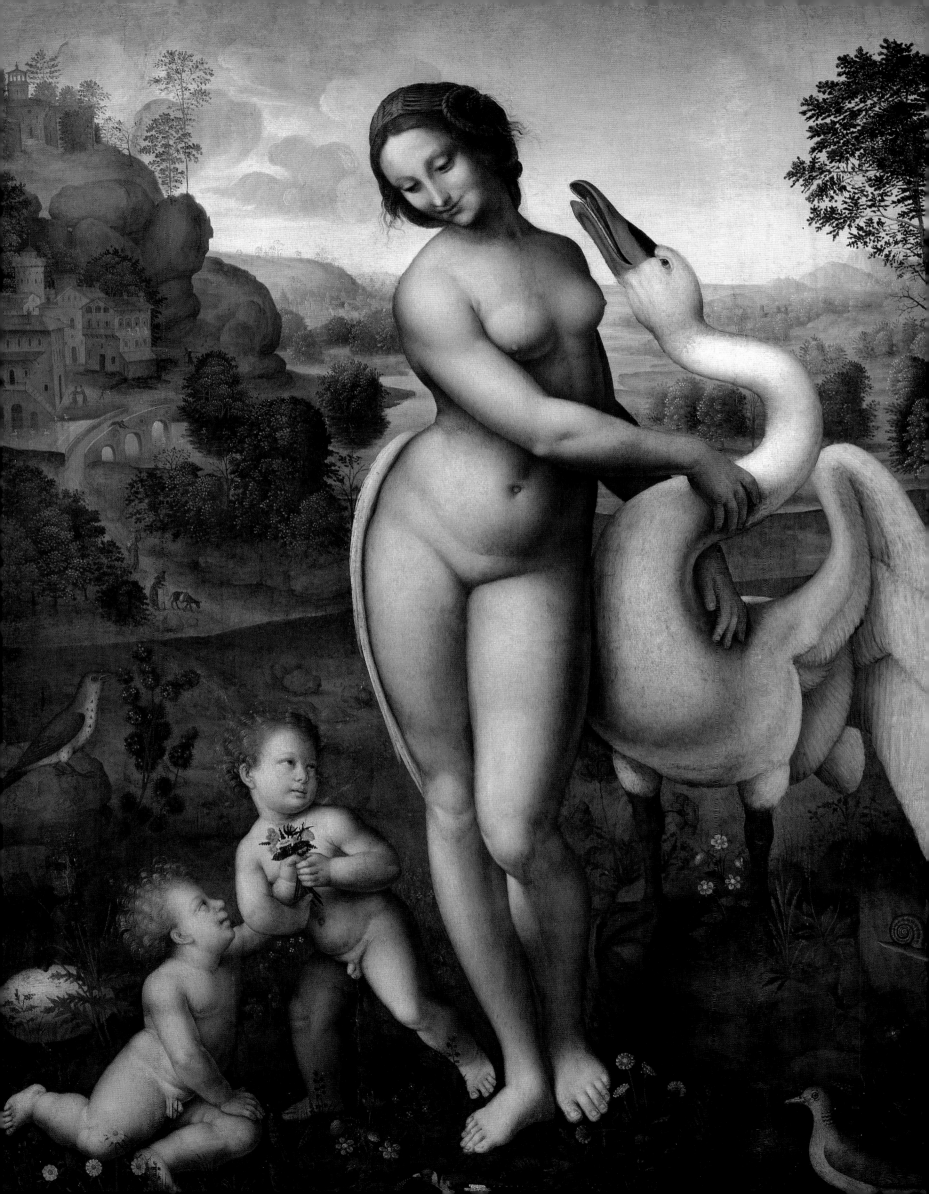

Leonardo da Vinci
(1452–1519)

Study of Female Anatomy
Ca. 1508

PEN AND INK, WITH TRACES OF CHALK, ON OCHRE-WASHED PAPER
18 ¾ X 13 IN (476 X 332 MM)
ROYAL LIBRARY, WINDSOR CASTLE, LONDON

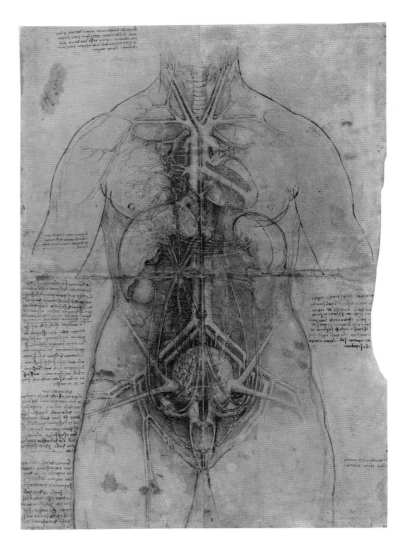

AMONG the most important of Leonardo's anatomical illustrations (see the "Anatomy in the Renaissance" sidebar), this especially large folio represents the organs of the chest and abdomen and the vascular system of a woman. There are clear indications from the notes that it was meant as an introductory piece to a section of Leonardo's proposed anatomy book, prefacing the other images of the female reproductive system and the fetus in utero: "Your series shall be with the beginning of the formation of the child in the womb, stating which part of it is formed first, and so successively putting in its parts according to the periods of pregnancy until birth, and how it is nourished, learning partly from the eggs laid by hens." This last comment again demonstrates how Leonardo made analogies between human and animal systems, for both abstract natural connections and practical purposes, to clarify the bewildering complexity of the bodies he was examining so minutely and, surely, so quickly before they decayed. Likewise, certain visual elements are clearly derived from animal organs rather than those of humans. The heart is represented with only two chambers instead of four, and it is solely ventricular, as in an ox. The complex arrangement of appendages and branching veins of the cardiovascular system are a hybrid of human and animal observations. So, too, are the positions of the kidneys. The gall bladder and spleen are represented because they relate to the bodily humors of yellow and black bile; Leonardo was very much concerned with the discharge of these bodily fluids. The humors, including also blood and phlegm, were thought to govern human character and health. Many of Leonardo's assumptions follow the writings of Galen of Pergamon, the second-century Greco-Roman physician whose authority, even in the hands of a supreme observer like Leonardo, often went unchallenged.

Leonardo was conscious that certain aspects of the interior cavities and organs could not be seen by approaching from one direction during an autopsy. His notes contain directions to open the body from behind in order to see things that cannot be represented here, such as vessels and arteries that attach themselves to the spine and provide nourishment to the bones of the back.

The most surprising and relatively accurate representation on this sheet is the uterus. Its size is exaggerated, perhaps to represent the organ in pregnancy. Other aspects of the female reproductive system, especially the process of egg production, are confused, both in rendering and in relation to the authorities, but perhaps this conveys Leonardo's apprehension that what he read did not necessarily match what he observed. He rejected the Aristotelian notion of insemination as related by Mondino de' Luzzi (also called Mundinus), a fourteenth-century anatomist whose work was published with woodcut illustrations in Leonardo's lifetime. This view considered the sperm alone to be the carrier of life, like a seed implanted in the soil. Leonardo leaned instead in favor of the Arabic writers: "Mundinus, who states that the spermadic vessels or testicles [i.e., ovaries] do not excrete real semen but only a certain salivalike humor which Nature has ordained for the delectation of women in coition, in which case, if it were so, it would not be necessary that the spermadic vessels derive in the same way in the female as in the male."

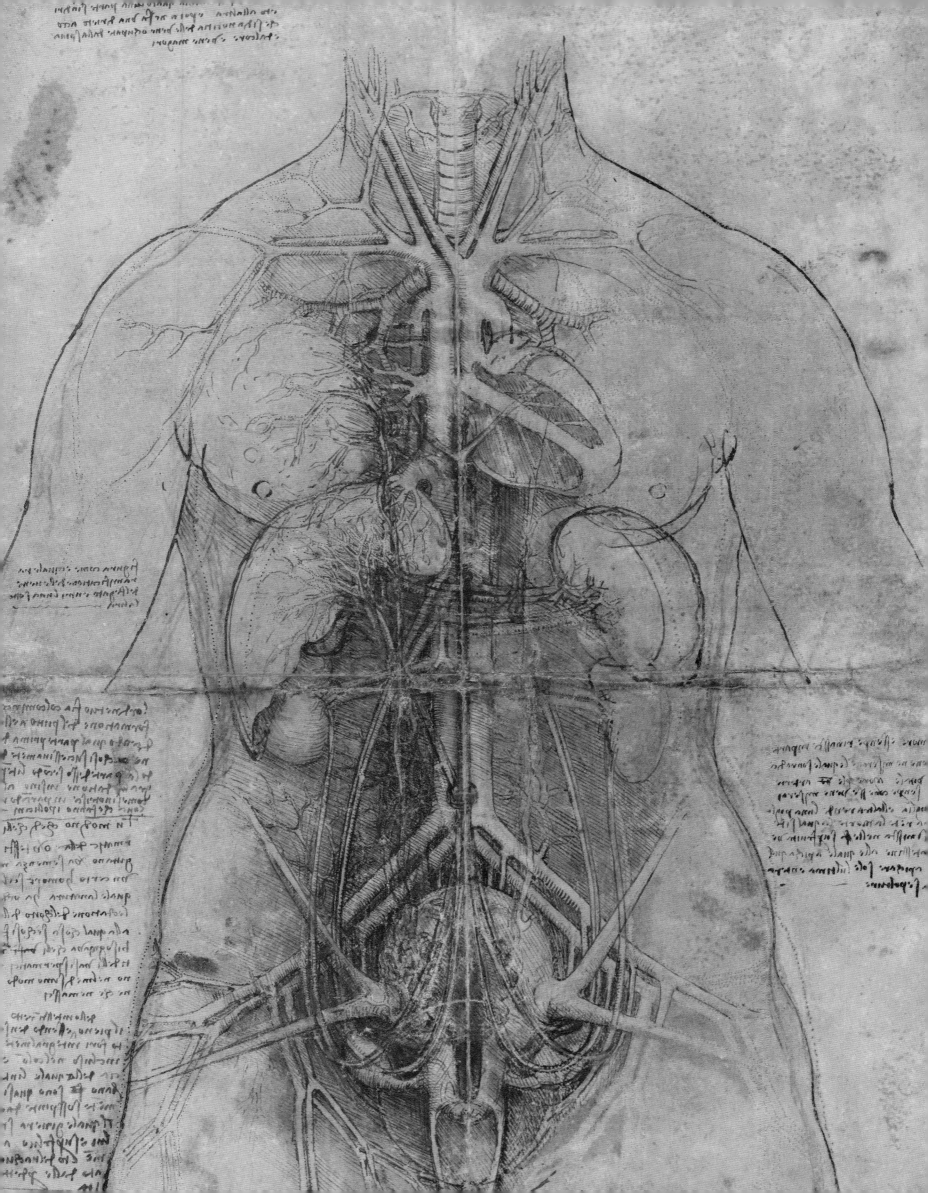

ANATOMY IN THE RENAISSANCE

NEAR the end of his life, Leonardo claimed to have completed more than twenty anatomies. He performed these not as a practicing physician but rather as a means to deepen the natural effects in his art. On a drawing of a cervical vertebra in one of his notebooks, he recommended the study of anatomy to fellow artists: "This illustration is as important for good draftsmen as the derivation of Latin words for grammarians, since he who does not know which muscles cause what movements will draw the muscles of figures in motion and action in a poor fashion." However, he also cautioned his colleagues that their desire to gain this knowledge must outweigh the realities of the practice: "And if you should have a love for such things you might be prevented by loathing, and if that did not prevent you, you might be deterred by the fear of living in the night hours in the company of those corpses, quartered and flayed and horrible to see. And if this did not prevent you, perhaps you might not be able to draw so well." There were indeed many excuses not to participate in anatomical lessons. Church officials frowned upon such procedures, which involved desecrating a human corpse; even in universities, only a limited number of dissections were approved to enhance medical study. Rogue anatomists ran the risk of excommunication. For Leonardo, the benefits to his artistic process of better understanding nature outweighed the negative consequences. According to Paolo Giovio (1483–1552), his earliest biographer, "In the doctors' schools of anatomy he dissected the corpses of criminals, undismayed by the brutal and repulsive nature of this study and only eager to learn how to portray in his painting the various limbs and muscles, their bending and stretching, in accordance with the laws of nature."

Leonardo was not the first artist of the Renaissance to perform dissections. Others such as Antonio Pollaiuolo (1429/33–1498) made promising contributions to the understanding of human anatomy. Pollaiuolo's images were primarily concerned with his own artistic skill, showing off by rendering similar figures with overwrought musculature from multiple angles (*"figure come fratelli,"* or "figures like brothers," as they were called). Leonardo wanted to learn not only how the body looked but also how it worked. He warned against making a figure look like a sack of walnuts, with bulging musculature

displayed for its own sake. He demonstrated that as the body moved, the muscles worked in coordination—certain ones tensed and others relaxed, depending on the action. This knowledge led to a more realistic, and at the same time more graceful, representation of poses and movement.

Some 120 anatomical drawings by Leonardo have survived. These were done primarily in two phases: one set dates from the late 1480s, the other after 1510. The earlier studies were based on information discerned from observation of the human body and skeleton, especially the skull and brain, as well as the bodies of animals. These examples of superficial anatomy explored the interplay of muscles and bones, whose workings just below the skin were visible. In the later studies, by contrast, Leonardo's curiosity carried him to the deeper tissues and organs of the body, less accessible and, until that time, less important to artists. As with most of his investigations of nature, his approach to anatomy was to test conventional knowledge. He largely followed the second-century Greek anatomist Galen, as conveyed in Johannes de Ketham's *Fasciculus medicinae*, published in the 1490s in various editions and illustrated with eloquent but schematic woodcuts.

Gradually, Leonardo moved away from information gleaned from texts and instead relied on his own observations and intuition. Notes written on the drawing titled *Study of Female Anatomy,* for example, reveal his assumption that previously unspecified sexual reproductive organs must have a vital function still to be discerned. Despite his inability to publish this work, other artists did eventually gain access through other avenues to much of the knowledge he codified. Models of flayed corpses demonstrating the sinews of musculature, later called *écorchés*, became a staple of academic artistic training by the middle of the sixteenth century. A generation later, with the publication of Andreas Vesalius's *De humani corporis fabrica* in 1543, the rest of Europe at last had a source that matched the unprecedented level of complexity found in Leonardo's mature studies of the human body. Ultimately, Leonardo's emphasis on deductive reasoning over ancient wisdom and divine truths marked a substantial step toward a modern scientific method and represented a huge intellectual leap for practical knowledge.

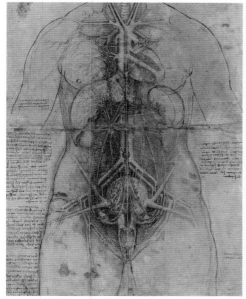

Study of Female Anatomy
(PAGE 180)

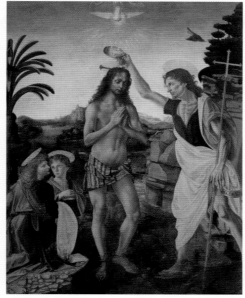

Baptism of Christ
(PAGE 40)

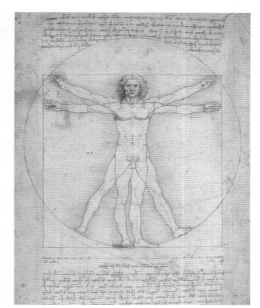

Vitruvian Man
(PAGE 144)

St. John the Baptist
(PAGE 134)

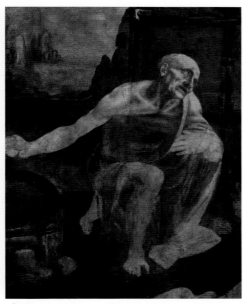

St. Jerome
(PAGE 110)

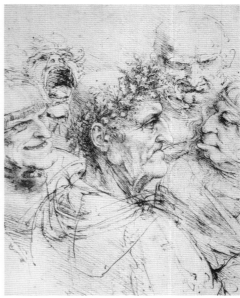

Five Grotesque Heads
(PAGE 166)

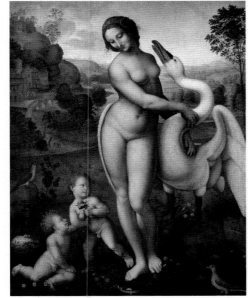

Leda and the Swan
(PAGE 176)

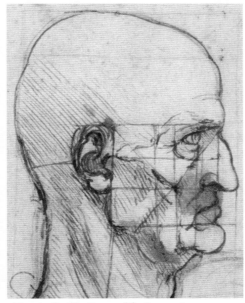

Man in Profile, Squared for Proportion
(PAGE 186)

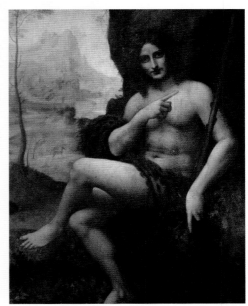

St. John the Baptist (with Attributes of Bacchus)
(PAGE 138)

LEONARDO DA VINCI
(1452–1519)

Man in Profile, Squared for Proportion
CA. 1490 AND CA. 1504

PEN AND INK AND RED CHALK OVER METALPOINT
11 X 8 ⅔ IN (280 X 222 MM)
ACCADEMIA GALLERY, VENICE

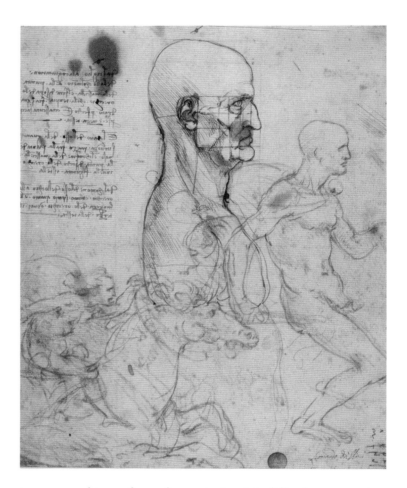

THIS SHEET of studies was likely executed in two phases. The metalpoint drawing of a man's profile is enhanced with pen and ink wash, and this figure, along with the written notes to the left that explain it, probably dates to an earlier point in Leonardo's career, perhaps around 1490, although some scholars have dated it earlier than 1480. The red chalk drawings of the horse and rider, on the other hand, seem to be related to the various studies of horsemen for the *Battle of Anghiari*, discussed in a later entry.

Leonardo was fascinated by the idea of a perfect geometry that underlay outward varieties of the human form. This notion was first proposed in ancient Greece, particularly by the fifth-century-B.C.E. sculptor Polykleitos, whose statue of a spear-bearer, or *Doryphoros*, was nicknamed "the canon" because it embodied an ideal set of proportions. We see Leonardo exploring the specifics, the fleshy protrusions of cheek, neck, chin, brow, and so on, superimposed by a squaring set of lines. In the left margin he wrote: "From the eyebrow to the junction of the lip with the chin, and the angle of the jaw and the upper angle where the ear joins the temple will be a perfect square." He also noted that the hollow of the cheekbone occurs halfway between the tip of the nose and the top of the jawbone. He emphasized that point here with a dark pen mark and the crisscrossing of diagonal lines as he triangulated the face. Leonardo moves so fluidly between observation and mathematical precision that we can readily discern how the man might have a deep fleshy recess at that point in his cheek. He also noted on the sheet that the angle of the eye socket to the ear is equal to the length of the ear, which is one-third of the face. In other drawings and notes, Leonardo measured and calculated such ratios in nearly all the outward parts of the body.

In the chalk drawings of horsemen, Leonardo works through two very different types of poses. The larger figure on the right seems to be an expanded version of the profile squared. In this way we get a glimpse of Leonardo's process: he did not study proportions merely for triviality, but rather with the aim that these sketches would be kept to be used again even years later, to be incorporated into a figure for a painting. It is difficult to ascertain the relationship of the two riders. Are they variations on the same figure or two entirely different figures? One is erect and holds the reins low, seemingly taking a casual command of his horse. We know that he is engaged in battle, however, because he thrusts a long knife horizontally at his side. The lower left figure, conversely, is exuberant, with his hair billowing backward in the wind, and he holds the reins high as the horse strides forth in full gallop. The tenor of stress and action carries through to the face of the horse. Vasari remarked on the importance of Leonardo's horses to the drama in the *Battle of Anghiari*, "for rage, hatred, and revenge are seen in them no less than in the men."

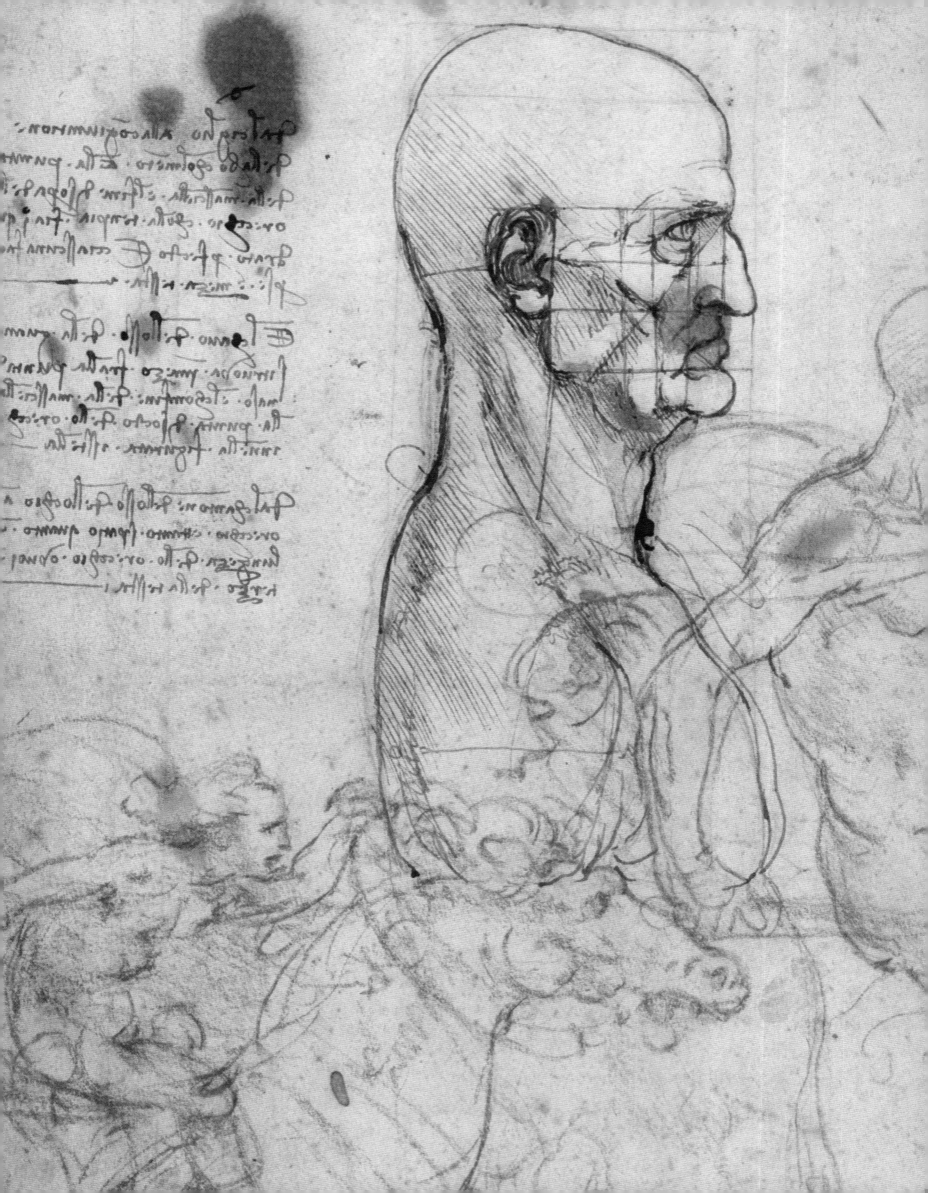

LEONARDO DA VINCI

(1452–1519)

Studies for the Trivulzio Monument

CA. 1508–10

PEN AND INK
11 ½ X 7 ⅞ IN (280 X 198 MM)
ROYAL LIBRARY, WINDSOR CASTLE, LONDON

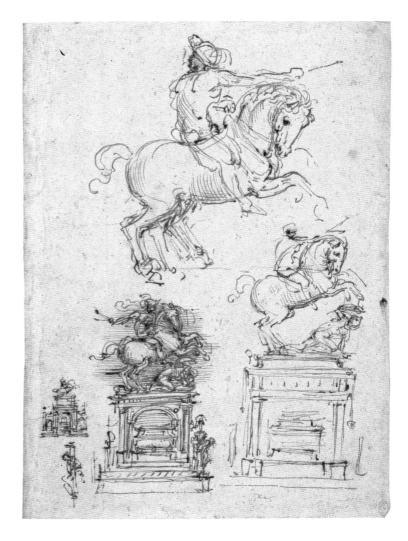

I N 1483 the Duke of Milan, Ludovico Sforza, decided to create a monument in honor of his father, Francesco. He commissioned Leonardo, who proposed an audacious project, a 12-*braccia* (24-foot) bronze equestrian statue. If it had been built as envisioned, it would have been the largest equestrian statue in the world. Leonardo worked on the project until 1499, when it was canceled because of the war between Milan and France.

The Sforza monument was a massive undertaking, and one that would have been extraordinarily difficult to cast in bronze. A contemporary observer records that about 72 tons of the metal were obtained for its creation. Leonardo's first design showed the duke astride a dramatically rearing horse trampling an enemy, but later the sculpture was changed to portray a walking steed. The modification was probably due to the technical difficulties presented by casting a horse of that size in a raised pose: modern analysis suggests that the sculpture would have collapsed under its own weight. Leonardo first constructed a clay model to scale, built four enormous furnaces, engineered a massive crate to transport the model to the work site, and designed a complex set of molds for the casting process. Sometime after 1494, Ludovico, under increasing military pressure, sent some of the bronze for the horse to make cannons. When the duke fled Milan in 1499, the project was abandoned. French archers then used Leonardo's clay model for target practice.

Though Leonardo wrote dismissively about sculpture in relation to painting, he was intrigued with the idea of an equestrian monument as well as the ancient art of bronze casting. Around 1508, he designed another equestrian sculpture. Commissioned by Gian Giacomo Trivulzio (1440/41–1518), a successful *condottiere* for the French, this project was smaller in scope and intended for an indoor location on Trivulzio's tomb. It too depicted a massive rearing horse, a rider in armor, and a defeated soldier. Seen in profile, the rider gestures forward with a baton while looking back, metaphorically urging on the imaginary troops behind. The recumbent enemy raises his hands in fear of the looming horse. The animal is shown in a half-rearing position known as a *levade*; this extremely difficult maneuver requires great skill from both horse and rider. In this flexible and mobile position, the rider can spin his steed away

from the defeated figure; the pose may perhaps convey the rider's mercy as well as his control and mastery.

In a cost estimate supplied to Trivulzio sometime between 1508 and 1510, Leonardo detailed the parts of the proposed tomb. It was to include a carved marble base, the bronze horse and rider, marble festoons, antique coffers and other ornament, an effigy of the general, and six harpies holding candelabra. The sculpture was intended for Trivulzio's funerary chapel in Milan's San Nazaro in Brolo, built by Bramantino in 1512.

Though Leonardo worked for the Sforza for almost two decades, he appears to have had no difficulty accepting a commission from their enemy Trivulzio, who captured Milan for the French in 1499. For Leonardo, politics took a backseat to art. Sadly, this project, like the earlier Sforza design, was never completed.

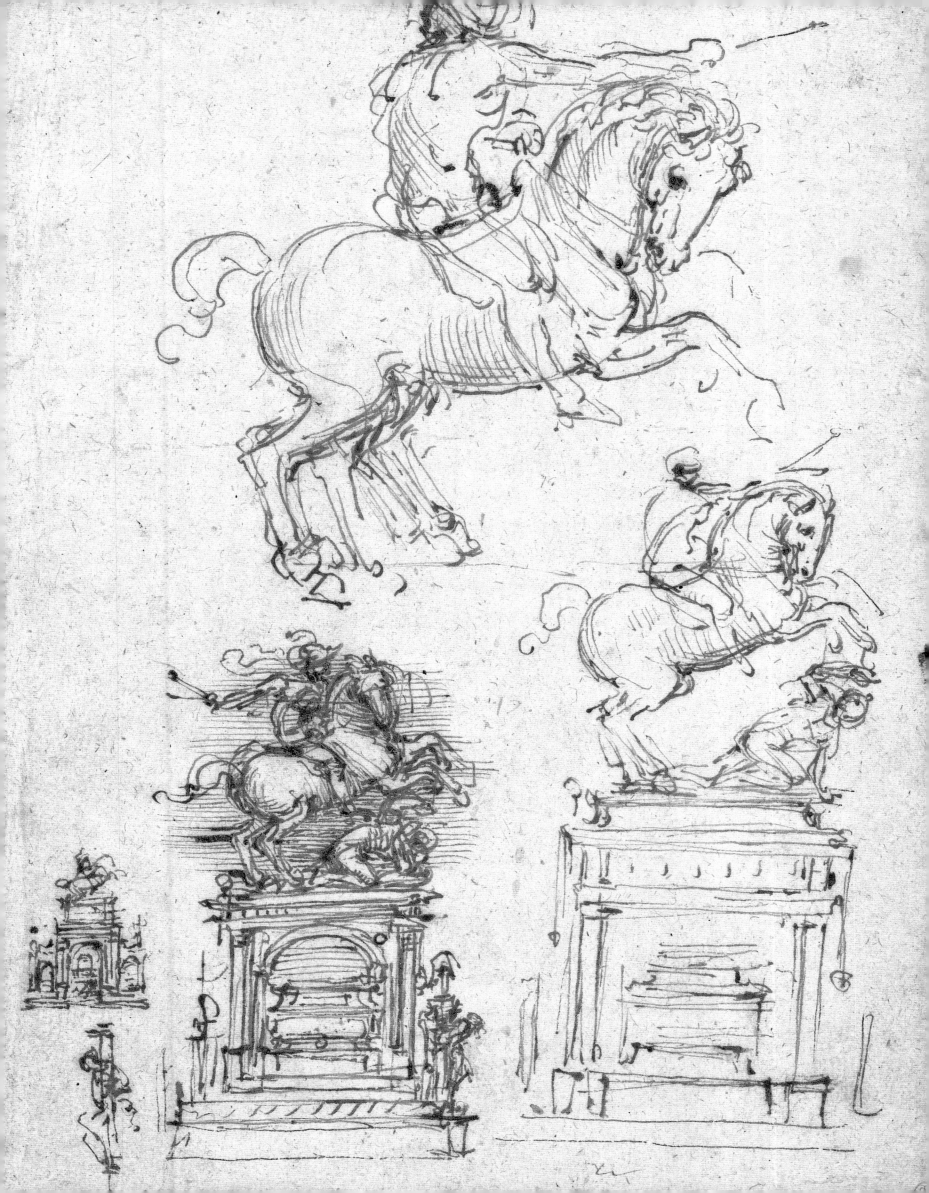

LEONARDO DA VINCI

(1452–1519)

Study of a Warrior in Profile

CA. 1476

METALPOINT
11 ¼ X 8 ¼ IN (287 X 210 MM)
BRITISH MUSEUM, LONDON

AROUND 1482 Leonardo compiled an inventory of the works he had done to date. Arranged by theme, the list showcases his varied talents: he includes botanical studies ("many flowers copied from nature"), inventions ("certain gadgets for ships"), and many examples of "heads." This head is one of Leonardo's most finished drawings, done in the elegant medium of metalpoint. A metalpoint drawing produces a light, silvery line; it is made by marking with a metal stylus on prepared paper, without the possibility of correction. Supple outlines and delicate cross-hatching mark this presentation-quality drawing, demonstrating Leonardo's considerable talents for potential clients. It was probably done during the artist's apprenticeship with Verrocchio in Florence.

Like the other so-called heads on Leonardo's list, this image is an imaginary construction, a type for a warrior rather than a portrait of an individual. Many of Verrocchio's pupils made such ideal heads, and Verrocchio is known to have sculpted reliefs of the famous generals Alexander the Great of Macedonia and Darius, emperor of Persia. Leonardo's image thus references a tradition of creative copying within the workshop and nods to Verrocchio's earlier example in sculpture. In Florence such visual quotations were highly admired. The sculptor Cennino Cennini, in his well-known text written earlier in the fifteenth century, advised aspiring artists to copy work from the past as a means to recognize and study great art. Drawing, or design *(disegno),* was the primary means of learning this kind of lesson, and it remained a foundational skill for Florentine artists. In this drawing, Leonardo not only emulated and referenced Verrocchio's work but also outdid his master in sheer visual inventiveness.

Leonardo drew military characters of this sort several times over the course of his career, suggesting that the type held considerable appeal for him. Several times he set the rugged visage of the soldier against the head of a graceful youth, allowing the contrast between the two to evoke thoughts of the passage of time, the ages of man, and the travails of life. Around 1480 Leonardo wrote in his notebooks, quoting from Ovid, of time as a "devourer of all things" and of "envious" old age as an agent of "lingering death."

The side view used here had a classical pedigree: profiles appeared commonly on antique coinage and medals, which were issued by Roman emperors as a means of advertising and commemorating their power. In this image, the reference to classical models

lends the warrior an aura of authority underscored by his stern countenance. Many Renaissance leaders, whether legitimate or not, adopted the profile view for their portraits, drawing overtly upon this classical legacy to support their own claims to power. Such *all'antica* ideas were especially common in Florence, which in the late 1400s enjoyed a thriving culture of classical revival, fed by the work of humanist scholars and translators.

This youthful drawing thus can be seen as a demonstration of Leonardo's skill at creating effects that both reference the past and emulate present masters. It also advertises the artist's capacity for fanciful invention. The taut reptilian wings on the helmet, paired with the beaklike visor, give the warrior a predatory aspect. Rosettes and garlands, as well as flowing ribbons, contrast with this belligerent effect. Such diverse but striking visual comparisons would have been highly admired in the Renaissance as a demonstration of the artist's creative genius.

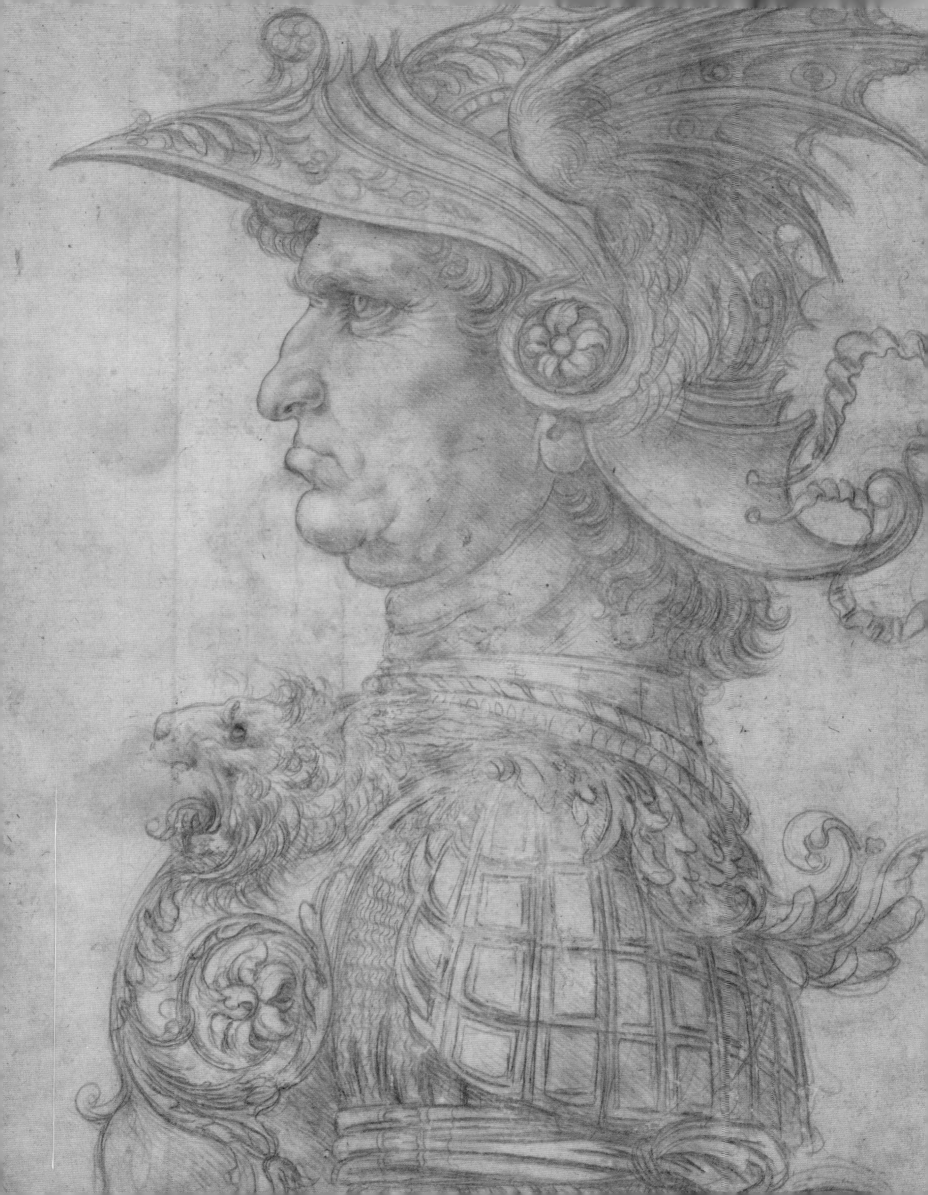

Leonardo da Vinci
(1452–1519)

Study of a Warrior in Profile, details
Ca. 1476

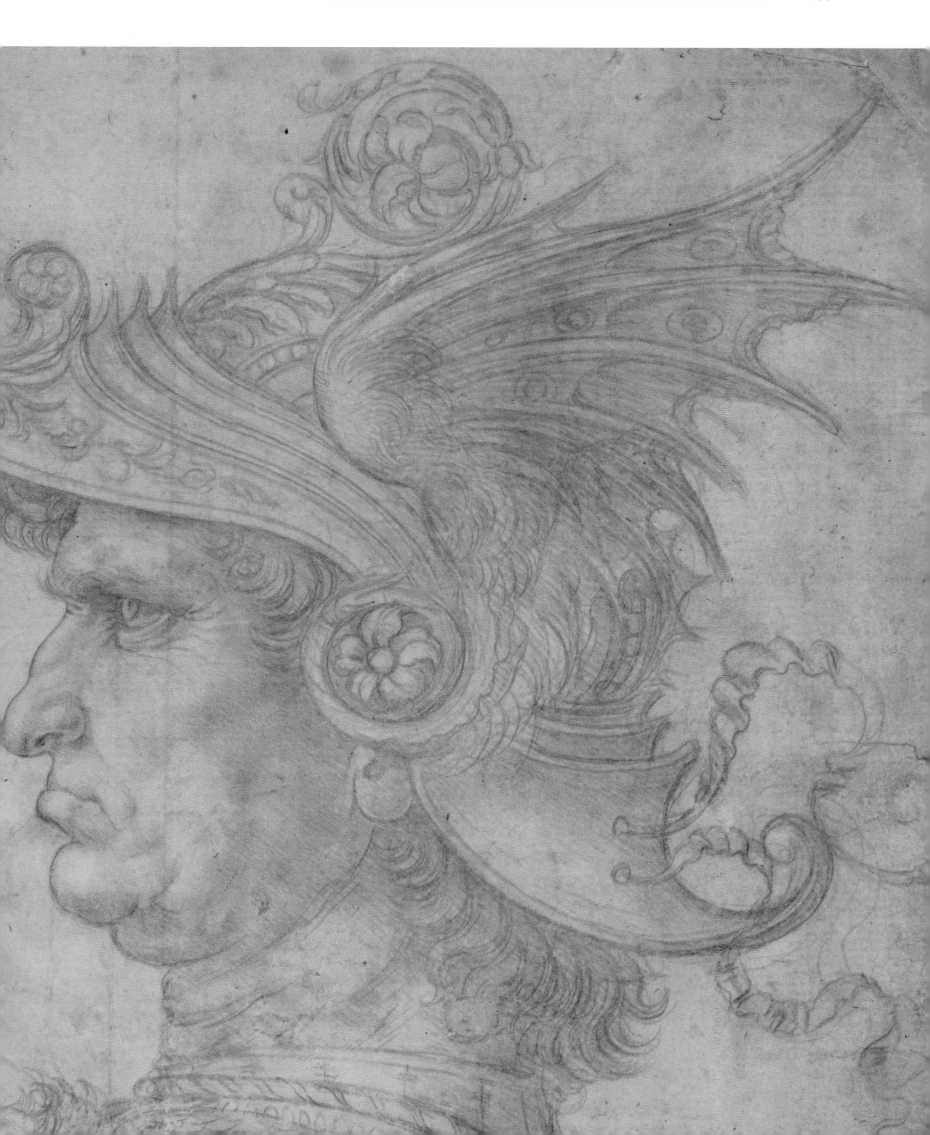

LEONARDO DA VINCI

(1452–1519)

Study for the *Battle of Anghiari*

1503

PEN AND INK
5 ½ X 6 IN (145 X 152 MM)
ACCADEMIA GALLERY, VENICE

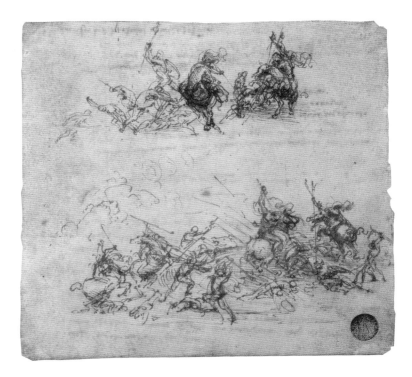

IN 1495 the Republican government of Florence decided to redecorate the town hall, the Palazzo della Signoria. In order to showcase the greatness of Florence, council members chose patriotic themes from the city's history and commissioned their best artists. For the main council chamber, the Sala del Gran Consiglio (today the Salone dei Cinquecento), they ordered elaborate carved wainscoting by Baccio D'Agnolo, an altar-piece by Filippino Lippi, and a grand new sculpture by Jacopo Sansovino. In 1503–4 two enormous (as large as 18 by 7 meters) frescoes depicting past Florentine victories were also commissioned: one from Leonardo for the Battle of Anghiari, and another from Michelangelo for the Battle of Cascina. However, the project was never realized. Neither Lippi nor Sansovino completed their works; Leonardo abandoned his partially finished fresco when he left Florence in May of 1506, and Michelangelo never began his painting at all. In the 1560s, Leonardo's work was destroyed by Giorgio Vasari during yet another renovation of this important civic space.

The Battle of Anghiari occurred in 1440, during Florence's war with Milan. Leonardo's fresco showed the famous episode of the capture of the Milanese flag by Florentine horsemen. Though the painting is lost, its design is known from a group of preparatory drawings as well as several later copies (including the one by Peter Paul Rubens, discussed next). In these early sketches Leonardo captured several ideas for the composition, using a quick gestural style and frequently revising. On the lower part of the sheet, he shows variations on the central scene for the fresco: the battle for the standard. In the right sketch, a rider on a wheeling horse grabs at the standard (shown as a vertical line) as his comrade pummels a fallen enemy. In the left sketch, foot soldiers are locked in combat while desperate horsemen whirl around the standard, now diagonal. This second iteration was the one Leonardo developed into the central scene of the final painting. By focusing on the precariously toppling standard, he highlights the drama of the moment. As the soldiers grapple frantically, the battle literally hangs in the balance.

This sheet also provides insight into Leonardo's unusual artistic process. Here, he sketched out several concepts for the scene and then revised them, adding thicker lines and wash to eliminate some parts while emphasizing others. (This technique can also be seen in the drawings related to the *Benois Madonna*.) In the process, he condenses the figures, adds dynamic action, and intensifies the fighting around the flag. Though he has not yet moved to the stage of defining individual figures, Leonardo is clearly interested in capturing the physical brutality, emotional urgency, and searing violence of war. Such graphic emotional intensity, a trademark of his art, was highly admired by contemporary observers as well as other artists.

Leonardo spent almost two and a half years on this project, which was meant to be a showpiece not only for the Florentine Republic but for himself as well. In addition to highlighting his skills as an artist, he chose an experimental approach to fresco. Documents show that he received loads of sponges, pitch, and resin for use in sealing the plaster before applying the oil paint, and that he lit fires under the wall to help dry the surface. As in the *Last Supper* fresco, however, the experiment was a failure. Today, the only remains of Leonardo's great public work of art are copies.

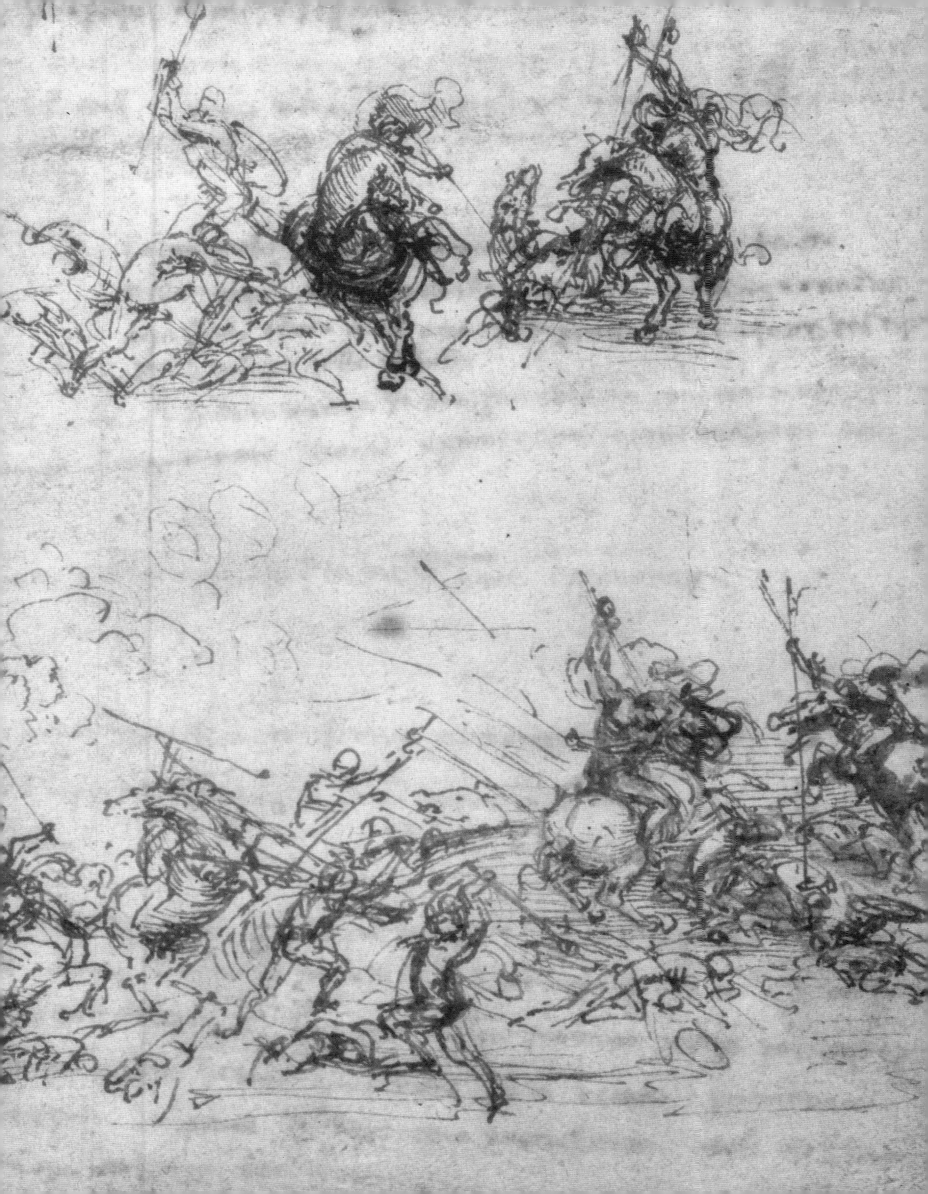

PETER PAUL RUBENS

(1577–1640)

Copy after Leonardo da Vinci's Battle of Anghiari

CA. 1603

BLACK CHALK, PEN, AND BROWN INK, HEIGHTENED WITH WHITE
17 ¾ X 25 IN (452 X 637 MM)
LOUVRE MUSEUM, PARIS

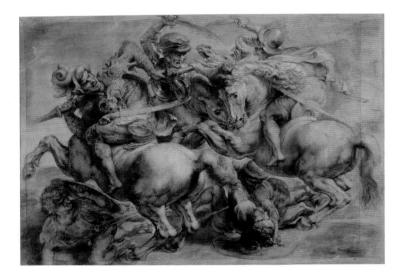

LEONARDO'S unfinished fresco representing the Battle of Anghiari (see also the previous entry) was recognized in its own time as a masterpiece. Later writers extolled its virtues in depicting the details of battle and the overall fury of armed conflict. Even though it was just a fragment, the painting was so popular that in 1513 the city government erected a protective fence around it. Leonardo's fresco was replaced with another scene in the 1560s, but already it had been widely copied. In the early seventeenth century, Peter Paul Rubens made this compelling drawing after one of the earlier copies. Rubens captured Leonardo's depiction of the emotional and physical mayhem of war.

This drawing reproduces the central scene of Leonardo's enormous composition. It shows four figures struggling over the Milanese standard, a central moment from the Battle of Anghiari that occurred on June 30, 1440. On the left are two of the most hated men in Florence, the Milan general Niccolò Piccinino (center left) and his son Francesco (far left). Niccolò was a *condottiere* who had abandoned Florence to work for the Milanese; Francesco was known for his brutal behavior in war. The Florentine and allied leaders are on the right side.

Rubens's free copy highlights the complex interlocking composition that Leonardo had developed in his preparatory drawings (shown on the previous page). The forms are densely packed into a small space. The horses are on different trajectories; they collide around the diagonal line of the standard. Grabbing frantically at the flag while swords fly, their frantic riders create a balanced but turbulent arc above. Fighting foot soldiers fill the negative space below. The parts are so closely crowded that some merge into others, capturing the desperate confusion of hand-to-hand combat.

In line with his concept that figures should express inner emotions, Leonardo painted the heads in his scene to capture the different states of battle. Rubens focused on Leonardo's heads, using lead white to heighten the details and highlight the emotions. Francesco Piccinino, at far left, is shown in a state of

extreme rage; his face is distorted by wrath, and his arms and torso are violently contorted. As his body fuses with his horse, Leonardo seems to be suggesting that Francesco is himself a beast, and that he shares the violent and uncontrolled nature usually ascribed to centaurs. The soldiers on the right—not by coincidence, Florentines—are equally vigorous and equally engaged in the conflict, but their figures and faces express a ferocity that is controlled, registering their intellectual and moral superiority over their opponents. Even their horses behave well; where the Milanese horse fights dirty, the Florentine one shows mercy by trying to avoid treading on the fallen below.

Though the Florentine audience certainly knew the outcome of the story (the Florentines capture the Milanese flag and the enemy is routed), Leonardo does not show the victory. Instead, he chooses a moment of contest, when it is unclear which side will prevail. The composition contrasts the ferocious energy of the figures on the left with the determination of the riders on the right. As they fight, even the horses enter into the melee, rearing, kicking, and biting. The scene is not patriotic (though it is possible to detect which side is Milanese and which Florentine); rather, it emphasizes the emotional immediacy and violence of war.

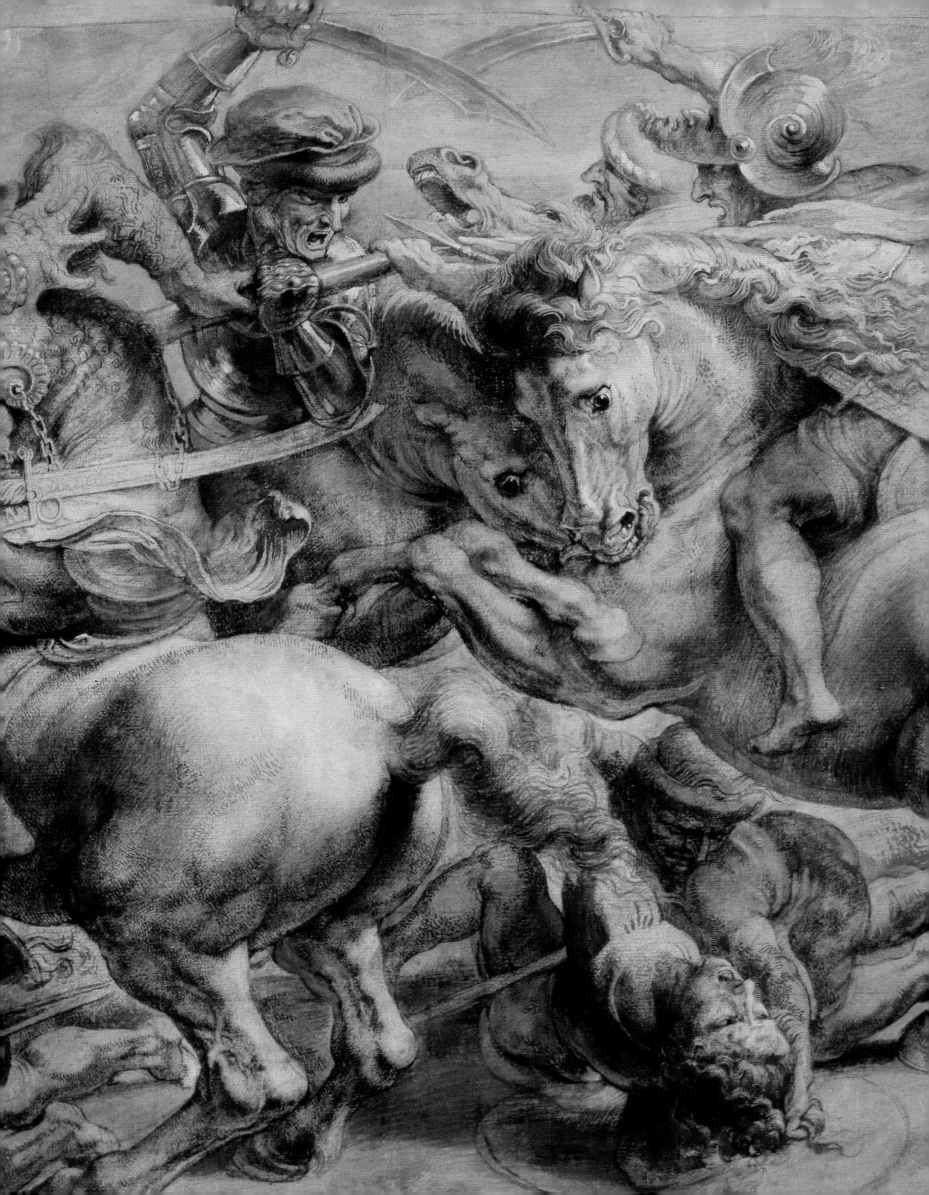

LEONARDO DA VINCI
(1452–1519)

Design for a Tank and Chariot with Scythes
CA. 1487

PEN AND INK WITH BROWN WASH
6 ¾ X 9 ½ IN (173 X 245 MM)
BRITISH MUSEUM, LONDON

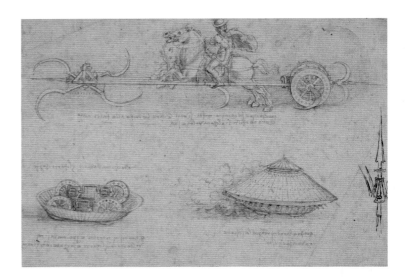

IN THE Renaissance, war was constant. The various Italian city-states were perpetually at odds with one another or defending themselves against foreign invaders. In this climate, *condottieri* and mercenary soldiers were a necessity; engineers, surveyors, and mapmakers were also in high demand. Milan was a military center, and Leonardo worked there as an engineer for Duke Ludovico Sforza during the 1490s.

This drawing shows two military inventions: a horse-drawn chariot with whirling scythes and an armored car with automatic weapons. Ideas for such conveyances had been around since classical times. In 1472 Roberto Valturio had published *De re militari*, an overview of ancient military practice and technology, which Leonardo certainly knew and in which a description of this kind of chariot appears. As in Leonardo's other military inventions, such as the famous giant crossbow, there is an element of self-conscious display in these drawings. Such contraptions were a useful way to get attention in the Sforza court. The drawings mix classical humanism, military history, and Leonardo's inventiveness with a dash of gruesome possibility.

Like many of the ideas in Valturio's book, this sketch shows concepts, not prototypes. Leonardo himself expressed uncertainty about whether the devices would work: of the chariot he wrote that it could "do as much damage to friends as [it] did to enemies." The inscription under the top drawing adds a further warning: "When this travels through your men, you will wish to raise the shafts of the scythes so that you will not injure anyone on your side." Many of the drawings in Leonardo's notebooks, such as this one, are for gadgets. In this period, Leonardo sought ways to execute repetitive tasks using machinery, like ratchets, screws, and levers. He probably learned about such machinery while working with Verrocchio on the Florence Cathedral dome, where Brunelleschi's famous hoists, gears, and other inventions were still in use.

At the bottom of the sheet are designs for a tanklike vehicle. Leonardo wrote specifically of this invention in a letter to the duke: "I can make armored cars, safe and unassailable, which will enter the serried ranks of the enemy with their artillery, and there is no company of men at arms so great that they will break it. And behind these the infantry will be able to follow quite unharmed and without any opposition." On the right, the four-wheeled circular vehicle is in motion, its velocity conveyed by horizontal lines emitting a cloud of smoke and dust. Guns fire from just below its central lip, barraging the enemy from all sides. On the left, we see the interior and its workings; a crank runs each set of wheels. Leonardo envisioned eight soldiers inside turning the cranks to provide momentum and maneuverability. However, the design does not show how the automatic firing of the guns would be accomplished. Though such a car might well have been a useful piece of military materiel, the omissions confirm that the drawing was more fantasy than technological reality.

Military work was one of Leonardo's primary occupations, but he despised the destructiveness of war. In drawings such as this, the realities of battle appear suspended, and the "beastly madness" of combat gives way to the charms of a wonderful machine.

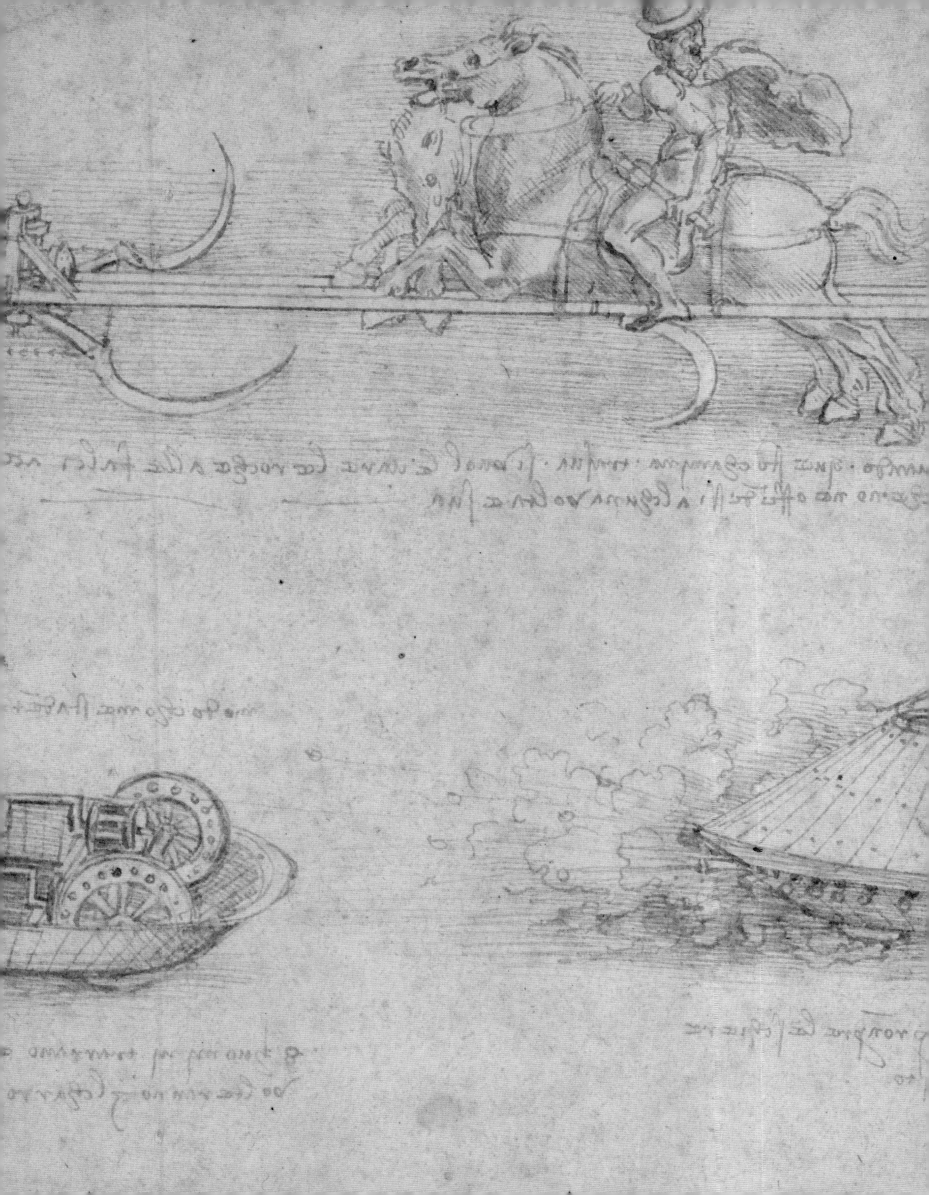

LEONARDO DA VINCI
(1452–1519)

*Design for a Tank and
Chariot with Scythes*
CA. 1487

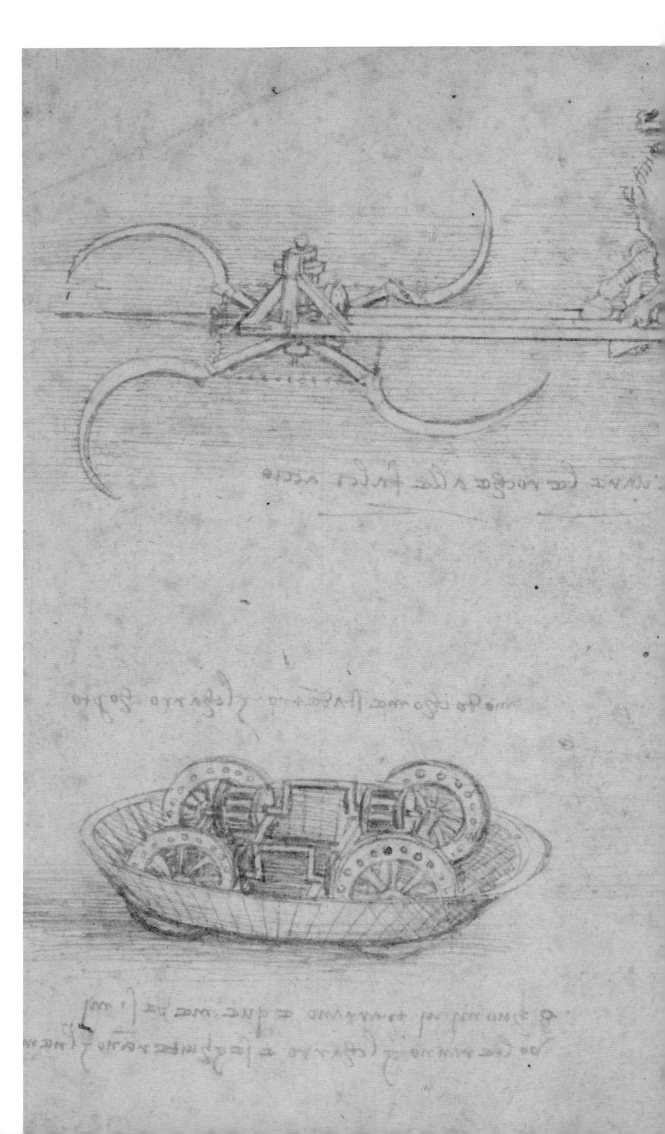

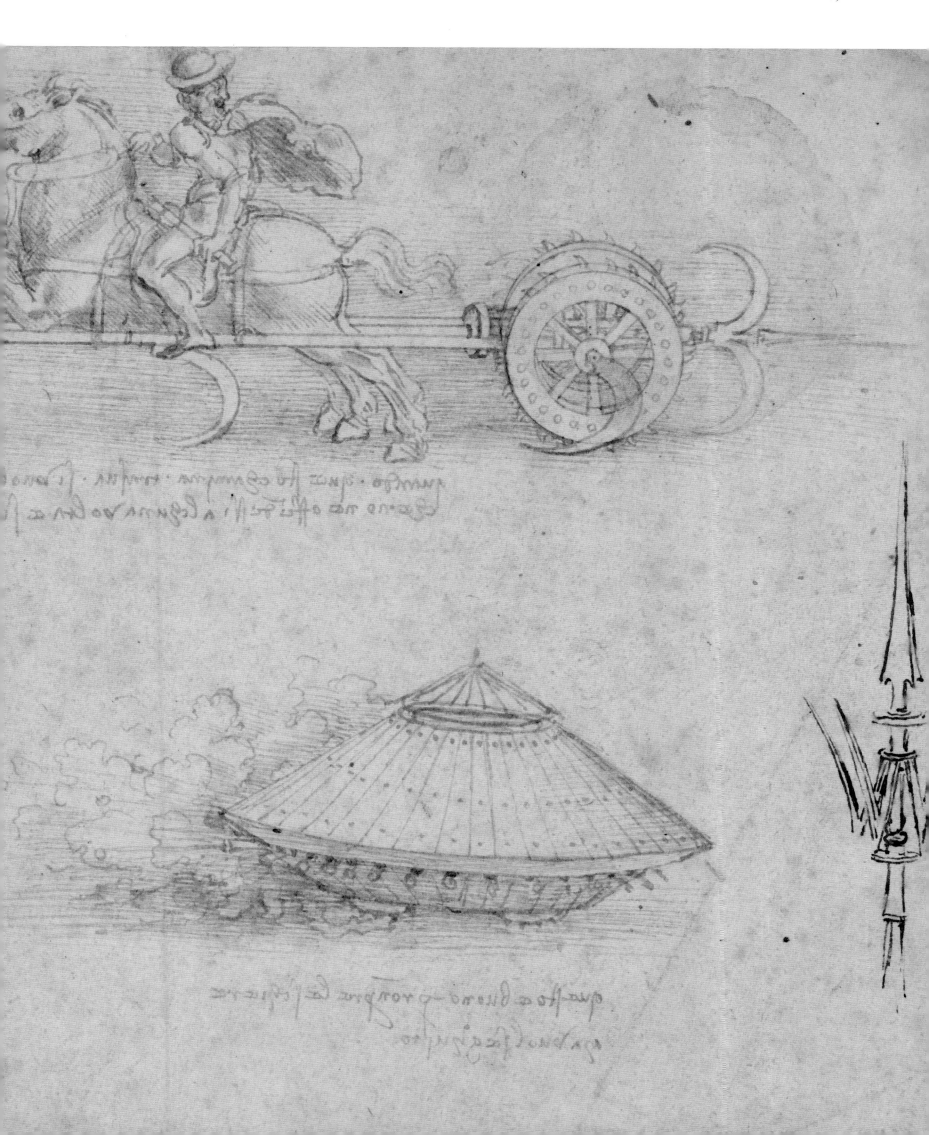

LEONARDO DA VINCI

(1452–1519)

Design for an Ornithopter Wing
CA. 1490

PEN AND INK
14 ½ x 10 ¾ – 11 ⅓ IN (369 x 272–289 MM)
BIBLIOTECA AMBROSIANA, MILAN

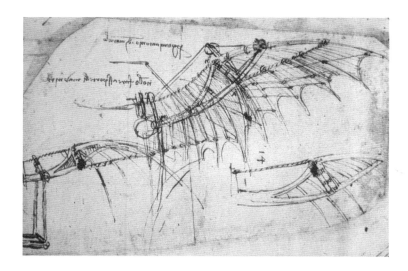

T HIS DRAWING for a mechanical wing is pasted onto a page of the *Codex Atlanticus*. The other drawings and notes on the page are from a later date. Leonardo often dismembered his drawings and notebooks as he put together his book projects; alternatively, the fragment may have been inserted there by Pompeo Leoni during the course of assembling the codex after Leonardo's death.

Leonardo studied the problem of human flight for much of his life. In Milan, he designed mechanical wings for theatrical performances, probably intended for use at the court of Ludovico Sforza. Drawings for machines that would actually fly appear in the *Codex Atlanticus* from about 1485 to 1515, and images and notes on the flight of birds fill most of his *Manuscript K*, from 1503–5. In 1505 Leonardo completed his treatise "On the Flight of Birds," which examined the question of flight from a natural-history perspective. Later, the artist worked on projects for gliders, which involved investigation of the properties of air and wind. In all these studies, Leonardo combined interest in engineering gadgetry (mechanical wings, human-powered flying machines, helicopters, and the like) with his careful observation of the natural world (birds, wind, thrust, and weight) and his concern for scientific principles (physics, meteorology, and aerodynamics).

Given the contemporary understanding of air as a material with its own density, the crucial component in Leonardo's plan for human flight was energy. After first lifting the wings, Leonardo thought the downward flap would compress the air, creating an upward movement. He constructed several experiments to measure empirically the kind of force a man could generate, studying whether it would be enough to lift his own weight (and the weight of the machine) off the ground. This drawing focuses on the design of the wings and the system of pulleys used to move them, seeking the most efficient solution to the problem.

The design at the center appears to be an elaboration in more specific form of the drawing on the left. Two vertical rods hold the wing in place and provide the base for the pulleys that stretch over the tops of the wings. These ropes would provide the vertical pull needed for the flapping motion. The outer portions of the wing are articulated, just like those of a bird, to increase both strength and flexibility; Leonardo devoted the detail drawing on the lower left to solving the problem of how to link the "bones" of the machine to the rope system. In other drawings, he showed how a pilot would sit (or stand) within the contraption, creating power by turning handles or pedals and steering with the head.

Leonardo never built or tested any of these machines, though in one manuscript he mentions trying out a design over a local lake. According to legend, one of his students did attempt to fly in such a machine and subsequently broke his leg. In reality, there is little chance any of these designs would have flown, and certainly not for any distance: the energy required by the pilot was simply too much to be sustainable. Later, Leonardo drew a fixed-wing glider intended to soar like bats and birds at rest: this design has been successfully built and flown in recent years.

LEONARDO DA VINCI
(1452–1519)

Lady with an Ermine (Portrait of Cecilia Gallerani)

1489–90

OIL ON PANEL
21 X 15 ½ IN (55 X 40.5 CM)
CZARTORYSKI MUSEUM, KRAKOW

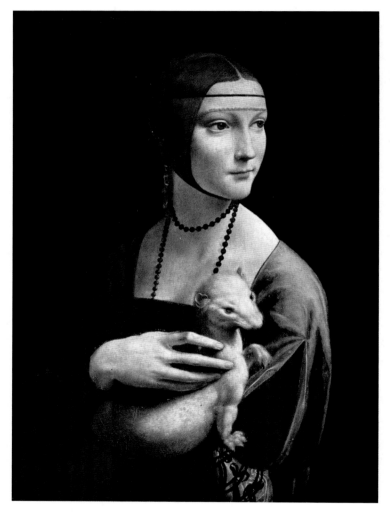

LEONARDO PERFORMED several different duties at the court of the Duke of Milan, Ludovico Sforza (known as Il Moro, "the Moor"). In addition to designing military, engineering, and hydraulics projects, the artist staged lavish court pageants. These were all part of Ludovico's program of consolidating his power through magnificent display. As court painter Leonardo was also called upon to make images for the duke. This is the first of two portraits of his patron's mistresses, done between 1489 and 1495 (the other is *La Belle Ferronnière*).

This portrait breaks with long-standing traditions in Italian Renaissance portraiture by placing the figure at a three-quarter angle, rather than in profile. The woman turns to her left, but her torso and head swivel to the right as she looks over her shoulder, clasping an ermine to her chest. This moving stance imbues the portrait with a lively quality, as if the woman is responding to something outside the picture plane. Simultaneously still and reactive, the figure communicates both the sitter's physical reality and her attractive personality. Leonardo used three-dimensional volumes, which flow effortlessly into one another, to lead the viewer's eye from hand to ermine to sloping shoulder and finally to his subject's lovely face. She is Cecilia Gallerani (1473–1536), a woman of noble birth who by 1489 had become Ludovico's mistress. Shown here at age sixteen, Cecilia displays a refined beauty that is striking. But the portrait is more than just an image of a pretty girl. Its appeal derives from Leonardo's artistic choices: the harmonious relationship of forms, which conveys her elegant deportment; the charming correspondence between the girl and her pet; and the radiant light that highlights her welcoming expression. Leonardo strove to express Cecilia's "motions of the mind." That a person's outward movements should express inner emotions would become a key concept in later paintings.

The background has been darkened by a nineteenth-century overpainting; the original color was a light blue-gray. The artist's powers of observation are evident here in the ermine, which seems to pose with a feline alertness in the girl's arms. Admired among the nobility for its snow-white coat, this sleek animal was associated with ideas of moderation and virtue. It was believed that the ermine ate only once a day and, as Leonardo wrote in one of his notebooks, "would rather die than soil itself." A connection can be made with Cecilia herself, for the Greek word for ermine (*galée*) mimics her surname. The metaphor can be continued in complex ways that were typical of courtly intellectual games: the ermine could refer to Ludovico himself, her lover, who received the aristocratic Order of the Ermine in 1488; alternatively, it could characterize their romance as a pure one. The ermine might also allude to the classical story of Alcmene and Zeus, whose illicit union led to the birth of Hercules, despite Hera's interference; Alcmene's maidservant Galanthis was turned into an ermine for assisting with the birth. In 1490 Cecilia was pregnant by Ludovico. She gave birth to their son Cesare in 1491, much to the displeasure of the duke's new wife, Beatrice d'Este. Soon thereafter, Cecilia married and retired from the court; she kept the portrait with her for the rest of her life.

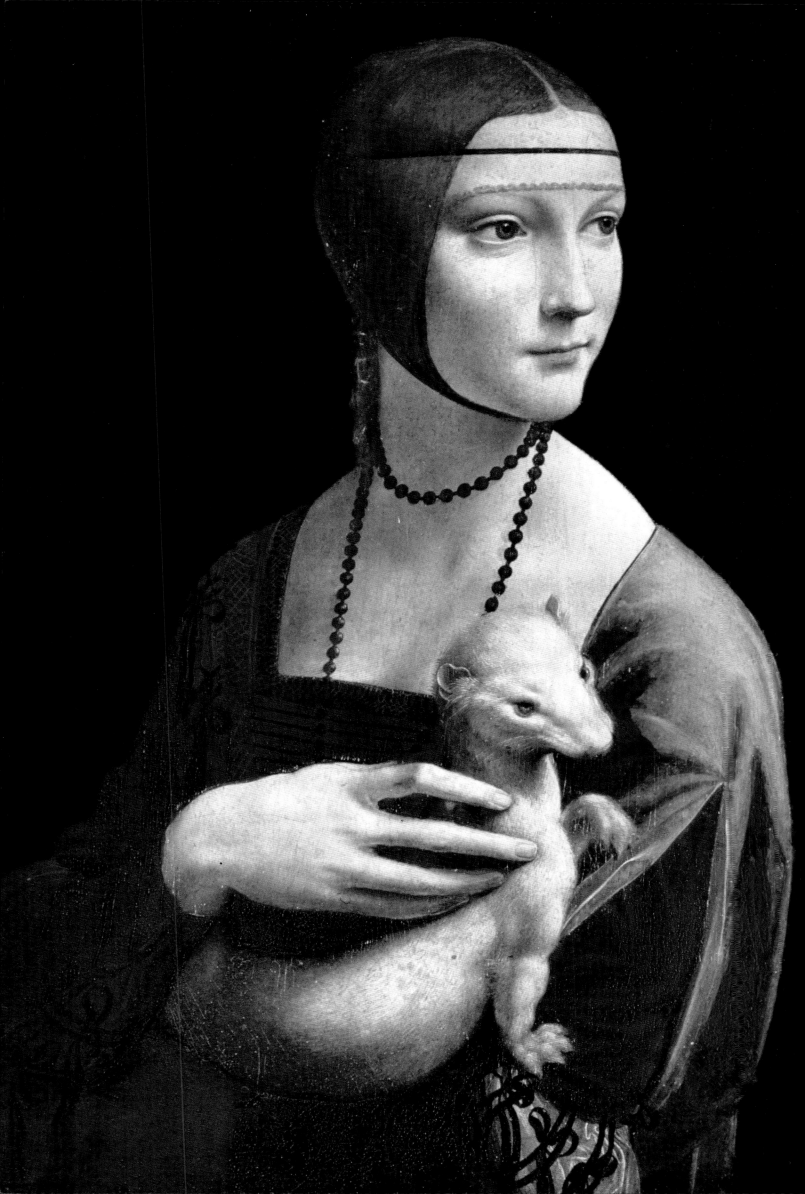

LEONARDO DA VINCI
(1452–1519)

Ginevra de' Benci
CA. 1475–78

OIL AND TEMPERA ON PANEL
15 X 14 ½ IN (38.1 X 37 CM)
NATIONAL GALLERY OF ART, WASHINGTON D.C.

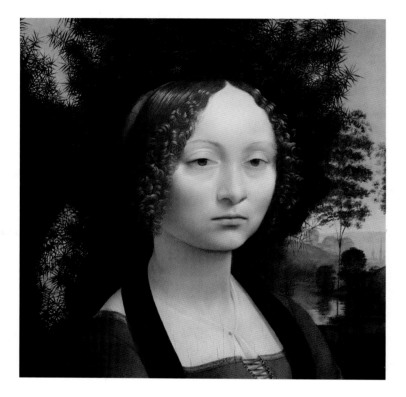

ONE OF Leonardo's first independent commissions, this portrait has long been admired as a seminal work of the artist's early career, both for its experimental craftsmanship and for the interesting visual riddle it contains. It shows Ginevra de' Benci, the daughter of a wealthy Florentine merchant. She married Luigi di Bernardo di Lapo Nicolini on January 15, 1474, at age seventeen.

Though well preserved, the painting does have some problems, notably the wrinkling of the paint in the background, which marks Leonardo's early experiments with the medium of oil paint. The details of the figure are exquisitely rendered, however, from the soft rosy glazes on her lips and cheeks to the textured curls on her brow. Leonardo created some of his characteristic atmospheric effects by pressing his fingertips and palms into the paint when still wet, thus blending the edges of forms and creating the impression of air.

The panel has also been cut down at the bottom and on the right. From preparatory drawings and later copies, we know that the portrait originally showed Ginevra's hands folded in front of her. The figure is placed in front of a dense juniper bush, with a view over a landscape on the right. This type of setting is unusual in Florentine portraits and shows the influence of Northern European art; Leonardo probably drew upon the example of Flemish painter Hans Memling (ca. 1430?–94), an elegant portraitist admired in Florence. Leonardo uses the motif to create an enclosed effect; within this bower (itself a symbol of virginity), both the bush and the girl are rendered as three-dimensional objects bathed in golden light and surrounded by soft atmosphere.

The juniper bush behind Ginevra makes a pun on her name (juniper is *ginepro* in Italian) and is also a symbol of chastity. Chastity is the subject of several poems written about Ginevra by an admirer, the poet and Venetian ambassador Bernardo Bembo. In keeping with chivalric tradition, Bembo's relationship with Ginevra (which began in 1476) was platonic, and his poems extolled her as an unattainable object of beauty and virtue. This painting has the same theme: rather than a depiction of her personality, Leonardo's image presents Ginevra as an icon of beauty, purity, and artistry.

In contrast to the striking naturalism of the portrait, the reverse of the panel portrays Ginevra intellectually. Here, Leonardo presented a visual poetic device (known as an *impresa*): branches of palm and laurel enclose a sprig of juniper, again reinforcing the pun on his subject's name. The plants carry associations of moral and intellectual virtue, respectively, as well as chastity. The inscription reads "Virtutem forma decorat" (Beauty adorns Virtue), and the device conceptually encapsulates the key elements of Ginevra's character. Both the device and the inscription, painted curling around the stems of the plants, are drawn from Bembo's own *impresa*, suggesting the painting may have been done on his instigation.

This sort of poetic play on words and images was highly admired in Renaissance intellectual circles. The front image gives the viewer a portrait in the "living color" of oil paint; on the back, the tempera device is a form of painted poem. In this painting, Leonardo embarks on one of his favorite games, known as a *paragone* (competition among disciplines). The panel tells the viewer that all that poetry can do, painting can do, too—and better.

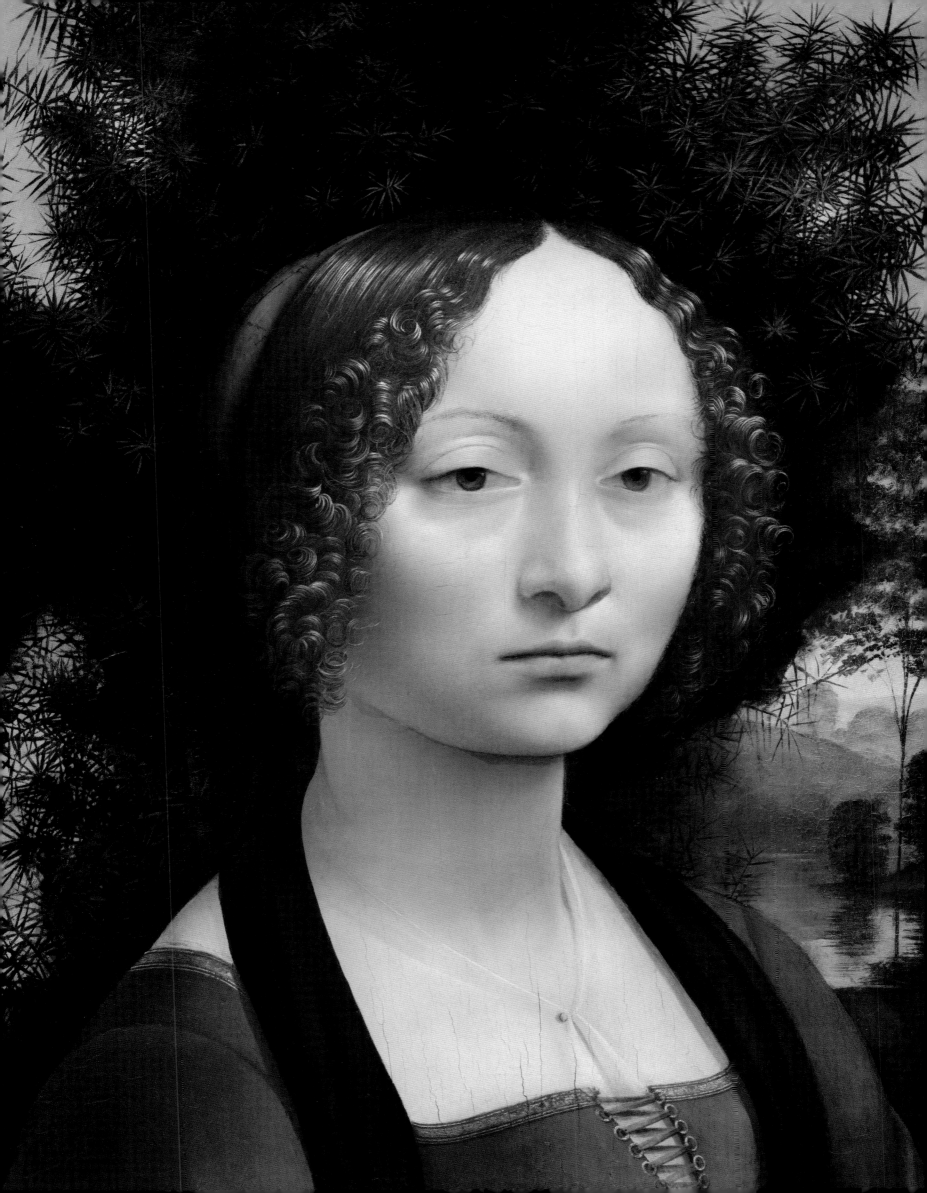

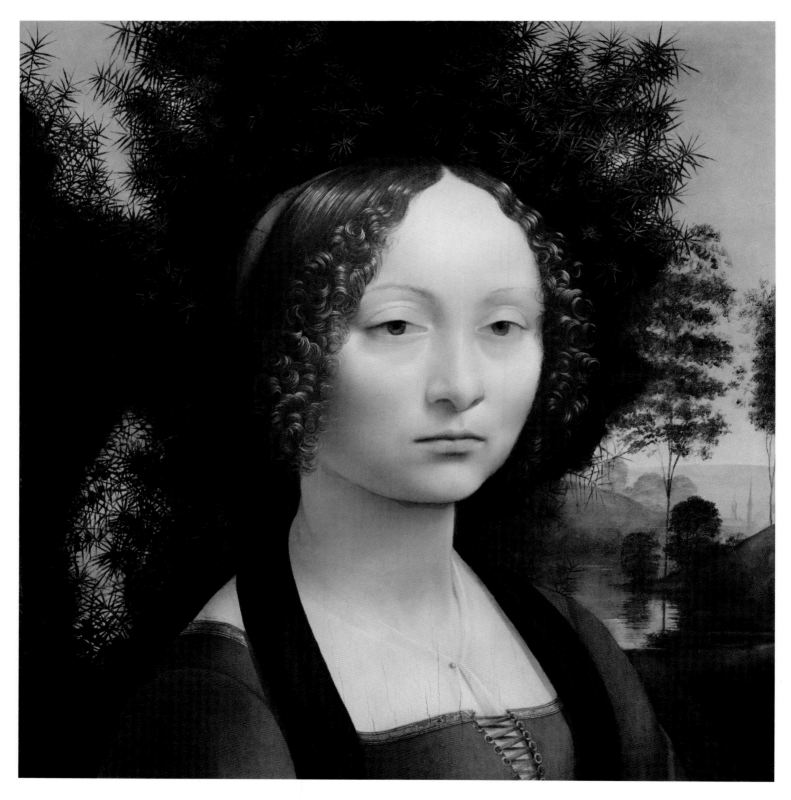

LEONARDO DA VINCI
(1452–1519)

Ginevra de' Benci,
front and back
CA. 1475–78

GIORGIONE
(1477/8?–1510)

Laura

1506

OIL ON CANVAS ATTACHED TO PANEL
16 X 13 ¼ IN (41 X 33.6 CM)
KUNSTHISTORISCHES MUSEUM, VIENNA

A WOMAN STANDS against a plain background decorated by a branch of laurel, her rich fur-trimmed cloak falling open to reveal a bare breast. Interpreting this image by the Venetian painter Giorgione presents many problems.

One access point to its meaning is provided by a connection between Giorgione and Leonardo. Leonardo was in Venice in March of 1500; Vasari described the younger artist as deeply influenced by Leonardo's style. Indeed, this painting refers to the latter's portrait of Ginevra de' Benci. But unlike Ginevra, who is set fully within the landscape, Giorgione's Laura poses in a self-conscious manner in front of a laurel branch. The connection between the foliage and the women is similar, however, and scholars have wrestled with the meaning of the laurel in Giorgione's painting. Does it refer to her name and thus to the famous sonnets written by Francesco Petrarch in the fourteenth century in honor of his muse? Is the signal of a female writer, perhaps a poetess, who stands before the leaves adopted by Apollo, god of poetry? Is she an image of the nymph Daphne, whose chaste resistance to Apollo caused her to be transformed into a laurel tree? Is she a seductive courtesan or a Venetian lady?

The painting complicates the viewer's understanding by subtly manipulating expectations. Such ambiguity is typical of Giorgione's works, which resist clear narratives in favor of more empathetic and poetic subjects. Unlike the portrait of Ginevra, this image contains no inscription identifying the woman. Though the painting certainly refers to Petrarch's Laura, who served as the poet's subject as well as a manifestation of his creative genius, this woman has dark hair and tawny flesh. (Petrarch's Laura was famously blonde, with snow-white skin.) If she is a female poet (as Ginevra was), what purpose would her half-clothed state serve? Though some scholars have tried to explain the nudity as a reference to chastity in marriage, such sensuality would have been entirely inappropriate in a portrait of a Venetian matron. The woman holds the edge of her fur-trimmed robe, bringing attention to her partial nudity. She occupies a liminal space, between poetic object and pictured woman, between female and male (the robe is a masculine outer garment), between inside and outside, between object and subject, and between socially celebrated beauty and its opposite, prostitution. Thus the portrait presents several avenues for exploration and, by denying each, forces the viewer to reengage with the image, deepening appreciation.

Another connection to Leonardo is the reference to the *paragone*, the ongoing rhetorical competition between the arts. Petrarch himself composed sonnets after a painting by the Trecento artist Simone Martini, using the occasion to argue that art could never rival the power of poetry to describe the beauties of the world (in this case, Laura) and to reveal truth. Leonardo denounced such claims in his writings; in fact, his portrait of Ginevra de' Benci makes the opposite claim. Giorgione's painting engages with this ongoing debate, cleverly inserting a poetic reference into this image of "Laura" but also insisting that his painting (which is clearly not Laura) transcends mere Petrarchisms.

Giorgione's few works were avidly collected by wealthy Venetian merchants and patricians. When the renowned collector Isabella d'Este, marchioness of Mantua, tried to acquire one of his paintings in 1510, not a single one was available.

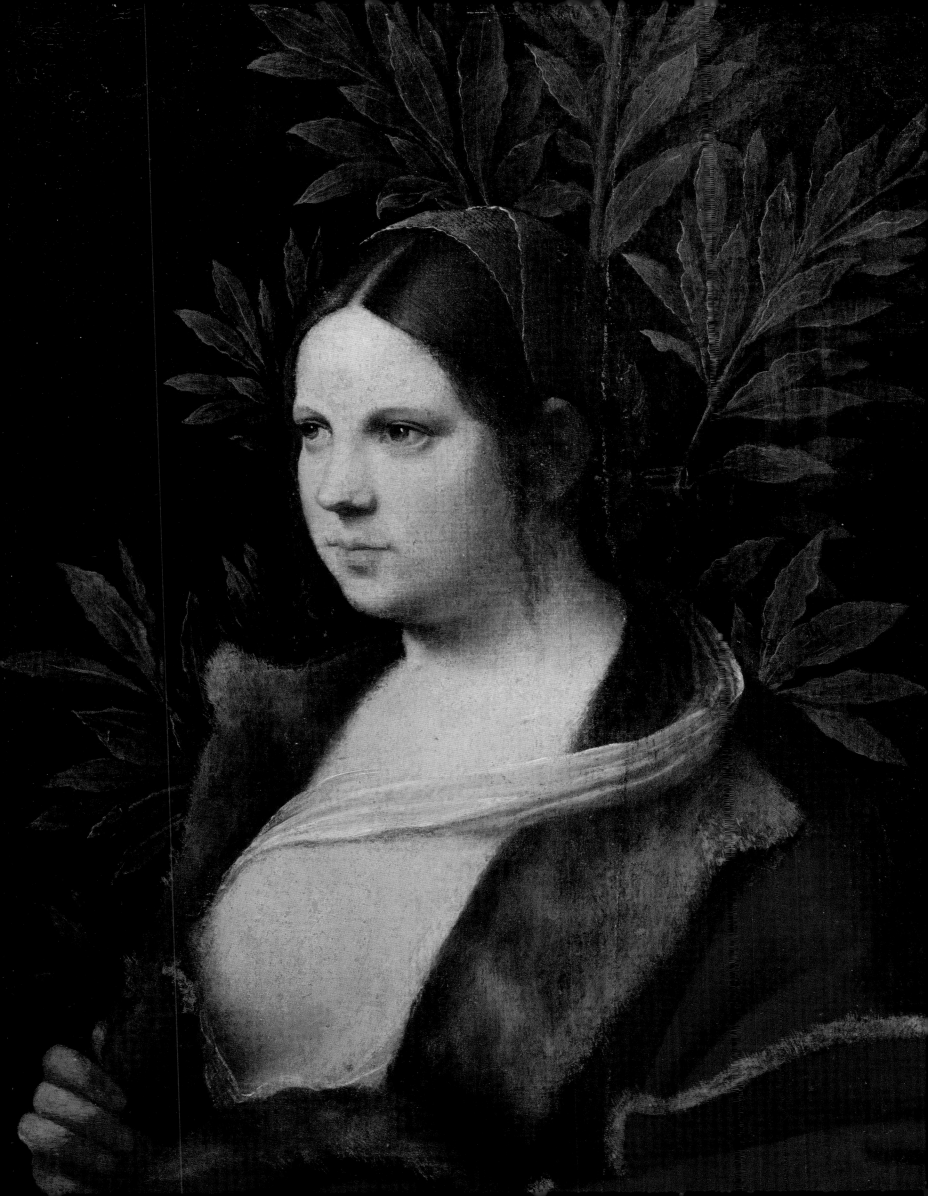

LEONARDO DA VINCI

(1452–1519)

La Belle Ferronnière

CA. 1490–95

OIL ON PANEL
24 X 17 IN (64 X 45 CM)
LOUVRE MUSEUM, PARIS

THE IDENTIFICATION of the sitter in this painting may derive from a poem in the *Codex Atlanticus*, the largest collection of Leonardo's documents, assembled in the late sixteenth century by sculptor Pompeo Leoni. In the poem, the author praises the noblewoman Lucrezia Crivelli (mistress of Ludovico Il Moro around 1496–97), salutes the honor and power of her lover, and pays tribute to the skill of the painter. Not all scholars accept the painting as a portrait of Lucrezia Crivelli; both Ludovico's previous mistress Cecilia Gallerani (at an older age) and his wife, Beatrice d'Este, have also been proposed.

In this painting Leonardo has chosen to place the woman against a stark background, dramatically emphasizing her physical presence behind the foreground parapet. As in the portrait of Cecilia Gallerani, her body is set in a moment of counterpoise, with her head turning off axis toward the viewer. Her eyes continue that movement, just missing the viewer's gaze as she looks to the right. Leonardo appears to be endeavoring to establish the volumetric qualities of a painted form, in line with his writings at the time on vision and lines of sight.

The portrait accords with Leonardo's strictures for images of women: she is shown with "demure actions," with her arms held tightly together, her head lowered and tilted to one side. The woman's social position, however, is unclear. Though she is dressed in rich fabrics, she wears no ostentatious jewelry. She therefore cannot be a recent wife or bride, since portraits of women in that moment of life always contained such elements as attributes of family wealth and honor. On the other hand, her uncovered hair and open neckline are sensual details not usually found in images of matrons. If the identification of the sitter as Lucrezia Crivelli is correct, her standing as the mistress of a powerful man may account for the portrait's ambiguities.

Seen in sequence with the slightly earlier portraits of Ginevra de' Benci and Cecilia Gallerani, as well as the later *Portrait of a Musician*, this image illustrates Leonardo's concern with specific pictorial problems. From the landscape setting and textural specificity of the earlier two paintings he moves to a more volumetric and sculptural approach. The development could well be a reflection of the artist's search for perfect forms, which came to be an important part of his artistic practice (see *Vitruvian Man*).

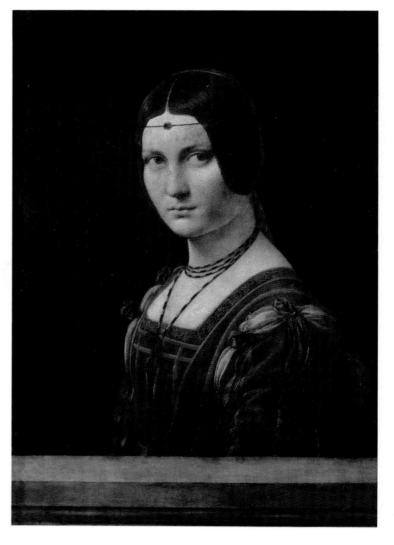

The epigram from the *Codex Atlanticus* connects Leonardo, Lucrezia, and Ludovico in a network of patronage and influence. Lucrezia is praised as a beautiful woman with god-given beauty. The poem continues: "Leonardo, first among painters, painted her; Moro, first among princes, loved her." The third stanza suggests that Leonardo's skill in achieving lifelike qualities challenges even the divine, and that the appreciative patron will use all his powers to defend the artist from the anger of the gods. This portrait thus negotiates between the desires of an autocratic patron, the social norms for women at the time, and the artist's creative freedom that Leonardo established with his imagery.

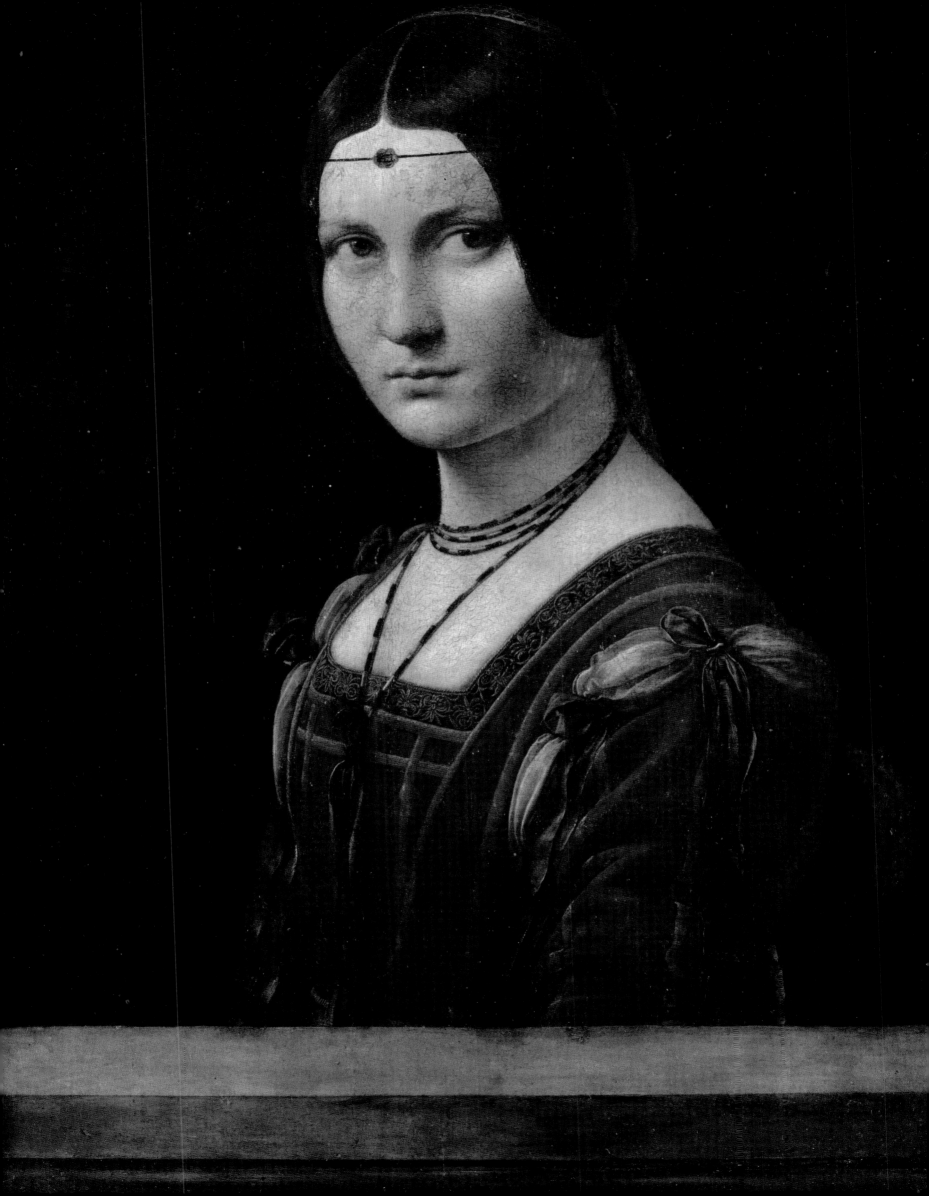

DOMENICO GHIRLANDAIO
(1448/9–1494)

Portrait of Giovanna degli Albizzi Tornabuoni

CA. 1489–90

TEMPERA ON PANEL
29 ¾ X 19 ½ IN (75.5 X 49.5 CM)
MUSEO THYSSEN-BORNEMISZA, MADRID

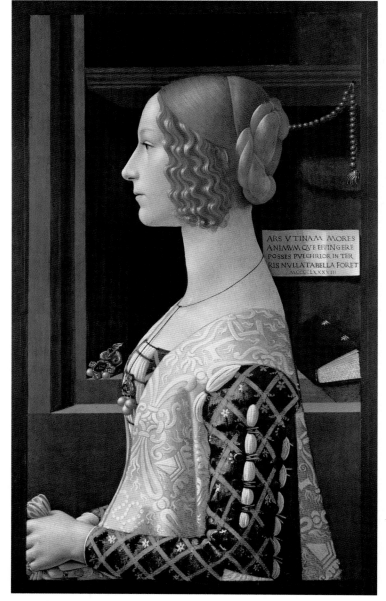

THIS LOVELY portrait, still in beautiful condition, is considered one of the finest Italian panel paintings of the late Quattrocento. The image of the sitter, Giovanna Tornabuoni (née Albizzi), is rendered with a refined technique of subtle glazes, the highlights touched in delicately with the point of the brush. Composed of blocks of rich color, the composition presents the young woman in an enclosed interior space. As she gazes out to the left, the viewer can admire her porcelain skin, her delicate features, her elegantly long neck, and her rich attire. Less a description of her appearance than a construct of ideal forms, this type of framed profile portrait was commonly employed in likenesses of wealthy Florentine women during the middle of the fifteenth century.

Giovanna Albizzi married Lorenzo Tornabuoni in 1486, at age eighteen. Their marriage created a strategic alliance between two respected Florentine dynasties. Although the union was short (she died during her second pregnancy, in 1488), Giovanna appears to have been cherished by her new family. Lorenzo kept this portrait of his first wife in his chamber for years, even after his remarriage. The poet Poliziano composed a classical epitaph extolling her virtues, and the Tornabuonis paid for an elaborate funeral. In 1490–91, Lorenzo had a family chapel dedicated to her memory, instituting weekly masses to be said on her behalf for one hundred years.

The painting is thus a posthumous record and memento of a beloved wife and family member. That it was not painted from life may be reflected in the choice of the profile view, which by 1490 was slightly old-fashioned. Set in a defined but inaccessible space, Giovanna looks aside, demurely avoiding the viewer's gaze. The portrait does not convey her personality; instead, it focuses on items of social display, such as clothing, jewelry, and possessions. She is dressed in a luxurious garment with a bodice made of gold brocade and heavily embroidered sleeves. Her bright white underdress appears through the slashed fabric, echoing the handkerchief she clutches in her hands. A gold necklace studded with pearls and rubies hangs from her neck, and small rings adorn her fingers. Behind her are another piece of jewelry (a similar brooch with a winged dragon crest) and a prayer book. A string of coral beads hangs above a *cartellino* bearing a Latin inscription.

Giovanna is literally surrounded by objects. Like these things, her portrait helps construct the Tornabuoni family identity. She wears her connection prominently: the Tornabuoni emblem (a pyramid shape) is woven into her dress, and her husband's first initial appears in the fabric on her shoulder. Items such as the jewelry and gold brooch (on the left side of the painting) convey the family's worldly status and wealth, while the prayer book on the right suggests piety. Finally, the coral beads behind her head served to ward off evil, emphasizing her purity. The inscription underscores the connection between Giovanna's outward beauty and her virtuous behavior in life. Her erect posture and elegant profile convey her noble birth and proper comportment.

The portrait provides a memento of Giovanna for the Tornabuoni family while making a case for her as a repository of family honor. In this portrait, Giovanna's chastity, purity, and virtue are as much Tornabuoni property as are the jewels and clothing that she so gracefully wears.

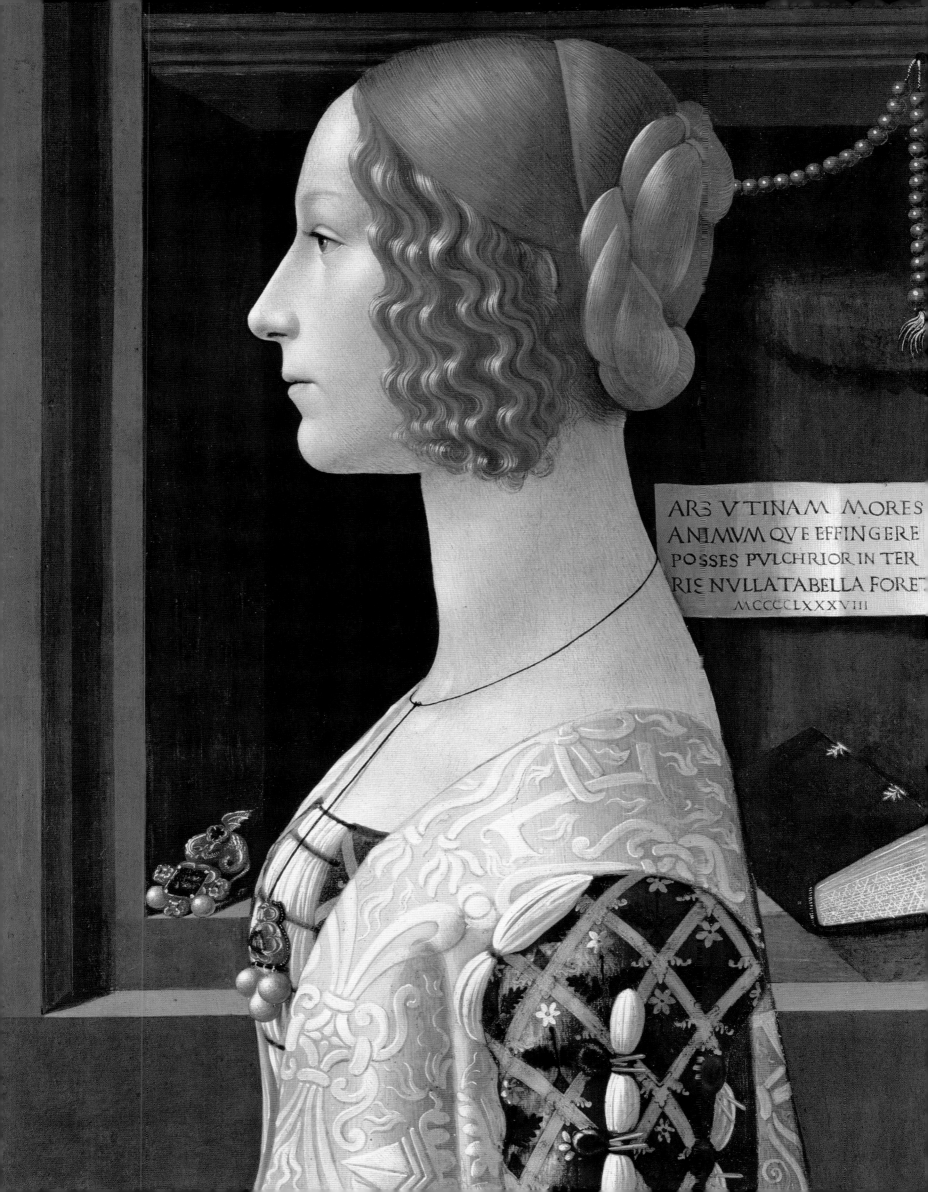

ARS VTINAM MORES
ANIMVMQVE EFFINGERE
POSSES PVLCHRIOR IN TER
RIS NVLLA TABELLA FORET
MCCCCLXXXVIII

LEONARDO AS A COURT ARTIST

DURING the Renaissance, artists could follow several different paths to achieve success. Some created works of art for sale to middle-class clients; others aimed for prestigious commissions granted by religious institutions or civic bodies. The pinnacle of achievement, however, was an appointment as a court artist. Once established in such a position, an artist could count on a stable and lucrative situation: he would receive a regular salary; enjoy perks such as free housing, food, and clothing; raise his status by association with nobility; and gain access to additional wealthy patrons. In return, the artist was at the command of the lord. He might be asked to do portraits, execute decorative projects, travel on behalf of the lord, and perform other kinds of ephemeral tasks. The menial aspects of the job were a small price to pay for the status, stability, and artistic autonomy that came with the position. Indeed, Leon Battista Alberti wrote that good art could be produced only at court, for only there could an artist find freedom from financial pressure.

In the republican city of Florence, artists made their reputations by competing for public civic and religious commissions. They made their fortunes by selling works on the market for private consumption. Leonardo's early career fits into this model: his family connections helped him win significant commissions for altarpieces (such as the *Adoration of the Magi* and *St. Jerome*), and his images of the Virgin were popular. However, in 1481, when Pope Sixtus IV asked Lorenzo de' Medici to send the best Florentine artists for a major project in the Sistine Chapel, Leonardo's name failed to make the list. His inability to finish a project on time may have contributed to his lack of success, and perhaps yet another factor was his humiliating arraignment on charges of sodomy in 1476 (though the charges were later dropped for lack of evidence). By 1482 Leonardo had moved to Milan, a duchy led by the Sforza family, where there was both wealth and opportunity. In his letter of introduction, he emphasized his skills as an engineer and military designer. Only at the end of his list of abilities (which included naval warfare, hydraulics, and weapons design) did he mention his training as an artist. Rather than signaling Leonardo's modesty about his artistic accomplishments, this prioritization shows the artist's awareness of the needs of the lord, who maintained his position primarily through military power.

Leonardo took up an official court position with Ludovico Sforza sometime between 1487 and 1490. His work for the duke was extremely varied. The earliest projects were portraits of Ludovico's mistresses *(Lady with an Ermine* and *La Belle Ferronnière)* and low-level court administrators *(Portrait of a Musician).* Later, Leonardo received a commission from the Sforza to paint the *Last Supper* on a wall of the refectory at Santa Maria delle Grazie. He also devoted many years to the duke's grandiose project for an equestrian monument dedicated to his father. However, the bulk of Leonardo's time at the Sforza court was spent on engineering and design projects, both social and military. Festivals, pageants, triumphal entries, and theatrical events needed elaborate settings and decorations to impress the diplomats and courtiers who attended. Leonardo was adept at producing not only visually stunning stage designs and floats but also remarkable gadgets (such as a mechanical lion) and theatrical machinery, which delighted the courtly audience. He also executed several architectural designs, using a radical new concept for a classicizing central-plan church. For the military needs of his patron, Leonardo designed innovative machines (such as a tank and scythed chariot) as well as siege equipment, automatic weapons, fortifications, naval vessels, and many other devices. While at court, he devoted himself to mathematical and proportional studies, embarked on his initial anatomical investigations, and began his *Treatise on Painting.* Thus, the sixteen years that Leonardo spent in court service in Milan, enjoying the stability and security that Alberti describes, resulted in a period of intellectual innovation and creativity.

When the French invaded Milan in 1499, Leonardo found himself without a benefactor. For several years he moved between cities and patrons; he spent time working for the general Cesare Borgia *(Bird's-Eye View of the Chiana River),* for the French governors in Milan, and for Pope Leo X in Rome. In 1516 Leonardo accepted an invitation from François I of France and moved to the French court. Though elderly, he was received with great honor and presented with a chateau and a generous salary from the king. As Leonardo lay dying, according to legend, the king himself went to his bedside. This mark of respect shows the esteem in which the artist was held at the end of his life.

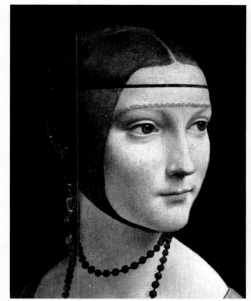

Lady with an Ermine (Portrait of Cecilia Gallerani)(PAGE 218)

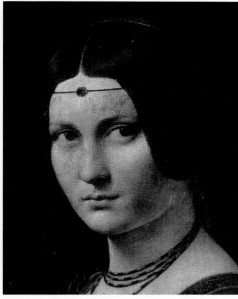

La Belle Ferronnière
(PAGE 232)

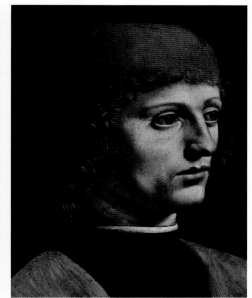

Portrait of a Musician
(PAGE 242)

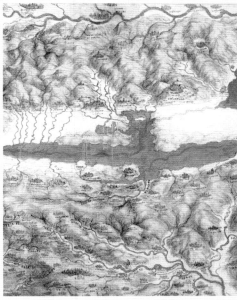

Bird's-Eye View of the Chiana Valley
(PAGE 152)

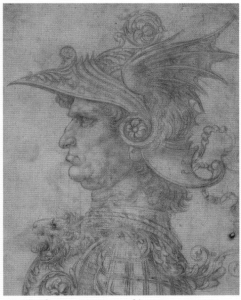

Study of a Warrior in Profile
(PAGE 194)

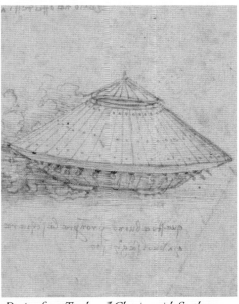

Design for a Tank and Chariot with Scythes
(PAGE 208)

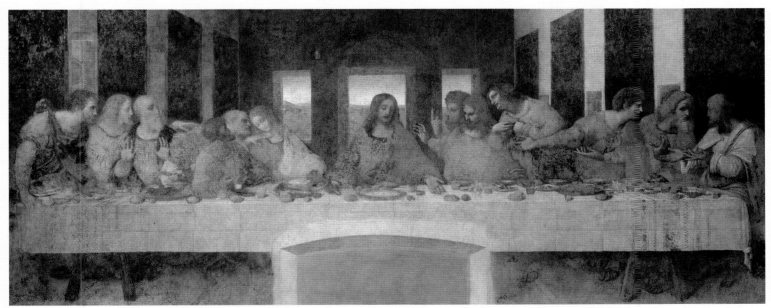

The Last Supper
(PAGE 124)

LEONARDO DA VINCI
(1452–1519)

Portrait of a Musician

CA. 1485

TEMPERA AND OIL ON PANEL
17 ½ X 12 ½ IN (44.7 X 32 CM)
PINACOTECA AMBROSIANA, MILAN

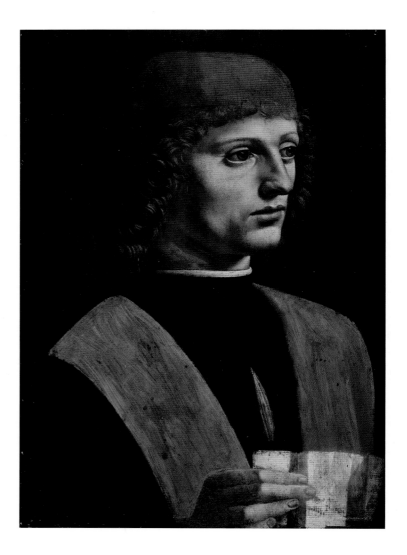

PORTRAITS OF men are rare in Leonardo's work. This one dates from the artist's first Milan period, when he made several portraits of Ludovico il Moro's mistresses (see *Lady with an Ermine* and *La Belle Ferronnière*). This portrait follows Leonardo's renowned formula: it features a bust-length figure in a shallow space spotlighted against a dark background. Leonardo's naturalistic details reveal the sitter's outer appearance as well as suggest his inner psychology.

Parts of the painting are unfinished, lacking the degree of polish that marks portraits such as *Ginevra de' Benci* and *Lady with an Ermine*. Some scholars attribute the lower part of the figure to Leonardo's assistants, noting the rough handling of the brown stole, for example. However, the nuanced treatment of the planes of the man's face, the luminous quality of the light, and the avoidance of hard edges are typical of Leonardo's work in this period. The dark background may show his knowledge of the work of Sicilian painter Antonello da Messina, a favorite of Ludovico, who traveled through Milan in 1475. The folded paper in the right foreground is not only a demonstration of Leonardo's skill with light and texture but also a clue to the sitter's identity. The notes and score visible there, with the abbreviated letters *Cant Ang* (short for *cantum angelicum*) suggest that he was a musician and composer.

Leonardo paints a quiet intensity in the man's expression, which may also be a reference to his profession. As he gazes off to the right, the figure seems to be in repose, perhaps waiting for a cue. The light streaming over his face suggests some kind of heavenly inspiration, giving the portrait an uplifting quality despite its calm composition and severe color palette. Leonardo's ability to convey a sitter's inner psychology through external features was highly admired by contemporaries.

Several possibilities exist for the identity of the sitter. One is that he was the court musician Franchino Gaffurio, who was appointed choirmaster of the Milan Cathedral in 1484. But Gaffurio was forty years old in 1484, seemingly too advanced in age to match the youthful appearance of this man, which Leonardo's own notes tell us he painted "from life." Other scholars suggest the famous Renaissance composer Josquin des Prez, who was Gaffurio's predecessor at the cathedral. But this identification, too, seems unlikely, given Josquin's departure from the city in 1484. A third possibility is Atalante Migliorotti, a close friend of Leonardo from Florence. Atalante traveled to Milan with Leonardo and is known to have been an amateur musician. If the portrait does indeed show a personal friend of the artist, its informal effect could thus be explained. In fact, Leonardo never received an official commission for a court portrait. On the contrary, his subjects were all fairly low in the court hierarchy: mistresses, women, and, in the case of this man, a humble musician. It may be that his sitters' modest stations allowed Leonardo the chance to experiment and innovate with their likenesses. Such license would not have been tolerated in official artworks showing the duke or his wife. Portraits like this one probably operated in a private environment, intended for an intimate audience of friends and family. In such a setting, the obvious markers of wealth and status could be exchanged for a more personal representation of one's identity.

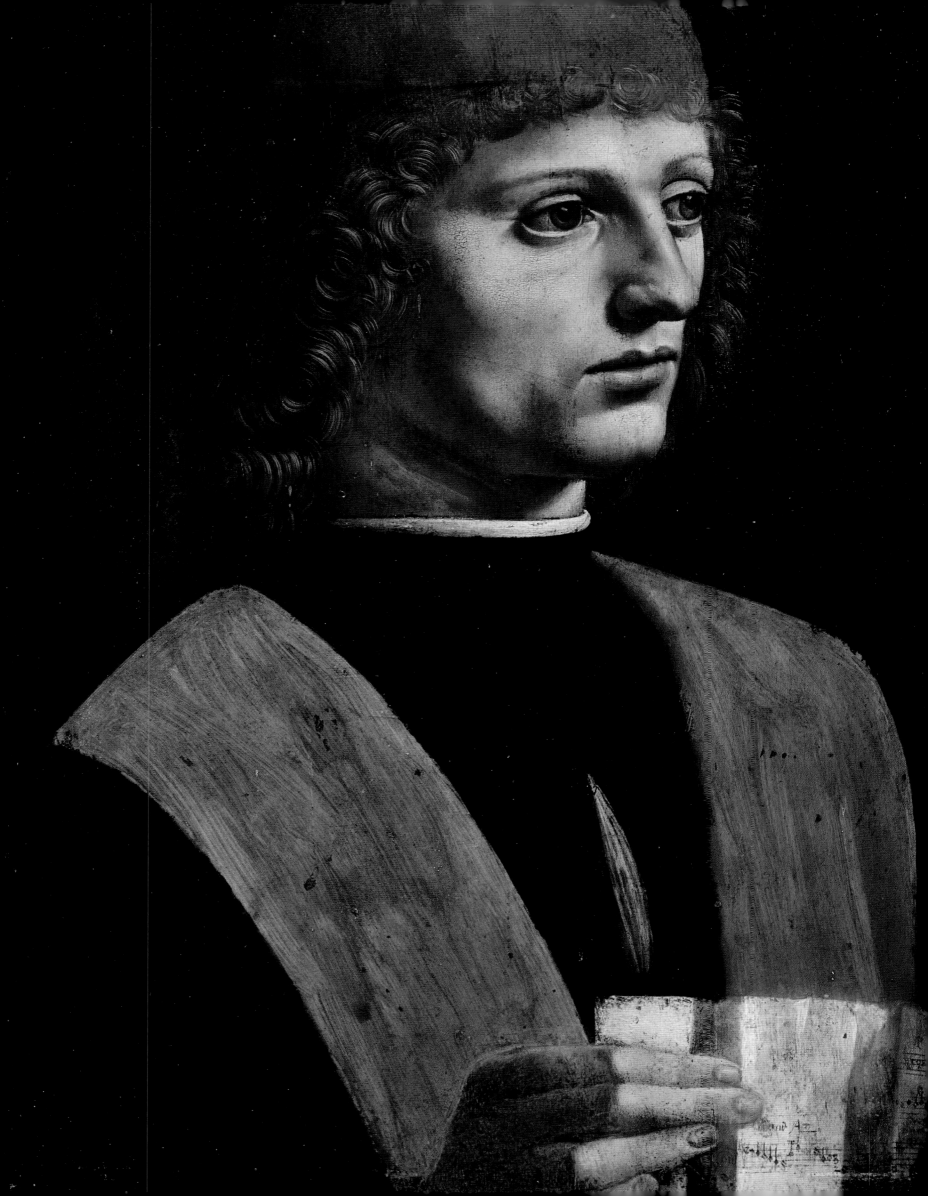

PIERO DELLA FRANCESCA

(1416/17–1492)

Portrait of Battista Sforza

CA. 1474–75

TEMPERA AND OIL ON PANEL
18 ½ X 13 IN (47 X 33 CM)
UFFIZI GALLERY, FLORENCE

PIERO della Francesca's *Portrait of Battista Sforza* provides one of the primary precedents for Leonardo's formula, seen most dramatically in the *Mona Lisa*, of placing a half-length portrait against an extensive landscape. The bright and relatively even lighting of Piero's composition contrasts with Leonardo's stylistic development toward a darker ground and hazy atmosphere, but a model can be seen in Piero's treatment of a deep, meandering landscape and subtle atmospheric perspective in the distant mountains. Although we cannot be certain Leonardo saw Piero's work and took direct inspiration from it, indications are that this particular painting was known to him.

The sitter, Battista Sforza (1446–1472), was a cousin of Ludovico Sforza, Leonardo's Milanese patron. Her line of the Sforza family assumed control of the seigniory of Pesaro, on the Adriatic coast, upon its conquest by her father, Alessandro. Battista was married to Federico da Montefeltro, the duke of Urbino, who was one of the period's most successful *condottieri*, or military generals for hire. This portrait is one of a pendant pair of panels, with Federico also shown in profile facing his wife and set against a similar landscape background. Both paintings have intriguing triumphal processions depicted on the verso, signifying both military rule and the triumph of love in antique rhetorical fashion.

The use of an extensive landscape as a feature in an early Renaissance portrait signified first and foremost an aristocratic, titular relationship to the place represented. That assumption is yet another of the oddities of Leonardo's *Mona Lisa*, because the sitter, Lisa Gherardini, held no such title and cannot be tied to a territorial acquisition. Perhaps that is one of the main reasons Leonardo emphasized the fantastic and mysterious aspects of the landscape rather than an identifiable province. The strict profile of Battista's portrait, mirrored in Federico's, would have been seen as supremely honorific, immediately recalling the standard form of imperial portraits on ancient Roman coinage and the more recent tradition of heraldic medallions cast in metal. As the two look at each other, the horizon lines of both paintings coincide with the necklines of their fashionable and expensive clothing. The result is that the bulk of their heads rises above in aristocratic detachment, as if to survey their holdings.

The landscape is ample—fertile in the country, prosperous in the waterways, and benign overall. That said, the duke and duchess of Pesaro very likely appreciated their portraits in a more poetic way, rather than merely as a demonstration of a domineering land grab. Writings of Neoplatonic humanists of the Urbino court often emphasized the relationships between natural environs and human nature. Battista Sforza's portrait emphasizes a protective characteristic, the walled city, perhaps a sign of her virtue in the same way that the *hortus conclusus*, or enclosed garden, was a symbol of the purity of the Virgin Mary. The reason and wisdom of an enlightened ruler, visualized by the restraint of the facial expressions, brought peace and prosperity, obfuscating the true history of her husband's military conquests.

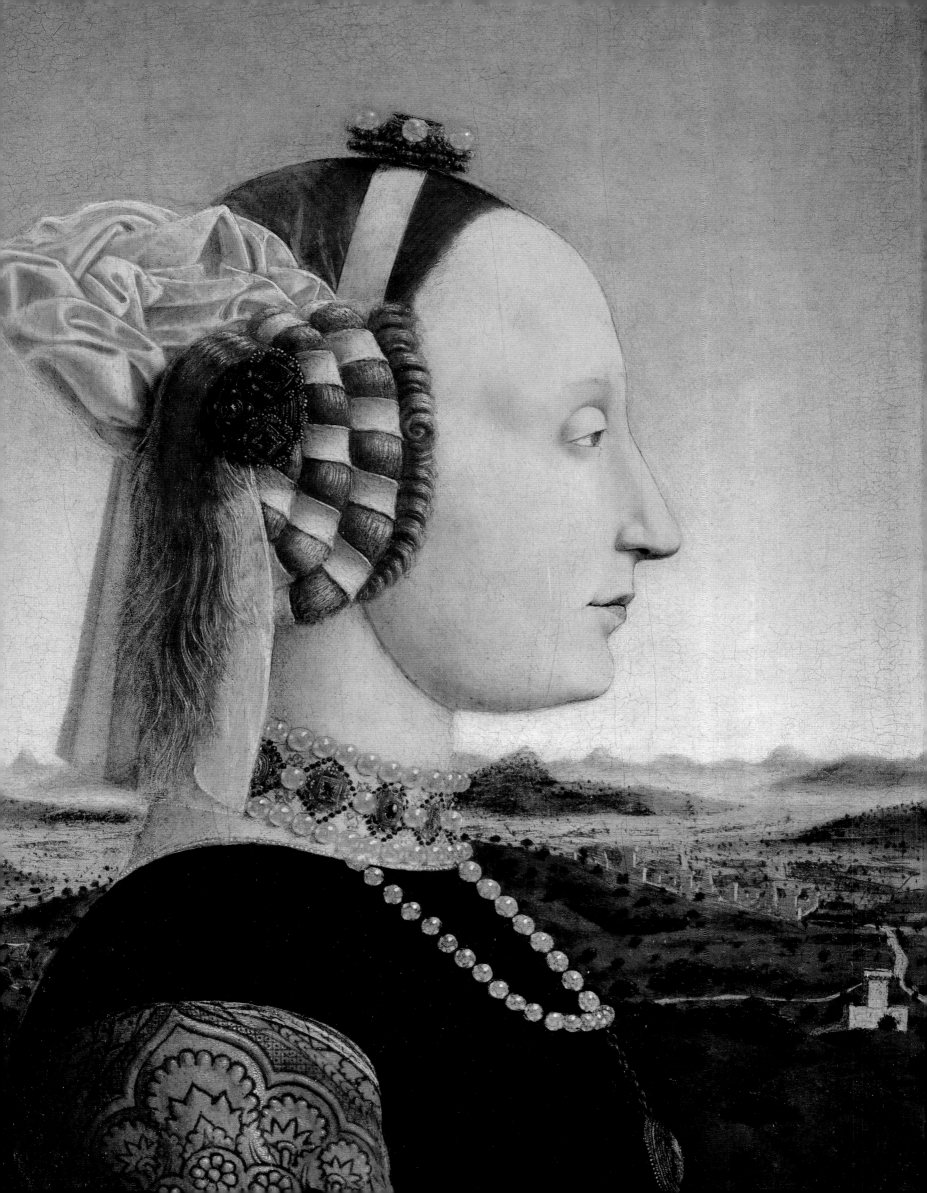

LEONARDO DA VINCI

(1452–1519)

Mona Lisa

CA. 1503–6, AND POSSIBLY LATER

OIL ON POPLAR PANEL
30 ¼ X 21 IN (77 X 53 CM)
LOUVRE MUSEUM, PARIS

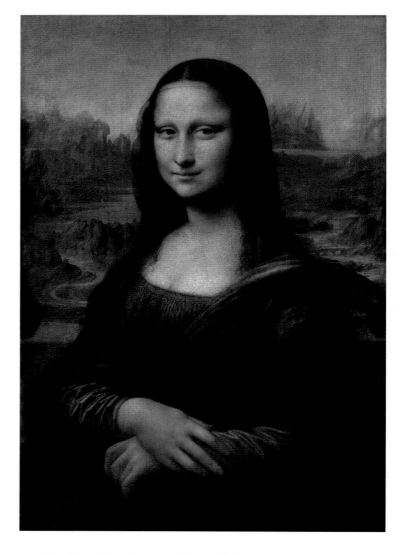

MANY ASPECTS of Leonardo's masterpiece known as the *Mona Lisa* were perfectly conventional by the first decade of the sixteenth century: the vast and meandering landscape, the three-quarter pose and half-length view, the hands placed in front of the figure, and even the hint of a smile can be found in earlier portraits. What sets this painting ahead of all others is Leonardo's precision in rendering complex details with a geometrically balanced underpinning, and his soft layering of light that creates an ambient atmosphere that he called *sfumato*, or "smokiness." This technical mastery has coincided for centuries with two mysterious questions surrounding the painting: who exactly is this woman, and why is she smiling?

The first problem has now been conclusively resolved, and that identity allows several suggestions to be made to address the second query. The painting was recorded in the inventory of Leonardo's pupil and heir Salai as *La Gioconda*, literally "the smiling woman." The fact that Leonardo kept the painting until his death and that this inventory listing seems to be more of a nickname than a proper identification led many scholars to suggest it was an idealized, even imaginary, portrait, despite that in the mid-sixteenth century Vasari claimed it was a portrait of *mona* Lisa, the wife of the wealthy Florentine cloth merchant Francesco del Giocondo. (In Italian, *mona* is a contraction of *madonna*, or "my lady.") A recently discovered marginal note in an edition of Cicero's *Epistulae ad familiares*, written in October 1503 by the Florentine official Agostino Vespucci, confirms the specific identity as the woman properly known as Lisa di Antonio Maria Gherardini. Cicero had written that the ancient Greek painter Apelles rendered the heads and shoulders of his Venus in greater detail than the body, and Vespucci noted that Leonardo did the same with his portrait of "Lise del Giocondo" as well as his painting of Anne, mother of the Virgin Mary. Given the substance of Vespucci's commentary, one wonders if the background wasn't largely completed later, when the artist returned to Milan. It certainly bears little resemblance to the Tuscan terrain but does correspond to many of the master's studies of the jutting rocks of Alpine geography. The territorial nature of the landscape behind the woman would seem more fitting for someone with a feudal claim to land, but Leonardo may have intended to connect her to unspoiled nature in a more general and poetic manner.

The firm identification thus enables an answer to the second question. Like the portraits of Ginevra de' Benci and *Lady with an Ermine*, the smile in the *Mona Lisa* is a visual pun on the sitter's name. In a more nuanced sense, though, her expression is a hallmark of her social position. It is difficult to define the exact nature of Mona Lisa's character, but she seems quietly confident, addressing the viewer directly, and yet simultaneously reserved, with her hands crossed before her. The smile is familiar, yet not exuberant. In all of these ways, it offers the epitome of lively naturalness but also of restraint and grace. One would expect a different attitude—and, indeed, one gains in Leonardo's other portraits a different sense—from an aristocratic sitter or one who was closely aligned with a court.

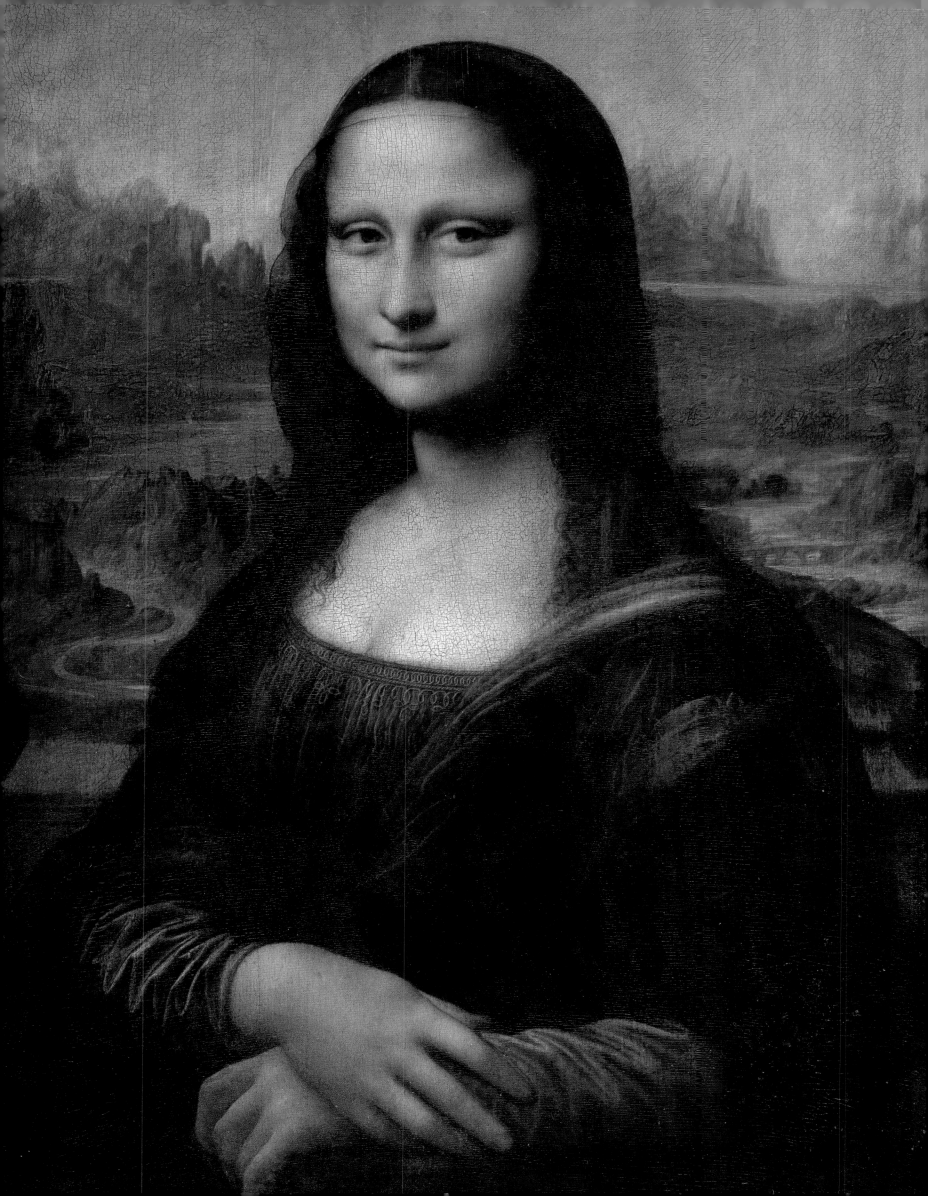

LEONARDO DA VINCI
(1452–1519)

Mona Lisa, details
CA. 1503–6, AND POSSIBLY LATER

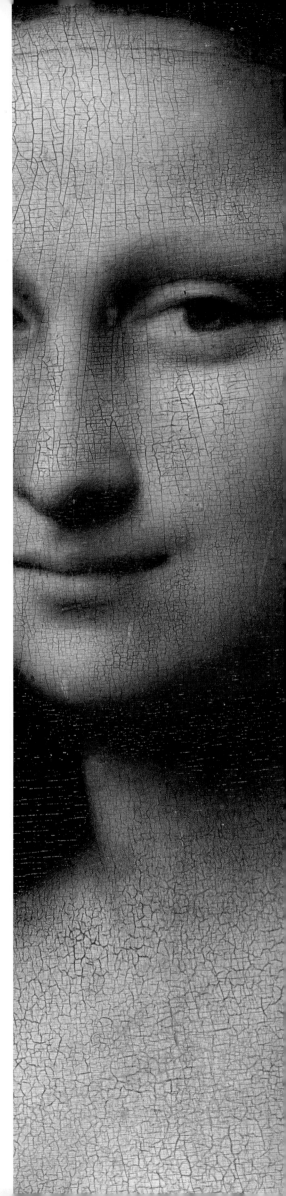

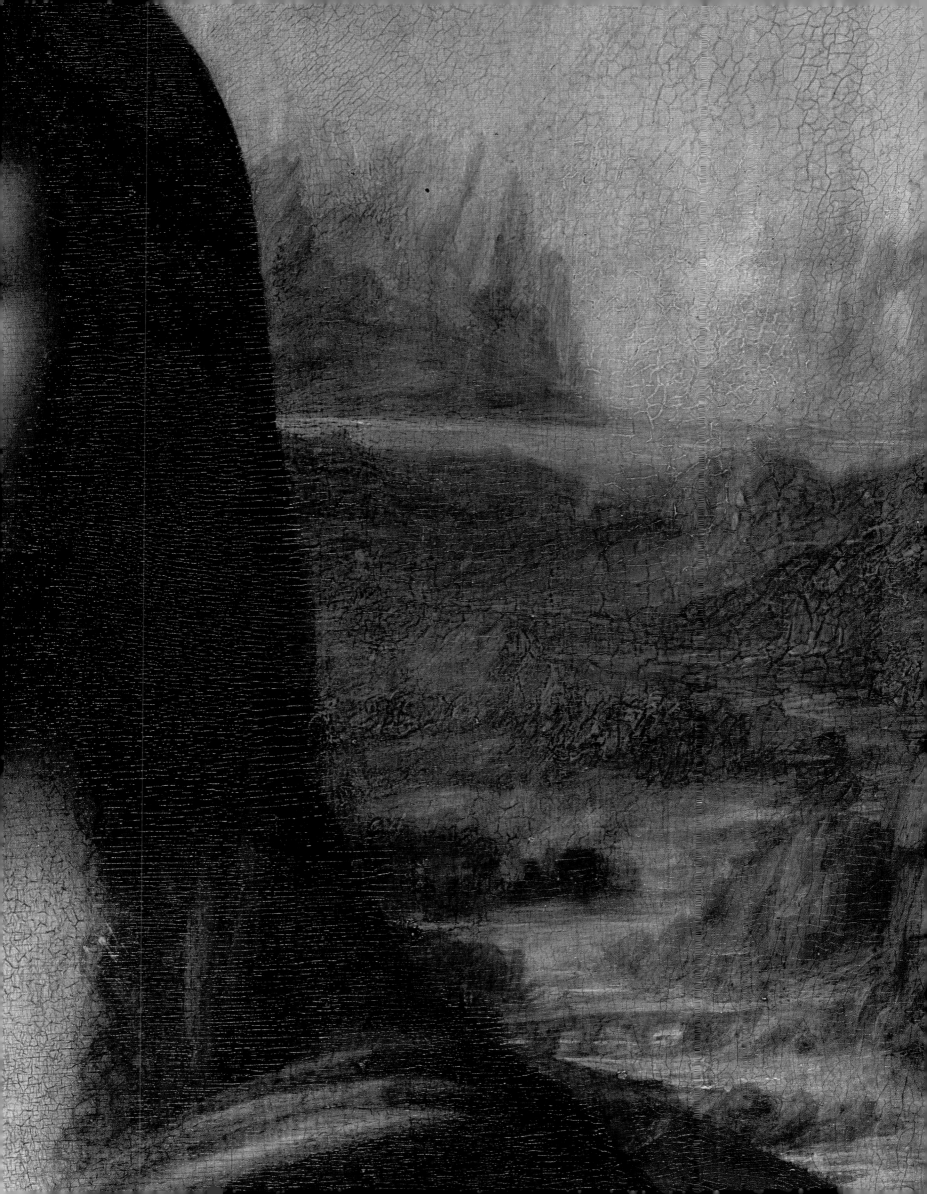

LEONARDO DA VINCI
(1452–1519)

Self-Portrait (?)
CA. 1512

RED CHALK
13 X 8 ½ IN (333 X 213 MM)
BIBLIOTECA REALE, TURIN

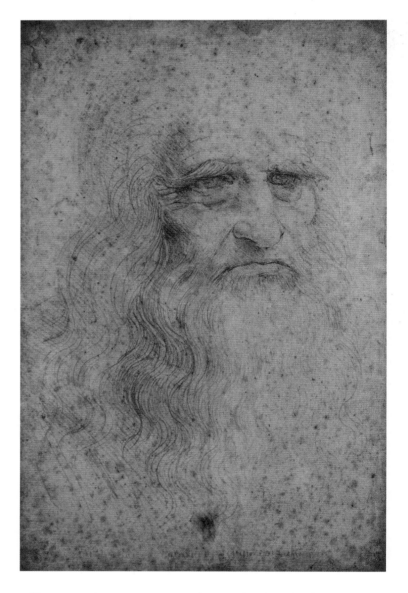

THIS DELICATE drawing shows the head of an old man in three-quarter view. A bright light shines on his face from the right, washing out details on that side and casting shadows on the left cheek and temple. Under such brilliant illumination, the figure appears almost ephemeral. The contours of the head disappear at the top, the hair dissolves into the paper on the right, and there is no indication of neck or shoulders. Deep set and heavily lined, the eyes are the focus of the work; they gaze off to the right. The flowing beard, sparse long hair, and copious wrinkles on cheeks and brow all combine to give the effect of advanced age. Wisdom and experience are written on the sitter's face; the focus on the eyes gives him a contemplative aspect, as if weighty thoughts occupy his mind.

The drawing has long been thought to be a self-portrait made by Leonardo around 1512, while in Florence. However, this identification is not universally accepted today. For one reason, although Leonardo was sixty years old in 1512, some scholars feel that this figure appears older. In addition, the precise style of the drawing seems to some scholars to be more typical of his works made before 1510, making the identification of the old man as Leonardo even less possible. Third, the drawing lacks the direct outward gaze that is a hallmark of observing oneself in a mirror. Nevertheless, the loose handling and medium of red chalk are typical of Leonardo's oeuvre, and most scholars agree that it is a work by the master, even though they differ on the subject. Some suggest it is a portrait, perhaps of Leonardo's father, Ser Piero da Vinci, or of his uncle Francesco, both of whom died at an advanced age. Others posit that it is a "type" image, showing a philosopher. Indeed, the drawing resembles the figure of Plato in the *School of Athens*, painted by Raphael in 1508–11 for the Stanza della Segnatura in the Vatican Palace. On the opposite side of the same argument, that very figure of Plato has long been believed to be a portrait of Leonardo, whom Raphael admired greatly. Lastly, Giorgio Vasari tells of Leonardo's fascination with drawing heads from life; this could well be one of those studies. Thus the possibilities for identifying the sitter are many: it could be a self-portrait, an image of a generic philosopher, perhaps even a self-portrait as a philosopher, or simply a captivating drawing of an old man.

Our knowledge of Leonardo's appearance is limited. One self-portrait drawing appears in his notebook on birds, but it is obscured by other sketches. Descriptions of the artist by contemporaries such as Vasari tell us that he was handsome and graceful, as well as an accomplished courtier. Portraits of Leonardo made by his assistant Francesco Melzi and others who knew him show attributes similar to those seen here: long hair, thick beard, deep-set eyes. In many ways, portraits like this one visually codified the legend of Leonardo as an artist of incomparable intellectual ability, a gifted thinker, and an inordinately skilled craftsman. Whether the image is a portrait or not, it provides a compelling type for Leonardo as the quintessential genius, a universal artist.

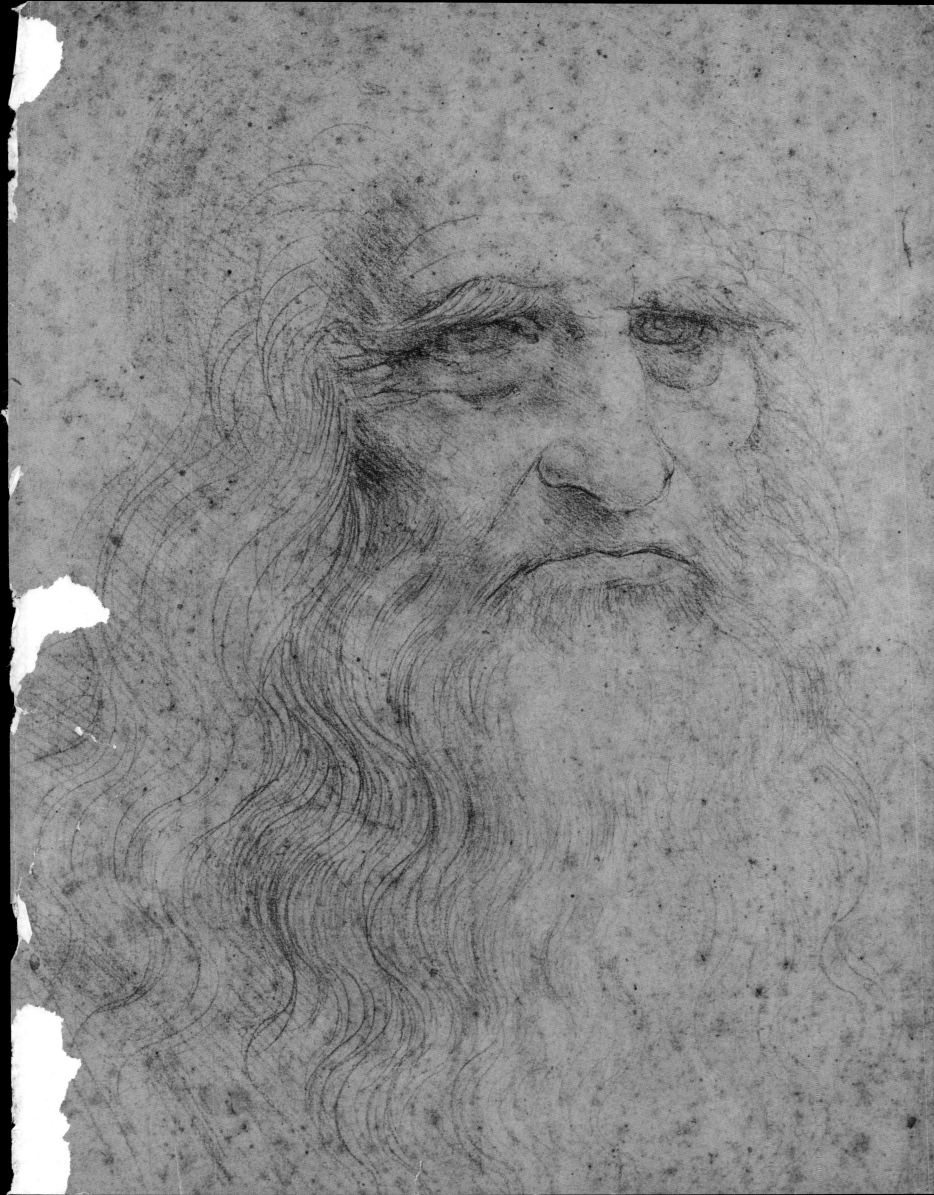

INDEX